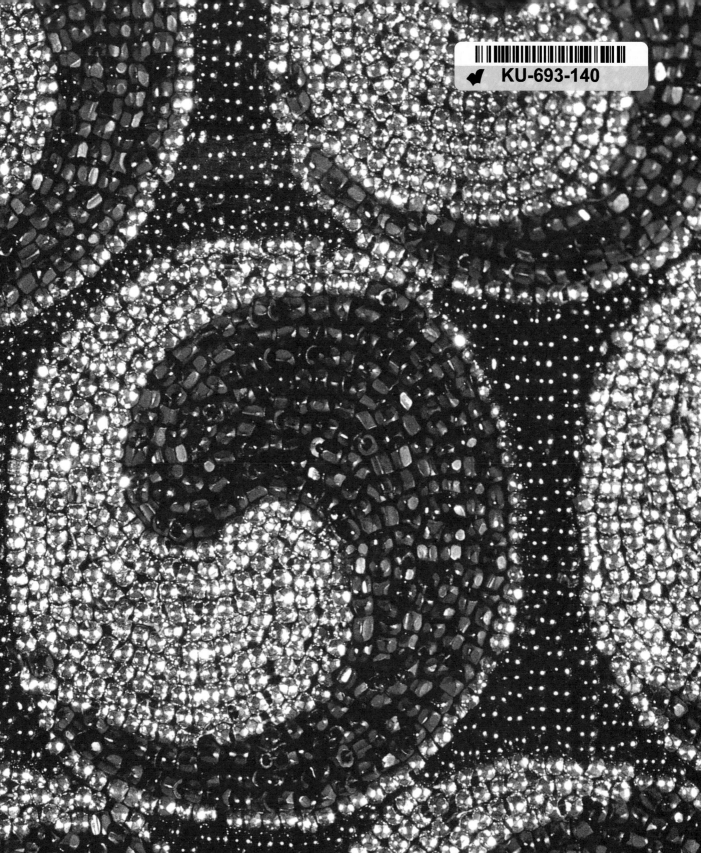

BEADS on BAGS
1800s-2000

With Price Guide

Photography by Leslie & Ramón Piña

Schiffer Publishing Ltd

4880 Lower Valley Road, Atglen, PA 19310 USA

Lorita Winfield
Leslie Piña
Constance Korosec

Front cover: Embroidered, cut-steel and black seed beads, marcasite studded frame. Art Deco, Chinese 'Yin-yang' symbol motif, tassel fringe, 9-inch length. c. 1930. *Author.* $400-500.

Back cover: Detail. Knitted, fine multi-color seed beads, Venice, Italy, small canal off Piazza San Marco, covered gondola and gondolier, small walking bridge, *Campanile* bell tower in the background. c. mid to late 1800s. *Courtesy of Veronica Trainer*

Copyright © 2000 by Lorita Winfield, Leslie Piña, and Constance Korosec
Library of Congress Card Number: 00-101729

Designed by Leslie Piña
Book layout by Bonnie M. Hensley
Type set in Bodoni Bd BT/Korinna BT

ISBN: 0-7643-1138-7
Printed in China
1 2 3 4

Published by Schiffer Publishing Ltd.
4880 Lower Valley Road
Atglen, PA 19310
Phone: (610) 593-1777; Fax: (610) 593-2002
E-mail: Schifferbk@aol.com
Please visit our web site catalog at **www.schifferbooks.com**

In Europe, Schiffer books are distributed by Bushwood Books
6 Marksbury Avenue Kew Gardens
Surrey TW9 4JF England
Phone: 44 (0)208-392-8585; Fax: 44 (0)208-392-9876
E-mail: Bushwd@aol.com
Free postage in the UK. Europe: air mail at cost.

This book may be purchased from the publisher.
Include $3.95 for shipping. Please try your bookstore first.
We are always looking for authors to write books on new and related subjects.
If you have an idea for a book please contact us at the address above.
You may write for a free printed catalog.

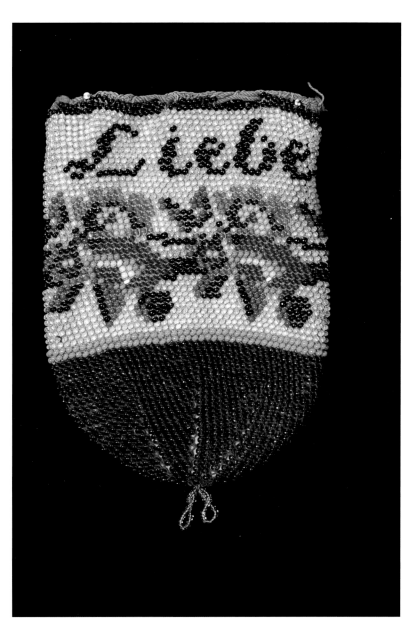

Knitted, unframed, multi-color fine seed beads, the word,
Liebe, German for "love," worked in beads. c. early 1800s.
Courtesy of Joanne Haug of Reflections of the Past

Acknowledgments

We would like to express our thanks to all anonymous sources and to the following individuals who contributed toward the creation of this book, and so generously provided the beaded bags for us to photograph.

Mr. & Mrs. Charles Abookire, Estate of Rose Allen, Virginia Mallett Azzolina, Paulette Batt of Larchmere Antiques and Paulette's on Larchmere, Lenore Hollander Bletcher, Linda Bowman of Legacy Antiques and Vintage, Douglas Brotherton, Mackenzie Brotherton, Anne Katherine Brown of Friends Antiques, Judith K. Brown, Mary Broyles of Ornamental Resources, Charlotte L. Cudlip, Frances Farrar Evans, Frances F. Dickenson, Susan Lehman Ellick, Giulia Fabris of Antichità, Venice, Italy, Estate of Gertrude Freedland, Shirley Friedland, Pearl Schwartz Fishman, Joyce Glickman, Nancy C. Goldberg, Anna Greenfield, Deborah Gulyas of Renaissance Parlour, Joanne Haug of Reflections of the Past, Carter Paul Johns, Jennifer Johnston, Knuth Shoes, Giuliana C. Koch, Elayne Roche Kramer, Ruth G. Kyman, Kathryn Ladra, Pamela F. LaMantia, Emma Lincoln, Gloria Azzolina Lorenzo, Dr. Enzo Luparelli, Ruth Marcus, Janet King Mednik, Sandra Burdette Mills, Aurora Mitchell, Sandy Osborn, Madeleine Parker, Edythe Swartz Phillips, Eileen Sullivan Ptacek, Alayne Reitman, Sylvia Reitman, Kathleen A. Rice, Beth Ries, Caroline Ries, Velma Behringer Roche, Arlene Schreiber, Chad Schreibman of Alson Jewelers, Tobe Schulman, Anita Singer, Sally Smith, Cheryl Dietz Stankus, Kay Stringari, Martha Cordes Towns, Veronica Trainer, Russell Trusso, Ursuline College Historic Costume Study Collection, Bunni Union, Victoria and Albert Museum, Cathy Winfield, Chaille Winfield, Frankie Winfield, Madelyn Winfield, and Teresa Winfield.

Thanks again to Ramón, for his loving work with the photography, the staff at the Ursuline library, Peter and Nancy Schiffer, Jennifer Lindbeck, Bonnie Hensley, and the gang at Schiffer Publishing.

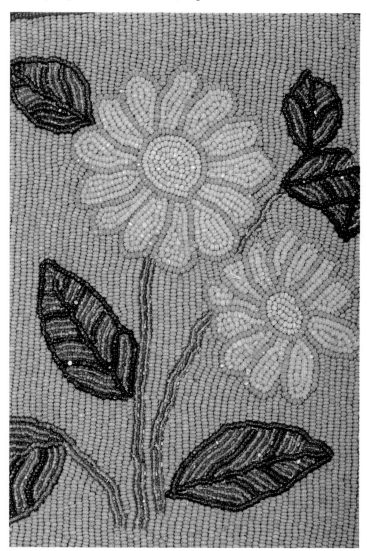

Detail. Yakima American Indian, belt pouch, fine turquoise seed beads, and cut glass seed beads in yellow and flesh color. c. 1915. *Author.*

Contents

Chapter 1
History & Technique

Beads: Gifts to a Commodity

An overview of the history of glass seed beads: function and fashion

Glass beads have a long history that dates to before 1,000 AD. The glass "seed" bead, however, was developed in Venice during the period that is regarded as the foundation of the Venetian glass industry, between 1200 and 1400. In 1292, all of the glass factories were relocated away from the main area of Venice to the island of Murano. This was done to protect Venice from the risk of fires caused by the continually burning furnaces. More importantly, the factories were moved to keep the glassmaking techniques secret. Glass was considered a luxury item with high trade value. The glassmaker's guild was directly under the jurisdiction of the highest governing body of the Venetian Republic, the Council of Ten, and Murano glassmakers were governed by a strict "non-compete" agreement. Under penalty of death, they were forbidden to share the secrets of their glassmaking, to leave the island, or to set up glassmaking factories elsewhere. These restrictions were effective for some time, but eventually glass factories were established in Holland, and Bohemia (Eastern Europe).

During the fifteenth and sixteenth centuries, the beginning years of exploration, discovery, and European expansion, Venice dominated the industry and the market. Tons of glass beads in a wide range of sizes were exported and used as gifts and barters on the trade routes to Asia, the Far East, Africa, and the Americas.

In the seventeenth century, needlework was considered an appropriate skill for young women. The smallest of the glass beads began to be used to enhance embroidery and a variety of objects and accessories. The first bags made entirely of beads appeared at this time. These were small bags for carrying coins made by weaving beads with a needle and thread.

In the eighteenth century, fashions were influenced by the opulence of the French court. Costumes were embellished with beads and gold threads and seed beads were used to cover large objects of decorative art and furnishings. Toward the end of the 1700s, and after the French Revolution, European fashions became less elaborate.

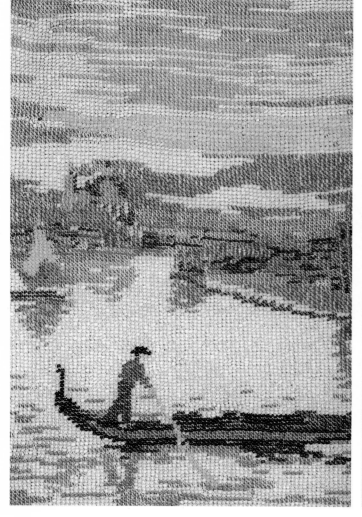

Left: Detail. Beaded scene of the Grand Canal of Venice, Church of Santa Maria della Salute in the background, open gondola and gondolier in the foreground. c. 1900. *Author*

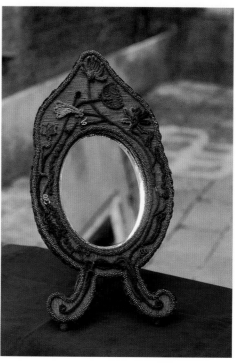

Bead encrusted mirror, Italian. c. mid 1800s. *Courtesy Giulia Fabris of Antichità, Venice, Italy. Photo by Dr. Enzo Luparelli, Venice, Italy.*

In North America, during those three hundred years, the glass beads brought by the European explorers as gifts to the indigenous cultures replaced natural ornaments such as quills in decorative needlework. As American Indian beadwork evolved, glass seed beads became a traded commodity. The Euro-Americans looked to France and England for fashion and culture. They imported European fabric, trims, and accessories—including beaded purses—for dressmaking and furnishings. American Indian tribes incorporated European patterns for their own tribal use. Eventually, the Indians of the Northeast designed and produced items such as beaded bags specifically for Europeans who had developed an interest in Indian beadwork.

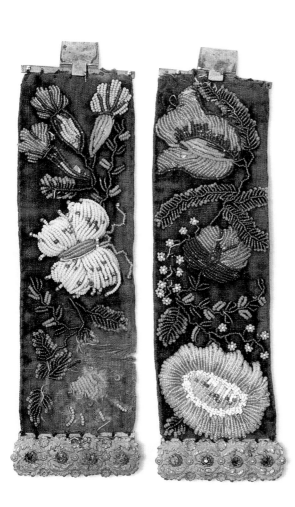

Bead embroidered bracelets, gilded clasp with colored stones. c. mid 1800s. *Courtesy Joanne Haug, Reflections of the Past.*

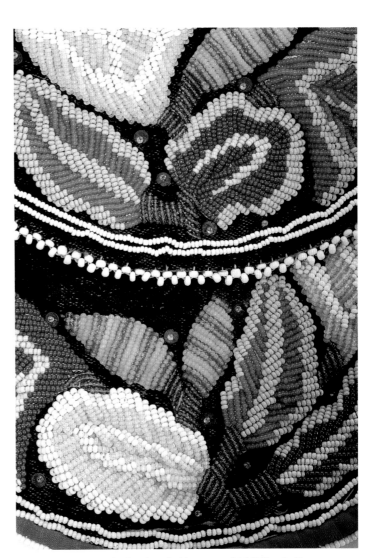

Detail. American Indian beaded bag. c. mid 1800s. *Author.*

By the late 1800s, bead embroidery and apparel decorated with beads were important in fashion. Following the end of World War I, beaded bags were at the height of their popularity. It was in the decade of the 1920s that purses found a permanent position in fashion and, subsequently, the glass seed bead.

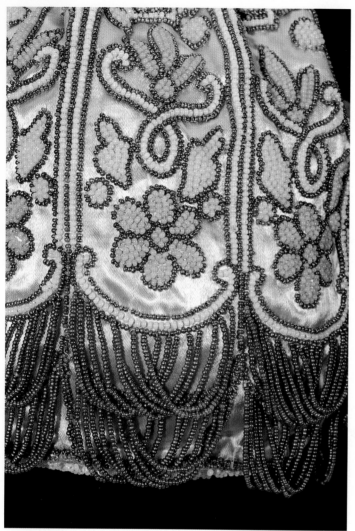

Detail. Bead embroidered bag on satin, seed and steel beads. c. 1920s.

used for making beaded bags in the nineteenth and early twentieth century.

Today, the glass industries in Japan and India are producing quantities of the glass seed beads used for beadwork and crafts. Japan, in recent years, has developed the technique to

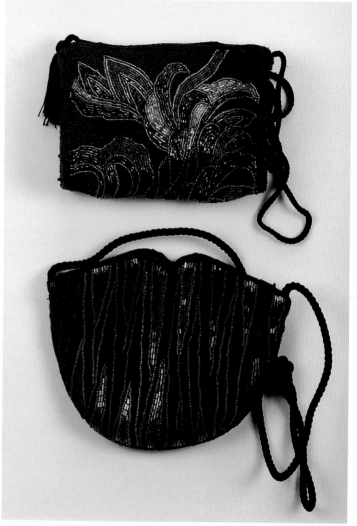

Two contemporary evening bags, bead embroidered in India. c. 1990s.

Where were the glass beads made that are on these beaded bags?

The tiny, glass seed beads on the bags illustrated in this book were made in countries with long histories of producing glass beads:

Italy: The island of Murano, a short boat ride off the main port of Venice, has dominated the world's glass bead market since the fifteenth century.

Czechoslovakia: Known throughout history as Bohemia, this eastern European country has a legacy of craftsmen skilled in the cutting and grinding of facets on tiny glass and crystal beads.

France: The French glass industry has been important in the production of glass beads for centuries and continues to supply the world with seed beads. In addition, France produced a cut-steel bead that was

produce "uniform" glass seed beads that "fit" perfectly against one another whether woven, embroidered, or strung. The variety of colors that the Japanese produce is unequaled. These beads are inspiring bead artists and bead embroiderers around the world.

India, since its independence, in 1947, has emerged as a major exporter of glass beads. It is also one of the most important centers of bead embroidery work. Many of the beaded bags that are now in high fashion are made in India.

How are glass seed beads made?

The method for making "drawn" beads is ancient. A glass blower takes a "gather" (a blob of molten glass) on his blowpipe from a crucible in the furnace. After "marvering" it (settling it against a slab of marble), he blows a bubble. An assistant attaches a gather, which is on the end of a rod, to the bubble. Both of the men move quickly away from each other,

pulling the glass bubble to form a long, thin tube, sometimes more than one hundred feet long. The "bubble" has been stretched to become the "hole" in the tube. The tube, which can be very small in diameter, is cooled and then broken into meter lengths (canes), later to be cut into small beads. The "raw" beads are sometimes tumbled in a powder over heat to round off the rough cut edges. Seed beads and bugle beads are made this way.

The "bugle" bead is a small bead shaped like a tube. The etymology of this word is not clear. In history, the bugle bead referred to both round and long shaped glass beads. In the late sixteenth century, there are references to "lace bugles" used for embroidery. Italians call bugle beads *tubetti,* and the French call them *longue perle de verre.* Like the seed bead, the "bugle" bead is cut from a glass cane, and left unpolished, in the same form as when it was cut from the cane with sharp edges on each end.

Most of the beads used for making beaded bags are seed beads, or *rocailles.* The very fine or very small seed beads may also be described as "sand" and/or "micro" beads. The majority of vintage embroidery beads were cut from a cane of

What are cut or faceted beads?

Faceting, a word derived from the French word for "face," is the cutting of flat planes on a rounded bead to produce a greater play and reflection of light. Until the eighteenth century, few beads with facets were made. Names given to faceted beads are: "one-cuts" and "two-cuts," seed beads with one or two flat facets; "three-cuts," which have irregular cuts all around the bead (also called *Charlottes*); and "hex-cuts," beads which are cut from a cane with six sides.

What are French "jet" beads?

French "jet" beads are black glass beads made to resemble true jet beads which were very popular during the Victorian period. Jet, a brown-black fossilized wood, was used in jewelry for thousands of years. There is little or no difference in appearance between the two types of jet—hard and soft. The hard jet is more durable; soft jet is brittle and cracks easily.

In England, jet gained in popularity during the early nineteenth century and became an important fashion when the country went into mourning for the death of Prince Albert, in 1861. The jet industry of Whitby, England, prospered from the time following the death of the prince until the first decade of the twentieth century. The peak of the production of jet was from 1870 to 1872. The demand in England, the continent of Europe, and throughout the world soon depleted the supply of the best quality hard Whitby jet. An alternative was an inferior soft jet, but this jet was quick to lose its polished finish and broke easily. Imitation jet, or French black glass, satisfied the demand.

Some ways to determine the difference between jet and glass are: glass is cold to the touch and heavier than jet; glass can be made into smaller beads than jet; true jet beads can be scratched with a pin and take on a dull, powdered appearance with age.

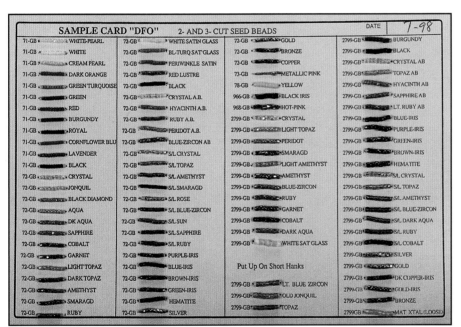

| SAMPLE CARD "DFO" | 2- AND 3- CUT SEED BEADS | | DATE | 7-98 |
|---|---|---|---|

71-GB WHITE-PEARL	72-GB WHITE SATIN GLASS	72-GB GOLD	2799-GB BURGUNDY
71-GB WHITE	72-GB BL-TURQ SAT GLASS	72-GB BRONZE	2799-GB BLACK
71-GB CREAM PEARL	72-GB PERIWINKLE SATIN	72-GB COPPER	2799-GB CRYSTAL AB
71-GB DARK ORANGE	72-GB RED LUSTRE	73-GB METALLIC PINK	2799-GB TOPAZ AB
71-GB GREEN TURQUOISE	72-GB BLACK	78-GB YELLOW	2799-GB HYACINTH AB
71-GB GREEN	72-GB CRYSTAL A.B.	966-GB BLACK IRIS	2799-GB SAPPHIRE AB
71-GB RED	72-GB HYACINTH A.B.	968-GB HOT-PINK	2799-GB LT. RUBY AB
71-GB BURGUNDY	72-GB RUBY A.B.	2799-GB LIGHT TOPAZ	2799-GB BLUE-IRIS
71-GB ROYAL	72-GB PERIDOT A.B.	2799-GB PERIDOT	2799-GB PURPLE-IRIS
71-GB CORNFLOWER BLU	72-GB BLUE-ZIRCON AB	2799-GB SMARAGD	2799-GB GREEN-IRIS
71-GB LAVENDER	72-GB S/L CRYSTAL	2799-GB LIGHT AMETHYST	2799-GB BROWN-IRIS
71-GB BLACK	72-GB S/L TOPAZ	2799-GB AMETHYST	2799-GB HEMATITE
72-GB CRYSTAL	72-GB S/L AMETHYST	2799-GB BLUE-ZIRCON	2799-GB S/L CRYSTAL
72-GB JONQUIL	72-GB S/L SMARAGD	2799-GB RUBY	2799-GB S/L TOPAZ
72-GB BLACK DIAMOND	72-GB S/L ROSE	2799-GB GARNET	2799-GB S/L AMETHYST
72-GB AQUA	72-GB S/L BLUE-ZIRCON	2799-GB COBALT	2799-GB S/L BLUE-ZIRCON
72-GB DK AQUA	72-GB S/L SUN	2799-GB DARK AQUA	2799-GB S/L DARK AQUA
72-GB SAPPHIRE	72-GB S/L SAPPHIRE	2799-GB WHITE SAT GLASS	2799-GB S/L RUBY
72-GB COBALT	72-GB S/L RUBY		2799-GB S/L COBALT
72-GB GARNET	72-GB PURPLE-IRIS		2799-GB SILVER
72-GB LIGHT TOPAZ	72-GB BLUE-IRIS	Put Up On Short Hanks	2799-GB GOLD
72-GB DARK TOPAZ	72-GB BROWN-IRIS		2799-GB DK COPPER-IRIS
72-GB AMETHYST	72-GB GREEN-IRIS	2799-GB LT. BLUE ZIRCON	2799-GB GOLD-IRIS
72-GB SMARAGD	72-GB HEMATITE	2799-GB OLD JONQUIL	2799-GB BRONZE
72-GB RUBY	72-GB SILVER	2799-GB TOPAZ	2799GB MAT XTAL (LOOSE)

colored glass and therefore the color, aside from fading, is somewhat permanent. However, in the early nineteenth century and into the 1920s, beaded bags were exported from Bohemia (Czechoslovakia) with beads that were cut from clear glass canes into which colored dye was infused. The colors of these beads, especially prevalent in pinks and lavenders, are not permanent and will fade more easily and "wash" away if exposed to water. Examples of these beads can be found in this book. Most of the embroidery beads are cut from colored glass canes. Some beads found mainly on bags from Czechoslovakia or Bohemia are clear glass infused with color. Although machines now do much of the work to make the tiny seed beads and bugles, the vintage beads represent many hours of hand labor and effort.

Left: Bead chart of cut glass seed beads. *Courtesy Mary Broyles, Ornamental Resources.*

Below: Black jet and French "jet" glass beads. c. late 1800s. *Author.*

What are the sizes of seed beads?

The method used to measure seed beads is based upon the sizing of the glass canes used to make the beads. The canes are measured in degrees or increments of "aught," meaning zero: the larger the number, the smaller the bead. Seed beads are smaller than 2mm, and usually sized from 10-aught to 18-aught. Vintage beads can be found as minute as size 20-aught or beyond. It is difficult to imagine the needle used for such small beads. Each country that produces seed beads calibrates them differently. So a size 11-aught bead from one country may be different in size from a bead of another country.

The adjective "fine" is used in this book to describe seed beads that are the approximate sizes of 14 to 20 aught. Most of the "fine" seed beads of the nineteenth century were made in Murano, Italy, and in France. Most of the "larger" seed beads that appeared at the end of the nineteenth and continued through the twentieth century were made in Czechoslovakia, formerly Bohemia.

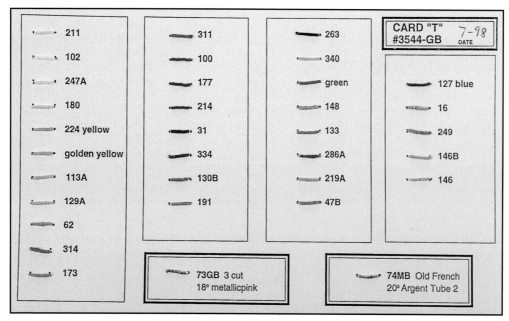

Bead chart, very fine seed beads, sizes 18-20. *Courtesy Mary Broyles, Ornamental Resources.*

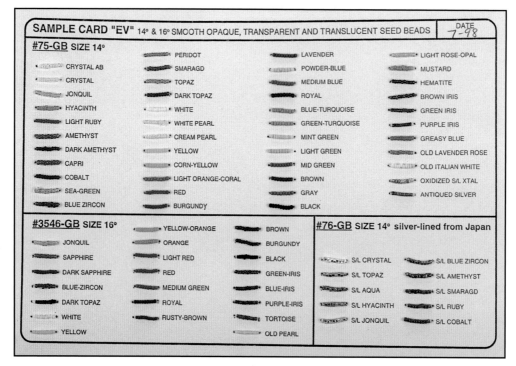

Bead chart, fine seed beads, sizes 14-16. *Courtesy Mary Broyles, Ornamental Resources.*

Bags: Pouch to Purse

An overview of the development of the purse: function and fashion

1100s–1200s

•*Almonier:* A small bag for carrying coins used by the Crusaders for distributing alms to the poor; made of leather, silk, velvet, and worn at the belt; continued to be used by both men and women in Europe until the eighteenth century.

•*Bead History:* The glass factories of Venice were relocated to the island of Murano, Italy, in 1292. Small, glass seed beads were not made at this time.

1300s–1400s

•*Chatelaine:* In Medieval times, the *châtelaine*, or mistress of the castle, kept the keys and other necessary equipment hung on the outside of her skirt attached to a belt. Essential implements worn attached to a hook at the waist continued as an on-and-off-again fashion until the beginning of the twentieth century.

•*Pouches:* Small drawstring bags made of leather with metal (iron) fittings, which were hung from the belt on long cords.

•*Bead History:* Venice established a glassmaking industry and dominated the world's markets. The production of beads increased in volume. In the late fifteenth century, the process of drawing hollow cane beads was introduced to Murano. This technique made it possible to mass produce beads in a range of sizes, including the small seed beads best suited for decorative embroidery.

•*Beadwork on Bags*: Described by Chaucer (?1340–1400) in "The Miller's Tale" of *The Canterbury Tales:*

> *"And by hire girdel* (belt) *hung a purs of lether*
> *T'assled with grene and perled* (beaded) *with*
> *latoun* (Italian beads)…"

1500s–1600s

•*Pouches:* Drawstring bags of embroidered silk, which hung from the waist on long ribbons or laces.

•*Pockets:* As the fashion for layered skirts took hold, bags began to disappear. Pockets, usually in pairs, one at each side, were worn under skirts. They were attached to a lacing that was tied around the waist. Because they were hidden, they tended to be less elaborate in decoration. A vertical slit in the skirt allowed access to the pockets. Pockets continued to be in fashion into the eighteenth century.

•*Pocket Book:* A flat container, shaped like an envelope, with many compartments and a fold over flap, which was used by both men and women to carry valuables. In the seventeenth century, these envelope-shaped containers held and protected letters, papers, and banknotes. Eventually, little notebooks were attached to the envelope to keep addresses, lists, poems, hairdressers' names, and samples of dress fabrics. Fine paper was used and sometimes a silver-topped pencil was attached. The *pocket book* was carried inside the woman's hidden pocket and in a man's topcoat pocket.

•*Wallet:* A double-ended bag with numerous partitions. The poor and the elderly carried their belongings in bags. The phrase "to turn to bag and wallet" was used from the early seventeenth century to describe a life of poverty.

•*Budget:* A handbag for documents or small items.

•*Bead History:* During the sixteenth and seventeenth century, the years of exploration, discovery, and European expansion, glass beads were produced in the furnaces of Murano, Holland, and Bohemia (Eastern Europe). In 1606, there were 251 bead manufacturers in Venice. Beads were exported in volume and used as gifts and barter on the trade routes to Asia, the Far East, Africa, and the Americas. Guilds were established in Europe for the purpose of making bags and purses.

•*Beadwork on Bags:* In both the Boston Museum of Fine Arts and in the Victoria and Albert Museum in London, there are examples of small bags, *almonieres,* made entirely of beads, needle woven, and backed in silk. They are dated from the early to middle of the seventeenth century. France dominated the market for luxury goods and accessories at this time and continued to do so until the middle of the twentieth century.

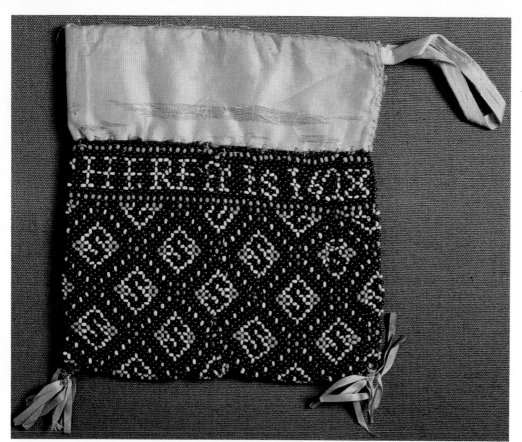

Needle woven, silk header, words, "HERE IT IS 1628" worked in beads, reverse side, "HIT OR MISS." c. 1628. *Courtesy Victoria and Albert Museum, London, England.*

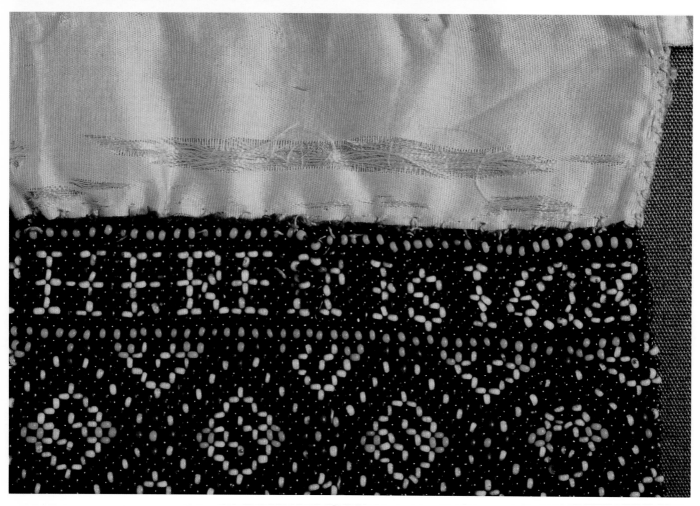

Detail.

1700s–1800s

•*Miser's Bags:* Needlework in the eighteenth century included openwork techniques such as netting and knotting. This construction was applied to a long tubular-shaped wallet purse, later known as the *miser's* bag. These purses were carried by both men and women, hung over a belt, or held in the hand.

•*Workbags:* A flat, linen or cotton, drawstring bag used for carrying needlework. The early workbags were large enough to store wool yarns and threads for embroidery. Later in the century, the art of "knotting" became popular.

•*Knotting Bags:* A flat, small, silk drawstring bag used for carrying knotting shuttles and thread. In this technique, a series of knots (*picots*) are made from linen thread that is wound from a small, decorated shuttle. The braiding, or knotting, that is produced can be embroidered on fabric. The art of knotting showed off needlework talents and the graceful hands of the elegant ladies who worked from their knotting bags during tea and visits in the parlor.

•*Reticules:* A drawstring pouch hung on long cords, or a small, draw string, or metal (pinchbeck) framed purse held in the hand by a handle or a chain. The name "reticule" came from the French word for netting. Reticules became essential accessories for ladies' fashion under Napoleon I, 1804-1814, the neoclassical period.

•*Bead History:* By 1764, the numerous smaller firms of Venice had merged to form 22 manufacturers and they produced forty-four thousand pounds of beads weekly. The European artisans of the eighteenth century used beads to decorate furniture in addition to embellishing fashions. When the Venetian Republic fell to Napoleon, in 1797, the glass industry in Venice was cut in half to twelve producing factories. Many of the workers were sent to France. In the nineteenth century, Venetian beads were again produced in volumes and shipments to the United States numbered six million pounds of beads per year.

•*Beadwork on Bags:* Knitted, crocheted, and embroidered beaded purses were high fashion. Purses were given as gifts throughout the eighteenth and nineteenth centuries. Reticules completely encrusted in beads were common accessories for the wealthy. The French professional beadworkers produced bead embroidered work on bags with super fine beads. This beadwork, called *sablé* (translated as "laid or covered with sand"), completely covered the purse. The beads are so minute, comparable to sizes 16 to 20, that there are as many as 1,000 or more beads in one square inch.

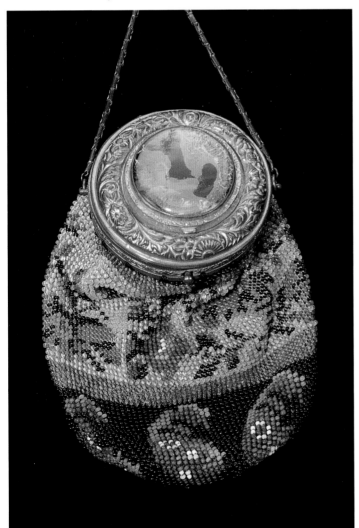

Framed reticule, knitted floral and paisley design, fine beads, round gilded closure, painted memorial landscape: pond, swans, and male figure. c. early 1800s. *Courtesy Veronica Trainer.*

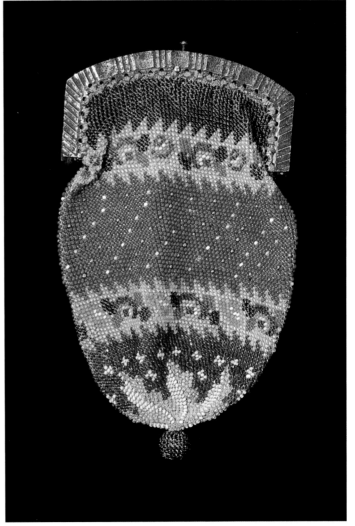

Framed, mini, knitted floral, fine beads. c. early 1800s. *Courtesy Joanne Haug, Reflections of the Past.*

1800–1820s

• Fine opaque beads were knitted, crocheted, or embroidered on small pouches (reticules).

• French cut-steel beads were crocheted on small bags.

• *Crochet*, as a needlecraft, came into fashion in France.

• *Pinchbeck*, developed in England by Christopher Pinchbeck, is an alloy of copper and zinc, made to look like gold. It was used as frame metal for beaded purses. Cut-steel was also used for frames, clasps, and for spangles or *paillettes*.

Woven reticule, French cut-steel beads. c. early-to-mid 1800s. *Courtesy Anna Greenfield.*

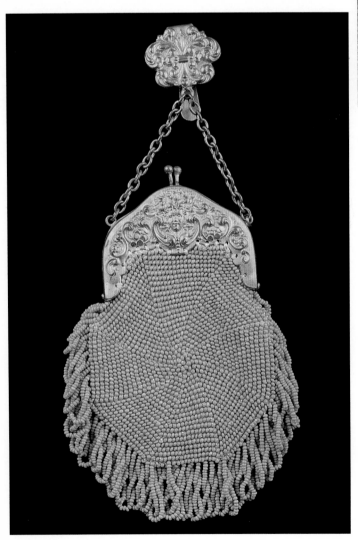

Pinchbeck frame, mini bag, fine beads. c. early 1800s. *Author.*

1830s–1840s

• Victoria was crowned queen in 1837 and the Victorian period begins.

• Germany and France were the important centers for the manufacture of bags and purses. Germany used glass seed beads from Bohemia that were knitted into beaded fabric. Bohemian beads were slightly larger than the tiny seed beads used by the French for the *sablé* embroidered technique.

• Circular pie shaped crocheted beaded bags were in fashion.

• Drawstring, framed, and bags with bead-woven handles were also worn.

• Pockets came into fashion again as skirts became fuller.

• Chatelaines were used to attach small objects as a result of the "romantic" influence.

• The "sentiment" or "language" of flowers was introduced in Europe and influenced the designs used in needlework.

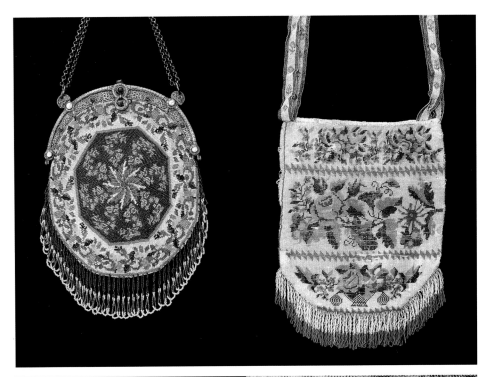

Top left: Pie-shape, crocheted floral, fine beads, jeweled frame. c. mid 1800s. *Courtesy Veronica Trainer.*

Top right: Embroidered, floral design, very fine beads, loom-woven handle. c. mid 1800s. *Courtesy Veronica Trainer.*

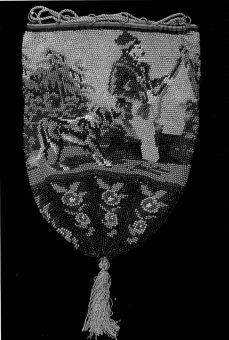 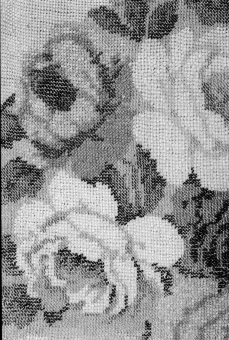

Bottom left: Drawstring, knitted, fine beads, hunting scene, possibly a tobacco pouch. c. early 1800s. *Courtesy Veronica Trainer.*

Bottom right: Detail. Knitted, fine seed beads, floral pattern. c. mid 1800s. *Courtesy Veronica Trainer.*

1850s

- Velvet reticules were embroidered with cut-steel beads.
- Decorative arts and bead patterns on bags illustrated the Victorian preference for the styles of past centuries.
- Crimean War: English accessory fashions were influenced by Turkish tobacco pouches.
- American Indians made purses in the European style to sell.

- Berlin wool-work, was a popular embroidery technique using worsted wool on canvas, and made with "tent" or cross stitches. Berlin, Germany was the main center for the printed patterns used for this needlework and for the dyeing of wool. The patterns influenced the designs made in beads by the American Indians.
- Knitting, crocheting, embroidery, and beadwork were popular needlework for ladies.
- The framed leather bag, or handbag, was introduced.

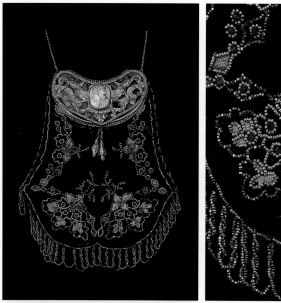 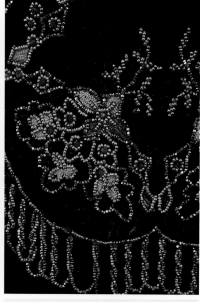

Top left: Embroidered, green velvet, floral design, gold and silver steel beads, red glass beads, gold-tone closure, Greek cameo. c. mid 1800s. *Courtesy Ursuline College Historic Costume Study Collection.*

Top right: Detail.

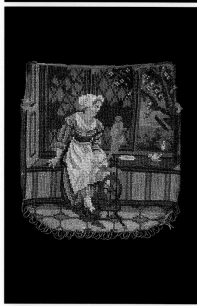 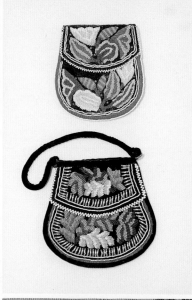

Center left: Knitted, very fine seed beads, spinning wheel, woman in seventeenth-century costume, sitting in a window seat, white bird coming through open window to feed from a tray. c. mid-to-late 1800s. *Courtesy Veronica Trainer.*

Center right: Two American Indian bags, bead embroidered on wool (*top*) and velvet (*bottom*). c. mid-to-late 1800s. *Author.*

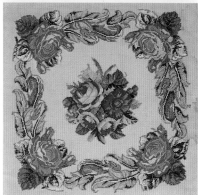

Bottom left: Berlin wool work, floral design, seed beads, from the Villa Bonin-Longare, Vicenza, Italy. c. mid 1800s. *Courtesy Carter Paul Johns.*

Bottom right: Detail.

1860s

• Death of Prince Albert: black jet and French "jet" black glass beads were used for mourning fashion.

• Knitted beaded bags with fine Italian and Bohemian beads and intricate patterns were commercially made in Germany and Italy.

• Publications, such as *Godey's Lady's Book,* gave instructions for beadwork and making beaded purses.

• ***Carriage bags*** *or* ***Carpet bags****:* large bags made of Berlin wool work and leather were used as luggage for travel.

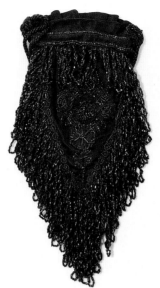

Embroidered on black silk, jet beads, drawstring. c. mid-to-late 1800s. *Courtesy Veronica Trainer.*

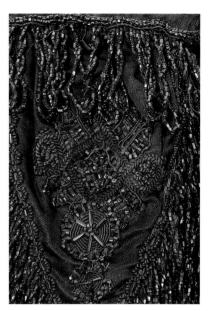

Detail.

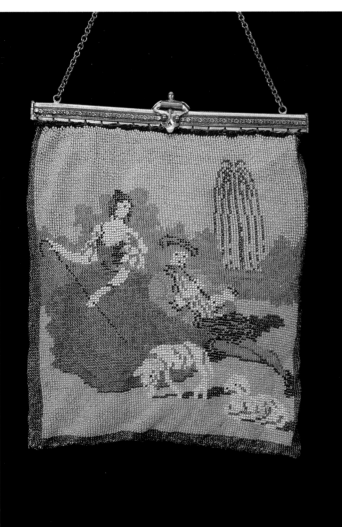

Knitted, fine multi-color seed beads, woman tending lambs, man playing flute, eighteenth-century costume, fountain in background, brass frame with four corner opening. c. mid-to-late 1800s. *Courtesy Veronica Trainer.*

1870s–1890s

• *Chatelaines*, as functional *jewelry* in solid gold and silver and metals embellished with jewels, came into fashion.

• **Finger purses**, small bags with small rings on the handles, carried on a finger, and bags attached to the belt (chatelaine bags) came into fashion.

• **Miser's bag**: a long net, knitted, or crocheted bag with ring closures.

• Art Nouveau style influenced the decorative arts.

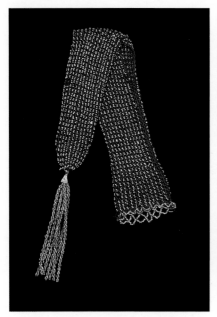

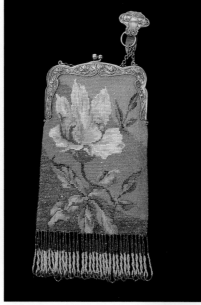

Chatelaine, Art Nouveau, German silver frame matches magnolia floral design, fine cut green, pink beads, twisted interlocked fringe. c. late 1800s. *Courtesy Veronica Trainer.*

Miser's bag, knitted in blue silk, French cut-steel beads, missing rings. c. late 1800s. *Courtesy Ursuline College Historic Costume Study Collection.*

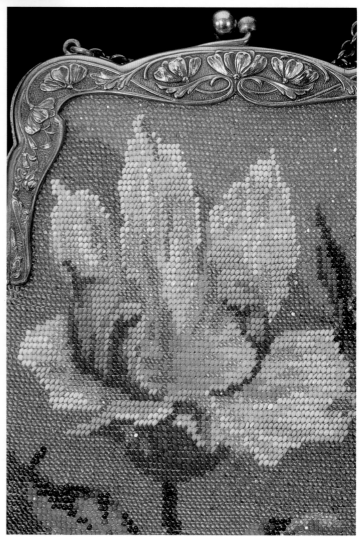

Detail.

18

1900–1910s

• Death of Queen Victoria, January 1901: end of Victorian epoch.

• Renewed interest in antique beaded purses. Crocheted coin purses and chatelaines in American cut-steel beads were in fashion.

• The *Ballet Russes* toured Europe and the Americas. Their costumes and dance styles influenced fashion with exotic designs.

• The supply of fashions and beadwork diminishes during World War I. (War ends 1919.)

• French cut-steel bead woven purses imported to the United States.

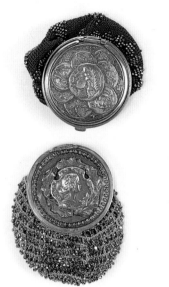

Crocheted coin bags, American cut-steel beads, nickel closures. *Top:* collection of antique coins. *Bottom:* profile of woman. c. early 1900s. *Courtesy Bunni Union.*

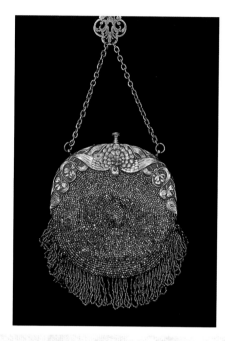

Chatelaine, crocheted, American cut-steel beads, German silver frame with peacock, clover, strawberries, label "Patent Pending," reverse side in leather, entwined fringe. c. late 1800s to early 1900s. *Courtesy Ursuline College Historic Costume Study Collection.*

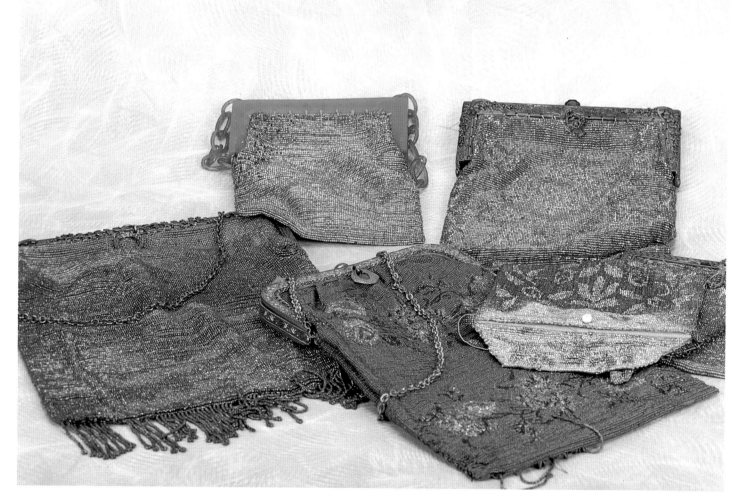

French cut-steel beads, loom woven. c. early 1900s.

1920s

• The purse became essential in fashion. Instruction books were published for beaded purses.

• Heavily beaded purses in glass and steel beads were imported in quantity from Europe.

• The *1925 International Decorative Art Exhibition* was held in Paris and marked the beginning of the Art Deco period.

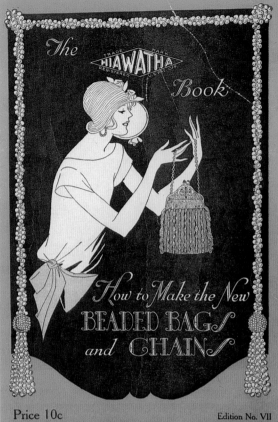 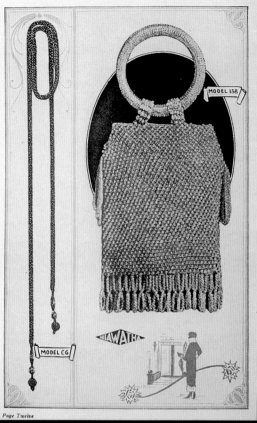

Top left: Cover of bead instruction book, *The HIAWATHA Book: How to Make the New Beaded Bags and Chains.* c. 1924. *Author.*

Top right: The HIAWATHA Book, page twelve, illustration of bag. c. 1924. *Author.*

Bottom left: Needle woven, glass seed beads, geometric pattern, trimmed with Peking glass handle and beads. c. 1920s. *Courtesy Mackenzie Brotherton.*

Bottom right: Bohemian beads, tambour embroidered on lawn, celluloid frame, man wearing hat. c. early 1900s. *Courtesy Janet King Mednik.*

1930s

- Art Deco influenced the decorative arts.
- *Vanity bags:* a purse with a mirror and storage area for cosmetics built into the closure were in fashion.
- *Bakelite*, the trade name for pressed plastic material made from heating phenol and formaldehyde, was developed in the United States and became popular for use in jewelry, buckles, and buttons.
- The supply of fashion accessories and beadwork diminished during World War II.

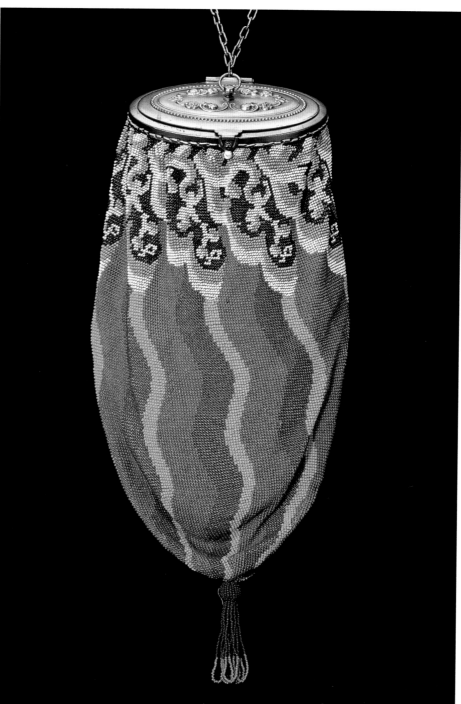

Top: Bead embroidered evening bags, geometric pattern, glass seed beads, silverlined and white bugle beads, *faux* pearls. c. 1920s. *Courtesy Jennifer Johnston.*

Bottom: Detail.

Vanity bag, knitted, fine beads, vertical wave pattern. c. early 1900s. *Courtesy Veronica Trainer.*

1940s–1950s

- World War II ends in 1945.
- Bags tambour stitched with faux pearls were exported from France, Austria, and Japan.
- Purses were made of vinyl.

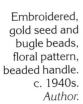

Embroidered, gold seed and bugle beads, floral pattern, beaded handle. c. 1940s. *Author.*

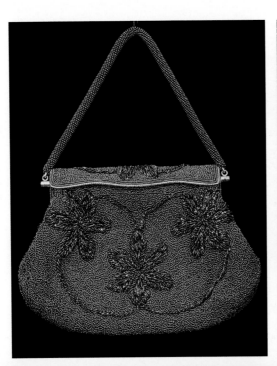

Detail.

Below: Gold cut-steel beads, hatbox design, twisted beaded handle; six months to complete, Rose Golub, designer. c. 1940s. *Courtesy Tobe Schulman, The Cleveland Plain Dealer.*

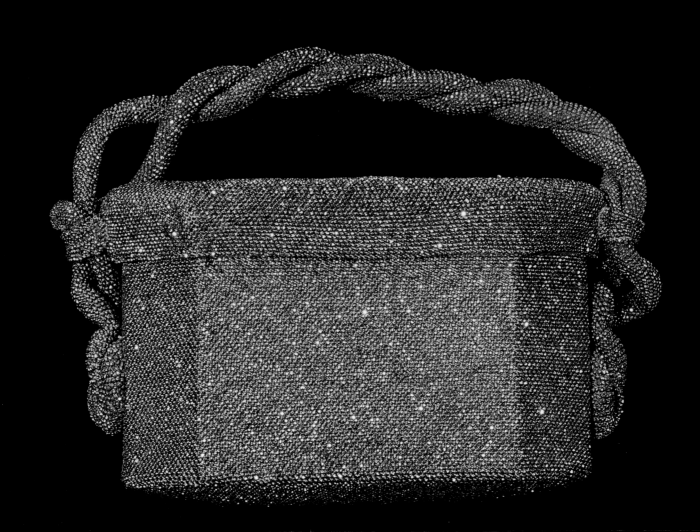

French, tambour embroidered, evening bags. c. 1950s. *Courtesy Sylvia Reitman.*

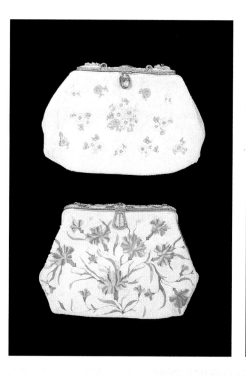

Japanese, tambour embroidered, evening bags. c. 1950s.

Below: Vinyl, embroidered, black cut beads, black braid, scrolled design. c. 1950s. *Courtesy Anna Greenfield.*

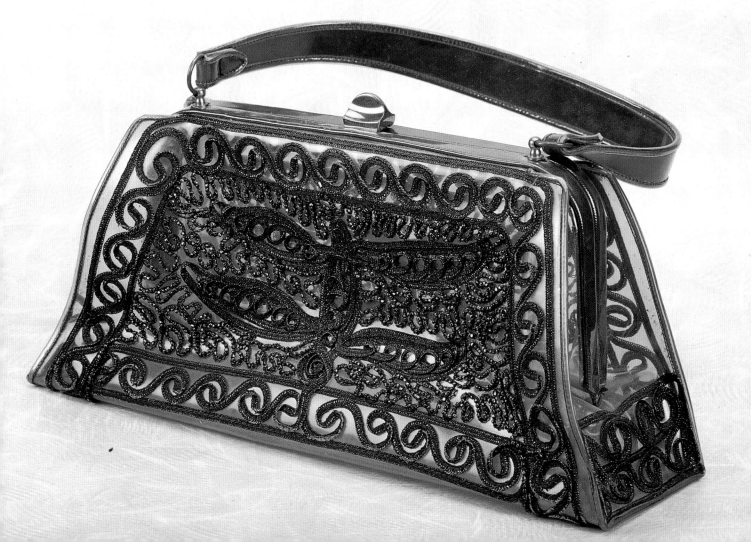

1960s

- Purses were made with wooden and plastic beads.

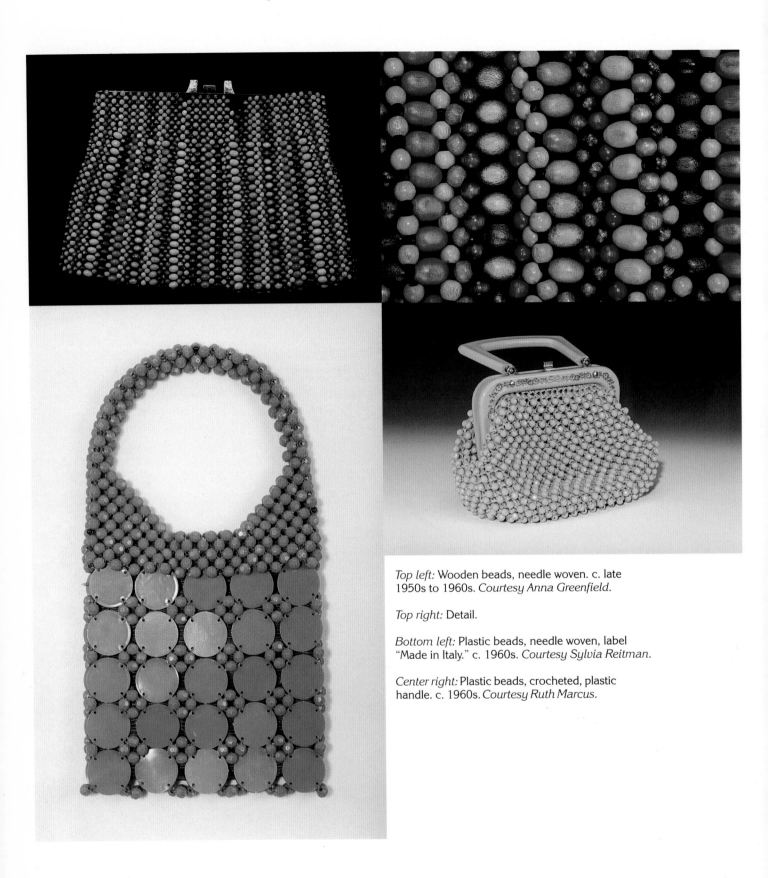

Top left: Wooden beads, needle woven. c. late 1950s to 1960s. *Courtesy Anna Greenfield.*

Top right: Detail.

Bottom left: Plastic beads, needle woven, label "Made in Italy." c. 1960s. *Courtesy Sylvia Reitman.*

Center right: Plastic beads, crocheted, plastic handle. c. 1960s. *Courtesy Ruth Marcus.*

1970s

• Purses were made with American Indian and ethnic inspired beadwork.

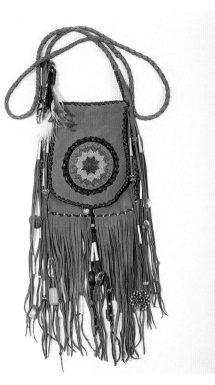

Leather, American Indian beadwork, similar to bags made in 1970s. c. 1990s, by Gypsy Woman, Aspen, Co. *Courtesy Arlene Schreiber.*

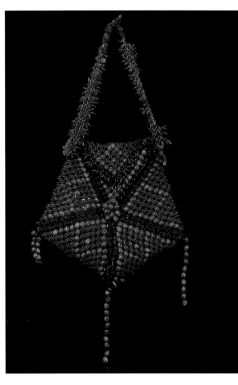

Seeds, needle woven, ethnic. c. 1970s to 1980s. *Courtesy Anna Greenfield.*

Detail.

• A new interest in beadwork began. Books were published on collecting beads and beadwork such as beaded purses. Instructions for beadwork appeared in publications, such as *Bead and Button* Magazine.

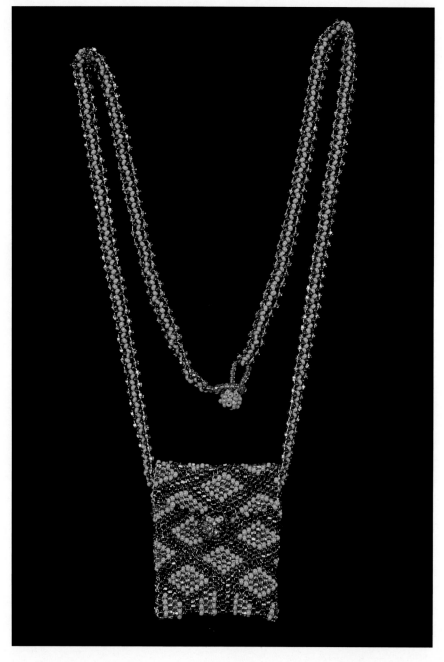

Amulet, needle woven.
c. 1990s.

What is the history of the Chatelaine bag?

The chatelaine was a medieval and utilitarian fashion that originated from *châtelaine*, the French name for the lady of the *château*. The Baroness hung the keys to the great store rooms of the castle from a jeweled belt on her waist. Along with the keys, she attached other necessities and tools, such as needles for lace making and weaving, seals, and scent bottles. Eventually a purse was added to store the more valuable and personal items; it was also hooked to the belt.

In the early nineteenth century, ladies began to adopt this four hundred-year-old fashion and wore chatelaines made from solid gold and silver. These chatelaines were actually ornamented jewelry and worn by the upperclass. In the 1840s, the Victorians suspended bags or pouches from belts, and, in 1842, the first description of chatelaines as "purses" hanging from the waist was printed in a fashion periodical.

Today's collectible chatelaines are those made during the 1870s. These jeweled ornaments became popular due to the fashion writers of the time, such as in *The Queen Magazine*, and because British royalty commissioned them from the Royal Jeweler. It was not until the late nineteenth and early twentieth century that the chatelaine *bag* was in high fashion. The chatelaine bag was also worn hooked to the belt.

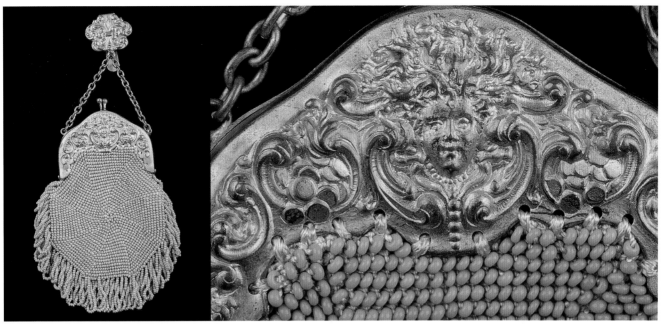

Chatelaine, embroidered, reverse in leather, gilded hook and chain. c. late 1800s to early 1900s. *Author.*

Detail.

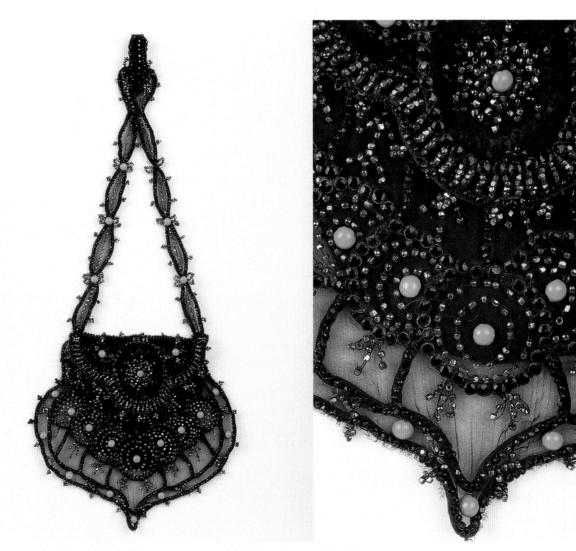

Chatelaine, embroidered, black silk organza, cut-steel, black and turquoise glass beads. c. mid-to-late 1800s. *Author.*

Detail.

What is an "indispensable"?

"She had a knotting-bag, embroidered, hanging to her arm—'tho indeed,' said she 'I never knott, but the bag is convenient for one's gloves and Fan.'"
from Lady Mary Coke, *Letters and Journals*, reprinted by Kingsmere, 1970; in *Bags and Purses* by V. Foster

Indispensable is another name for the "reticule," in which a lady carried her "indispensable" items. There are theories of why the hand-carried pouch bag was given the name "reticule," which comes from Latin, *reticulum,* meaning "net." Women of the late eighteenth and early nineteenth century carried their needlework with them in a small pouch called a "knotting bag" because knotting, or netting was the popular fancywork of the time. As

Netted, needle woven, French cut-steel beads. c. early 1900s. *Courtesy Bunni Union.*

French dress fashions changed to slimming lines and light-weight fabrics, based on the classic costumes of ancient Greece and Rome, pockets could no longer be hidden under skirts. Ladies transferred items usually stored in their pockets to their workbags. Another possible origin for the reticule comes from ancient Roman (classic) fashion popular at the time. Roman ladies carried netted bags.

By 1799, reference to the reticule appeared in an English fashion plate: "Indispensables are bags, which the ladies used instead of pockets" (from *Gallery of Fashion*, November 1, 1799).

The popular ubiquitous bag was subject of satire. The English coined the name "indispensable," and the French, the word "ridicule" in satirical cartoons or articles about ladies' fashions. In the early nineteenth century, reticules were made in fabrics matching the gowns, and decorated with embroidery, braiding, and beads.

Silk and lace, embroidered with charcoal glass seed beads, silver threads and braid. c. mid-to-late 1800s. *Courtesy Kay Stringari.*

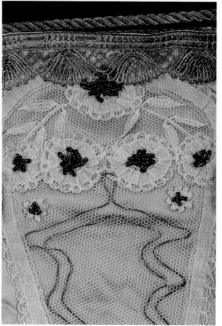

Detail.

How is the date of an antique beaded bag determined?

"How fortunate is the woman who owns an old fashioned knitted bead bag! Long forgotten it may have lain in chest or treasure box, but it is now in high favour, mounted in silver or gold . . . Fine silk was used at that time, and the beads were tiny, while the needles were like slender wire."
from *How to do Beadwork*
by M. White, 1904

Establishing the exact date a beaded bag was made is very difficult. Many bags from the early-to-mid nineteenth century, made up in very fine seed beads, were tucked away in boxes and drawers for safekeeping. Throughout the nineteenth century, bags were given away as gifts to both men and women. Some households accumulated numbers of bags—too many to be used. In the late nineteenth and early twentieth century, a renewed interest in these antique bags was born. They were taken out of storage and attached to newly crocheted headers or to beautiful frames.

It is rare to find beadwork with a date knitted or woven into the design, or to find the date engraved on the frame of a bag.

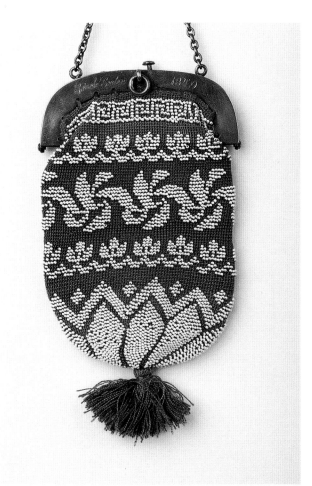

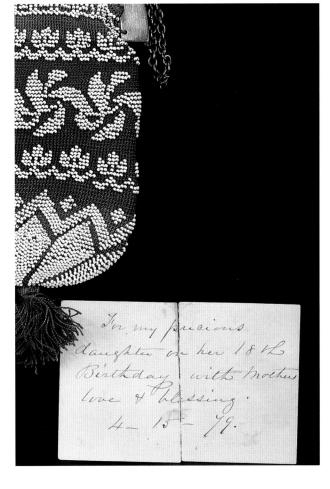

Top: Knitted, very fine seed beads. c. early 1800s. *Author.*

It is truly a "find" when written documents are found with the bag that give added information about its history.

The beaded bag illustrated here is a treasure. The silver frame is engraved "Sarah Emlen 1879" on one side. The other side is engraved with "Sarah Williams" in larger and more elaborate script and without a date. Inside the bag, there is a gift card inscribed in black ink: "To my precious daughter on her eighteenth Birthday with Mother's love & blessing. 4-15-79." This information provides a starting point for the imagination.

Without doing genealogical research, one theory might be: Sarah Williams, the mother (?), received this bag on *her* eighteenth birthday (?), some time in the late 1830s or early 1840s (?), and presented it to her daughter, Sarah Emlen on her eighteenth birthday in 1879.

The bag is crocheted with the finest, opaque, white seed beads. The style of the bag, the shape, the closure on the frame (press-button), the size of the beads, and the patterns are all characteristics of bags made in the 1820s to the 1840s. Examples of almost identical bags can be found in reference books and museum collections.

Bottom: Detail. Gift enclosure, "To my precious daughter on her 18th Birthday with mother's love & blessing, 4-15-79." *Author.*

29

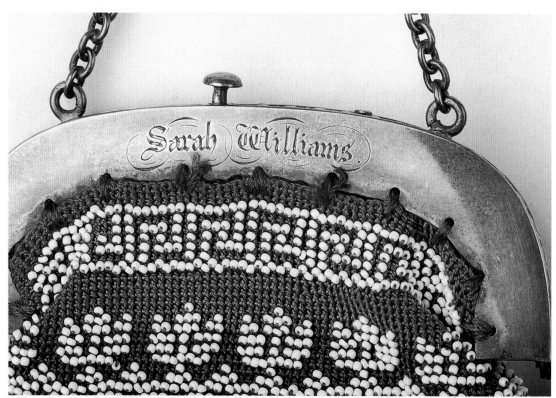

Detail. "Sarah Williams" engraved on frame.

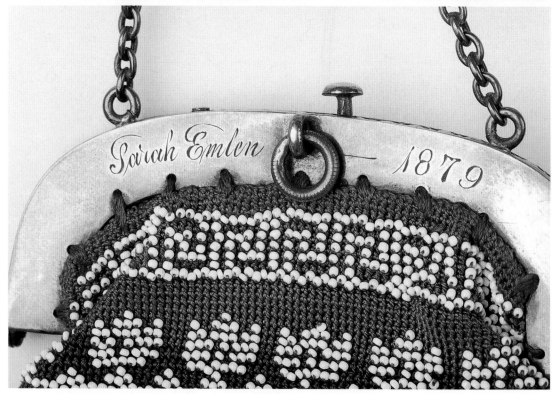

Detail. "Sarah Emlen 1879" engraved on frame.

How accurate are the dates that are given for the bags in this book?

Because very little information is available about the beaded bags of fine seed beads knitted in intricate patterns, in this book general time definitions were used: *early 1800s*—from the beginning of the nineteenth century until the 1860s; *late 1800s*—from 1865 to the end of the nineteenth century; and *early 1900s*—from the beginning of the twentieth century into the 1920s.

Some of the problems that prevent more accurate dating include the fact that many of the bags made in the early twentieth century are worked in older (very fine) beads. In addition, twentieth century bags are found that are made up in the patterns of the early nineteenth century. And, as beaded bags grew in popularity at the beginning of the century, antique bags from the mid 1800s were re-framed. The time periods given in this book are meant as guidelines.

What are some characteristics of early bags?

General characteristics of early bags (late eighteenth to early nineteenth century) recognized by collectors include:

Size: Usually the body is not more than 7-1/2 inches in length, not including the fringe.

Drawstrings: The header is usually made of silk fabric and extends one or two inches above the beading. Silk ribbons or laces were threaded through the header and tied on either side of the bag.

Frames: Frames are more prevalent in the 1820s and later. Silver, steel, gilded metal, or pinchbeck were materials used to make frames for bags. The frames were closed with a hook catch and opened by pressing down on a plunger like button. Elaborate, jeweled frames are from the middle of the century.

Shape: The sides are straight, and at the bottom of the bag, they are semi-circle or squared in shape.

Linings: Silk or satin were used for linings. Many times women used whatever material was available from garments no longer used.

Beads: The glass seed beads on early purses are minute. Their sizes are comparable to sizes 14, 16, 18, 20, and 22 (as measured today). These early micro-sized glass beads were hand made. The mouth blown, hollow canes were cut by hand. Beadworkers of the time needed to purchase their beads in a sufficient quantity to insure the size and/or color of the beads matched for the completed project.

Patterns: Early bags were beaded in scenes of interest to the home and family and with flowers, roses and morning glories, and vines. Many of the early bags are divided into two or three sections of design, with the center section having the larger designs. Some have scenes of villages on the bottom sections.

At the end of the nineteenth and in the early twentieth century, these early purses were again admired, and some of the familiar patterns were copied.

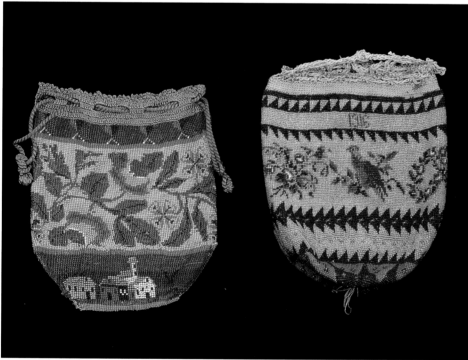

Knitted, drawstring, fine seed beads, floral and village designs, crocheted header. c. early-to-mid 1800s. *Courtesy Anna Greenfield.*

Knitted, fine seed beads, design inspired by early bags, parrot on one side, basket on the other side, "1916" worked in beads. *Courtesy Chaille Winfield.*

Detail.

What needlework techniques were used to make beaded bags?

Beaded bags are knitted, crocheted, needle embroidered, tambour beaded, loom woven, and needle woven.

Knitted

Knitting is the most common technique or method seen in antique, beaded bags. It is also the most satisfactory method because each bead is secured in place by a stitch. The stitches produced by an accomplished knitter are tight, smooth, and even. The beautiful knitted bags of the nineteenth century are not only works of art, but technical marvels. The tension of tiny stitches is remarkably even.

Materials needed for knitting a bag include: "purse twist silk," yarn, sewing silk, beads, a frame or cord, lining material, needles, and, of course, a pattern. It is most important to select the correct weight of silk yarns, and to carefully sort the beads for consistency of color and size to insure an even design. Another concern is the consistency of the tension of the stitches and this depends on the skill of the knitter.

To begin the project, beads are strung on the fine silk yarn and wound around a spool. Different colors and sizes of beads are placed on the silk yarn following the pattern, starting at the bottom right-hand row of the pattern, and proceeding back and forth across the rows to the top of the pattern (or to the top of a section of the pattern).

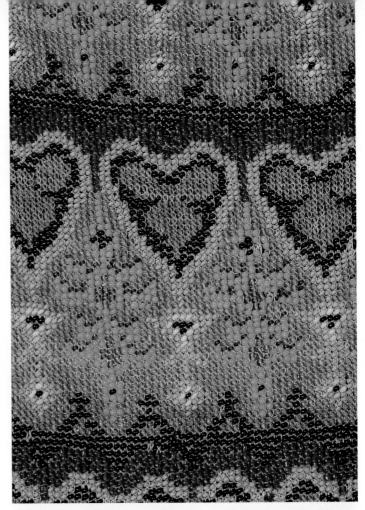

Top: Detail. Knitted, fine seed beads. c. mid-to-late 1800s. *Courtesy Veronica Trainer.*

Center: Detail. Knitted, cut glass, iridescent seed beads. c. 1920s. *Courtesy Janet King Mednik.*

Bottom: Frames. c. mid-to-late 1800s. *Author.*

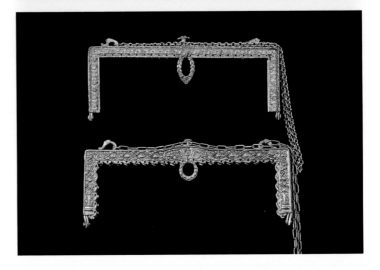

Crocheted

The materials needed for crocheting a bag include a heavier-weight silk yarn than for knitting, sewing silk, beads, a frame or cord, lining material, and a crochet hook. The same concerns for the consistency of the color and size of beads, as well as the evenness of the gauge still exist. The beads are strung on silk and wound around a spool, following the pattern, from the bottom to the top (as previously explained in the knitting process).

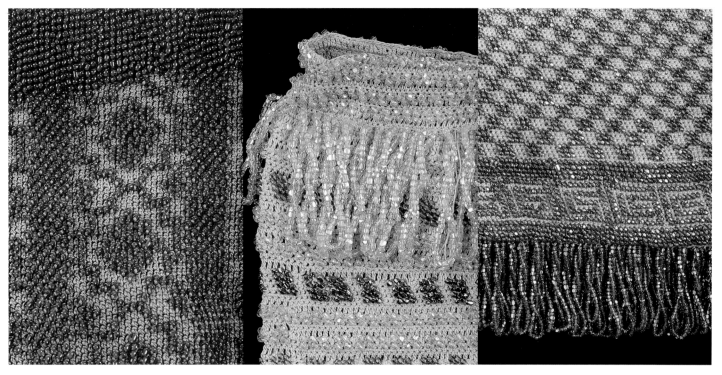

Detail. Crocheted, red glass seed beads. c. late 1800s. *Courtesy Anna Greenfield.*

Detail. Crocheted, glass seed beads. c. 1920s. *Author.*

Detail. Crocheted, French cut-steel beads. c. early 1900s. *Courtesy Anna Greenfield.*

Needle embroidered

The materials needed are silk or cotton thread, in a weight that will accommodate the size of the beads that are used. The same concerns for the consistency of the color and size of the beads apply. Each bead is stitched individually to the backing, which may be of silk netting as in early bags, silk fabric, velvet, or a loosely woven cotton fabric.

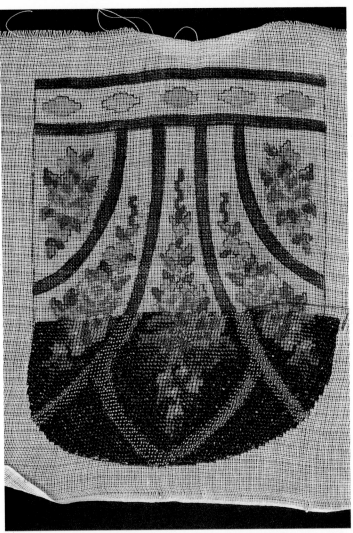

Stamped pattern on open weave cotton, bead embroidered, partially finished. c. 1920s. *Author.*

Stamped canvas, completed floral design in needlepoint, marked for beading. c. 1940s-1950s. *Author.*

Completed embroidery, black cut glass beads. c. 1940s-1950s. *Author.*

Opposite page:
Top: Detail. Beads embroidered on fine silk netting, discoloration of beads caused by netting. c. mid 1800s. *Author.*

34

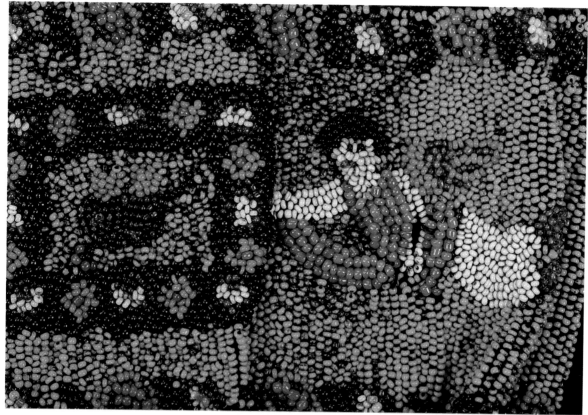

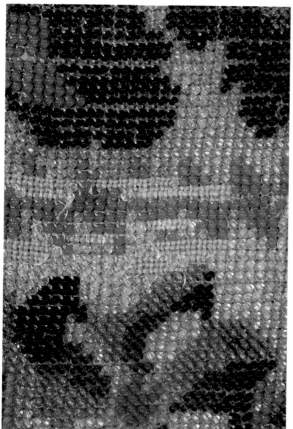

Detail. Beads embroidered on open weave silk. c. mid 1800s. *Courtesy Veronica Trainer.*

Detail. Beads embroidered following the warp on cotton. c. 1920s. *Author.*

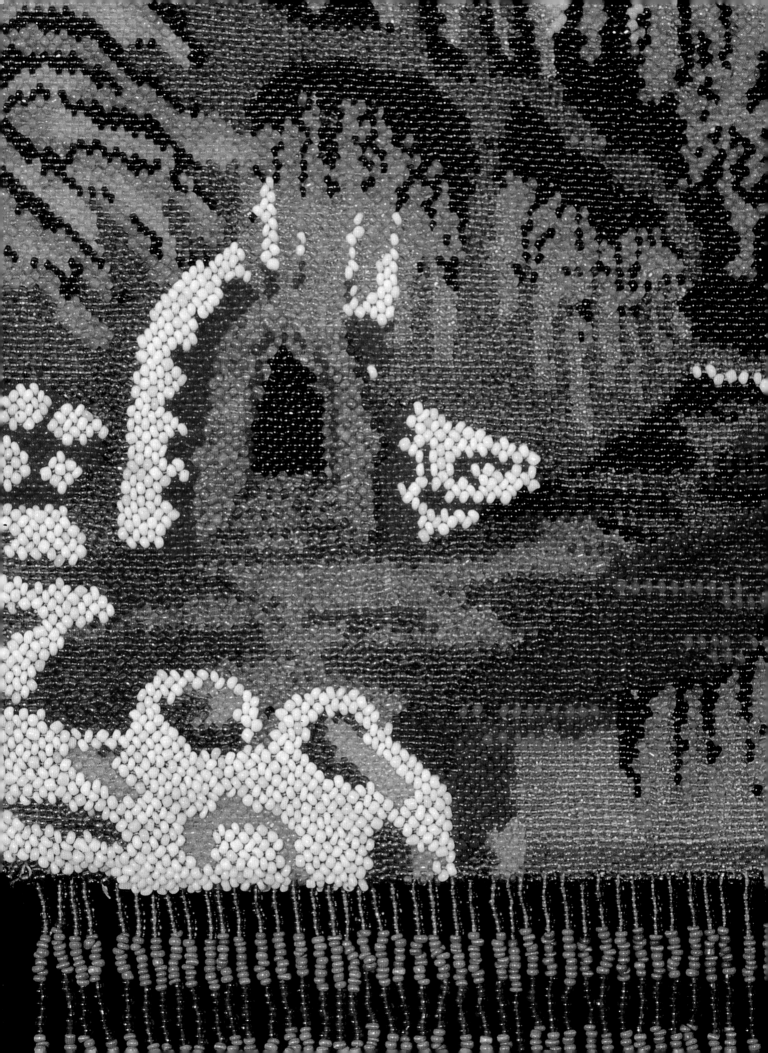

Detail. Beads embroidered following the warp on canvas. c. 1920s-1930s. *Courtesy Anna Greenfield.*

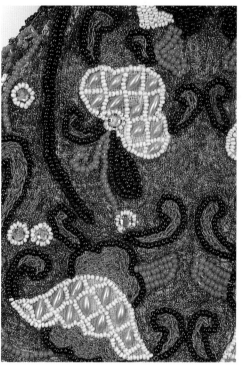

Detail. Beads embroidered on open weave cotton. c. 1920s. *Author.*

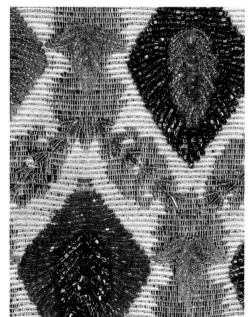

Detail. Beads embroidered on tapestry. c. 1950s. *Courtesy Ursuline College Historic Costume Study Collection.*

Opposite page:
Detail. Beads embroidered on knitted silk; fabric allows for sewing beads close together, creating a thick appearance, unusual work. c. late 1800s. *Courtesy Veronica Trainer.*

Tambour Beading

(pronounced tam-pour)

The technique of attaching beads using the tambour hook did not appear until the end of the nineteenth century. At the same time that the demand for beaded fabric brought about the development of the Cornely machine for sewing with beads, Louis Ferry, in Luneville, France, developed the use of the tambour hook for beading, *la broiderie perlee de Luneville.* It made beadwork faster, neater, and less expensive to produce.

The materials needed for tambour bead embroidery are: thread, beads, fabric, a work frame, and a tambour hook. The

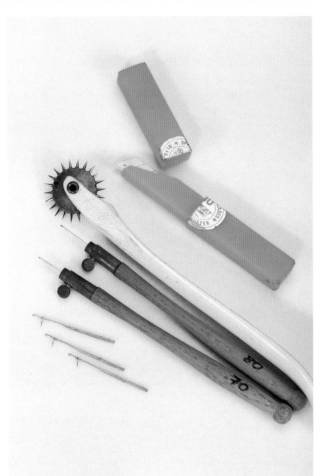

Tambour hooks and embroidery tools. *Courtesy Russell Trusso.*

fabric is stretched across a frame or a hoop. The word, *tambour,* is from the French word for "drum," which describes the frame first used to do this work.

A pattern is either marked on tissue paper that will be discarded later, or stamped on the fabric. Beads are pre-strung on a spool following the design of the pattern. The tambour stitch, which is actually a chain stitch, is made when the tambour hook is poked upward from below the fabric, or downward through the fabric (depending on the method of tambour work). The hook catches the thread just beyond the bead and pulls the thread through the fabric, forming a loop. This process is repeated following the lines and spaces of the pattern. It is a delicate stitch: if a thread is cut and then pulled, the chain stitch will unravel with the beads!

Detail. Reverse side of tambour beaded netting. c. 1920s. *Courtesy Ursuline College Historic Costume Study Collection.*

Detail. Tambour beaded and silk embroidered. c. 1950s. *Courtesy Pearl Schwartz Fishman.*

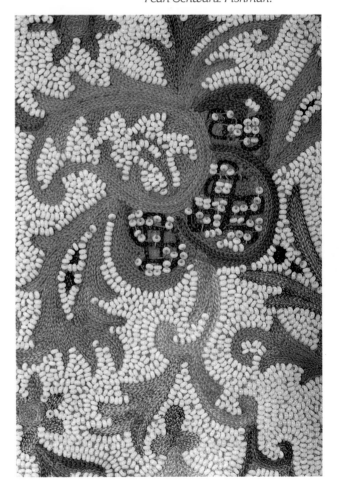

Loom woven

Following World War I, great quantities of French cut-steel beaded bags were exported from France and Austria. These bags are woven on a loom similar to the way that textiles are woven. One row of beads is strung on the thread according to the pattern, and then attached to the first warp (vertical) thread on the left. The row of beads is stretched from the left to the right, crossing underneath the warp threads. Then, from right to left, the needle and thread are passed back through the row of beads on top of the warp threads, to secure each bead in place.

Cut-steel beads are heavy, and the "fabric" of beads woven to create a beaded bag places a considerable strain on the bag itself. The warp and weft threads are silk and are the only support for these bags. French cut-steel bags are sometimes found as long as fourteen inches and weighing two or more pounds. If damage occurs and the warp threads break creating slits, satisfactory repair is almost impossible without reweaving the entire bag.

Detail. Woven French cut-steel beads. c. 1920s. *Courtesy Anna Greenfield.*

Detail. Woven French cut-steel beads. c. 1920s. *Courtesy Anna Greenfield.*

Detail. Woven French cut-steel beads. c. 1920s. *Courtesy Anna Greenfield.*

Needle Woven

The materials needed to make a needle woven bag are: thread, needles, beads, a frame or cords, and fabric for the lining. The method for stitching beaded "lace" is the same one that was used by the Egyptians in 3,000 BC. Different numbers of beads are threaded together to make large or small spaces or "holes" like netting or lace, a method referred to as off-loom weaving.

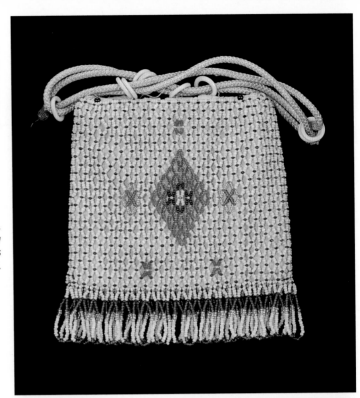

Needle woven, lattice design, drawstring. c. 1920s. *Courtesy Paulette Batt, Larchmere Antiques and Paulette's on Larchmere.*

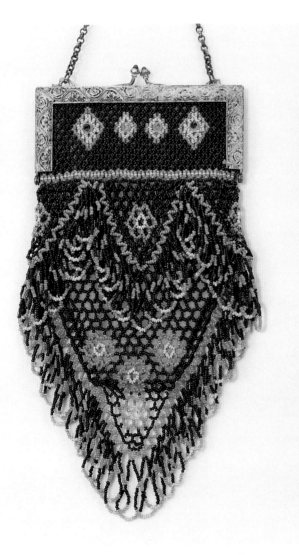

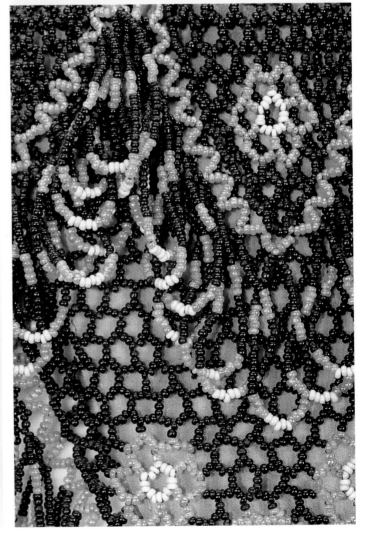

Needle woven, net design, framed. c. early 1900s. *Courtesy Bunni Union.*

Detail.

40

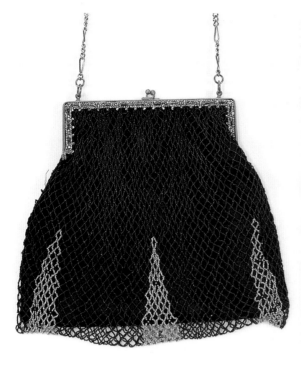

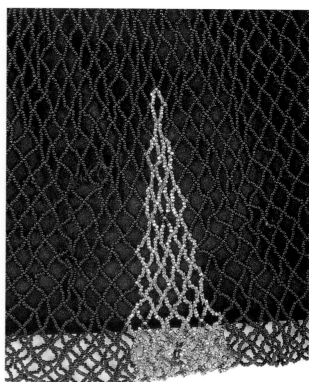

Needle woven, lattice design, framed. c. 1920s. *Courtesy Paulette Batt, Larchmere Antiques and Paulette's on Larchmere .*

Detail.

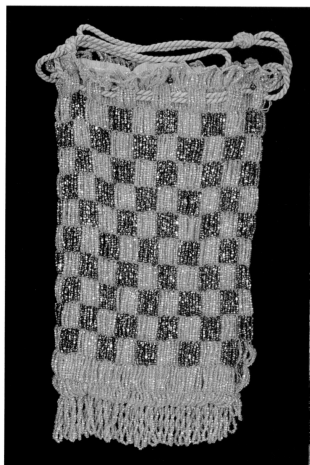

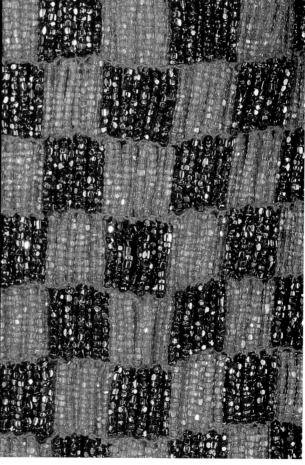

Needle woven, checkered design, drawstring. c. 1920s. *Courtesy Caroline Ries.*

Detail.

Detail. Needle woven, lattice design. c. 1920s.
Courtesy Mackenzie Brotherton.

Detail. Needle woven fringe, lattice design,
French cut-steel beads. c. early 1900s. *Author.*

Who made these beaded bags?

Both amateur and professional beadworkers made the beaded bags presented on these pages. In most cases it is difficult to determine whether the bag was made in the front parlor by a "lady of leisure," or by a "professional" beadworker hired by wealthy buyers or merchants.

The beaded bags from the early nineteenth century are more likely to have been made as a needlecraft by ladies who prided themselves on their skilled handwork. By the middle of the nineteenth century, cottage industries existed in Italy, France, and Austria. Working women, with excellent needlework skills, produced the large beaded bags with intricate patterns and in fine seed beads—in their homes, on commission, or for firms that sold and/or exported their work. Families in Europe passed these skills from generation to generation. However, little, if any, research has been done to establish information about these beadworkers.

What is known is that beadworkers were a part of the sweated industries of the late nineteenth and early twentieth centuries. In the first decade of the twentieth century, a brief exhibition was arranged in a church in the east end of London showing the effects of sweated work. The catalog published for the exhibition described the problems of the beadworkers as follows (from *The Handbook of the Daily News Sweated Industries Exhibition,* London, 1906, in *Bead Embroidery,* by J. Edwards):

> *"The work is often trying to the eyes as beads are of different sizes, shapes and colours and have to be sorted out, counted, and arranged in patterns. The examples shown in the exhibition include some done in London, and also some done in country cottages. There are villages where a woman will fetch work from London and then let it out to the villagers around, each whom does it for a price less (than) that paid to the middlewoman, and the sub-contracting leads to very low wages."*

In the large cities of America there were co-operatives that were organized to collect and sell on consignment the needlework done at home by women. European immigrants, principally, were the sweated labor of the garment and accessory industries.

Chapter 2
Miser Bags

". . . you will see
Way down deep inside of me
In centuries long, long ago
Ladies' monies swayed to and fro."
From a poem found inside of an old purse.
In "The Ingenious Miser's Purse,"
G.B. Kinsler,
Ornament Magazine, 1996

How did the "miser's bag" get its name?

It is not clear how or when this nickname came about. The style, which is also called "ring," "stocking," "hooker," "almoner," "wallet," "string," or "long" purse, began to be used in the late eighteenth century. It is believed that the design of this purse was a revival of the medieval practice of carrying coins in the toe of a stocking, which was followed by the double-ended wallet used by beggars and the elderly. The design of the miser's bag makes coins secure and difficult to lose.

What is the design of the miser's bag?

The miser's bag, or miser, has an elongated shape, which is very different from any other antique purse or container that is meant to carry coins and currency. It is found made in fabric, netted, knitted, or crocheted. Decorations are in silk and bead embroidery, or tiny beads incorporated into the knitting and crochet work, and it has trims of tassels or fringe.

The purse is narrow and closed on both ends. In the mid section, a slit is open for inserting money. The slit can be secured by moving two rings, or sliders, toward the end pouches of the purse. In that way, the coins cannot escape through the slit. The rings are made of various metals such as brass, steel, gold, or silver, or materials such as mother-of-pearl and bone. Many times, bags are found with missing rings, because they could be slipped off easily.

In the earliest styles, some are one-ended, with one pouch; the other end is pointed and has a slit closer to the point end, somewhat like the early pocket. The most popular shape of the bag has two pouches: one at each end, each different in shape, one round and the other square. Sometimes the end pouches also differed in size. The varying sizes and shapes of the pouches allowed the wearer to distinguish by feel in which end of the purse he or she had stored the gold or silver coins, for example.

Who used the miser and how did they wear it?

Both men and women wore this unusual purse draped over a belt with the ends hanging. Size generally indicates if the bag was made for a man or a woman. A man's bag is longer and could measure up to a yard in length. Men would carry them in their hand, stuff them into a coat pocket, or wear them on the belt. Navy blue and green were two popular colors for men. Women's purses were knitted or crocheted with floral patterns and other delicate designs. Women carried their bags in their hand or wore them on a belt.

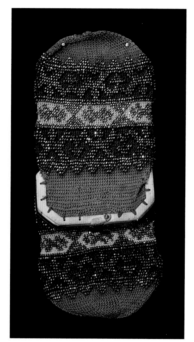

How long did the miser bag remain in fashion?

The double-ended style miser was the most popular and common purse during the Victorian era. With the appearance of commercial leather coin purses in the late nineteenth century, the miser's bag became less fashionable. However, they did remain popular until the late 1920s, when they were used mainly for storing game counters. Instructions for these easily constructed purses were published in *Godey's Lady's Book* and in knitting and crocheting books throughout the nineteenth century. The same instructions were re-printed until as late as 1925.

How is the date of a miser's bag determined?

Some of the very early (late eighteenth to early nineteenth century) purses have only one pouch (or "toe"), one ring, if complete, and a pointed top that can be folded over the belt. The knitted patterns of early silk miser's bags are small and intricate in detail, with verses or names included in the designs. Crocheted miser's bags date from the late nineteenth and into the twentieth century.

It is difficult to distinguish the exact dates of misers made during the nineteenth century. Instructions were readily available, and old patterns were re-produced in numbers. They were favorite items at bazaars of the mid to late nineteenth century, such as depicted in an oil painting in the Tate Gallery called *The Empty Purse* by James Collinson, 1857.

The size of the beads and the designs used are clues that help date a purse. Early ones were made with very fine (tiny) beads. Toward the end of the nineteenth century, the beads available for needlework were larger in size. The early patterns were more detailed than designs produced late in the nineteenth century.

In the late nineteenth century, as the miser came to a height in its popularity, the demand was great and many women filled their days fashioning these purses. Making one proved to be a quick and easy project, requiring techniques and patterns that were fast and dramatic.

Crocheted, cut-steel beads, double sided, brass frame, 4-1/2 inch length. c. late 1800s. *Courtesy Joanne Haug, Reflections of the Past.* $250-300.

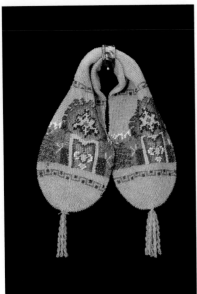

Knitted, fine multi-color seed beads, German silver ring, twisted fringe, 10-inch length. c. late 1800s. *Courtesy Veronica Trainer.* $300-350.

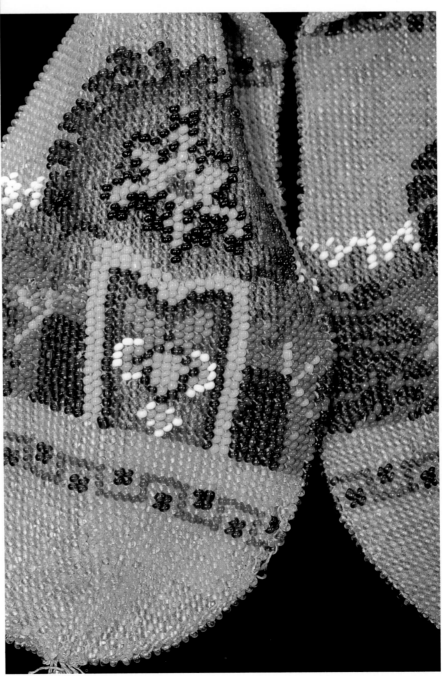

Detail.

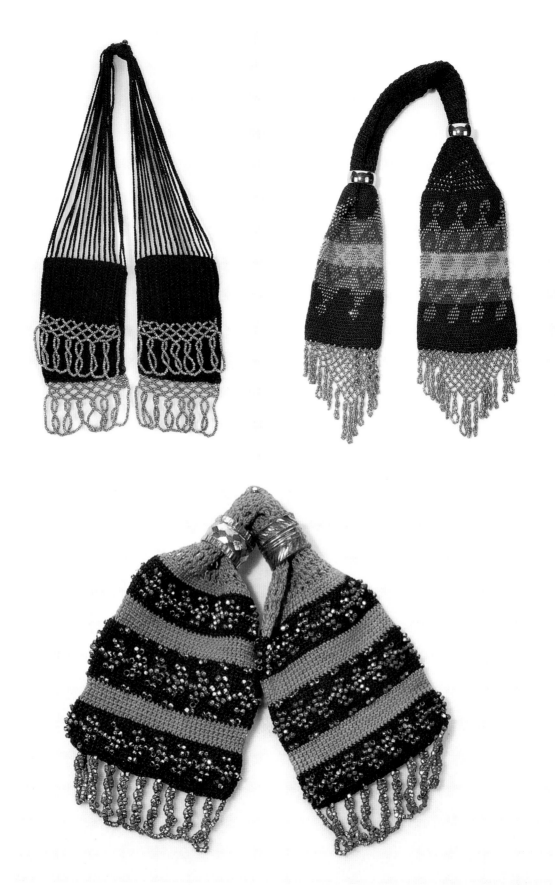

Top left: Crocheted, lattice design, silver steel beads, net, entwined fringe, 16-inch length. c. late 1800s to early 1900s. *Courtesy Paulette Batt.* $90-125.

Top right: Crocheted, silver and gold French cut-steel beads, German silver rings, lattice fringe, 16-inch length. c. late 1800s to early 1900s. *Courtesy Veronica Trainer.* $225-275.

Bottom: Crocheted, American silver cut-steel beads, German silver rings, entwined fringe, 10-inch length. c. mid 1800s to late 1900s. *Courtesy Joanne Haug, Reflections of the Past.* $90-125.

Chapter 3
American Indian Bags

"The present interest in beadwork undoubtedly sprang from our enthusiasm for Indian handicrafts."
from *How To Do Beadwork*
by Mary White, 1904

Did the indigenous cultures in the Americas use purses?

Like the Europeans, most Native American cultures carried bags for practical purposes—for storing tools and possessions that were necessities for daily life. Before the Europeans imported glass seed beads into the Americas, the Indians of the northeast decorated their bags with dyed porcupine quills and woven plant fibers.

When did the Native American cultures begin to use glass beads for ornamentation?

In the seventeenth and eighteenth centuries, colonists and traders gave the Indians quantities of small glass beads as gifts. By the late eighteenth century, the Indians began to incorporate these glass beads in the ornamentation of clothes and accessories. These small beads were available in a variety of colors. They were easy to sew, individually, or in numbers strung on thread and aligned in "lanes." Eventually, the Indians came to value these seed beads for their beauty and for the economic prospect of selling and trading their beaded products. This increase in demand caused European traders to exchange small glass beads by the pound for goods and supplies.

Why did the Native Americans begin to produce European styled purses?

After the Revolutionary War, as the northeastern Indians lost lands and other means of economy to the Euro-American settlements, they began to produce beaded bags for sale to the Euro-American settlers. The Indians adapted the designs of their beadwork to please the tastes of the Euro-American "tourists."

How did European needlework influence the Native American designs?

At the end of the eighteenth century, Indians were decorating their own bags in a sparse linear style, sewing beads in singular rows to create designs. Many of these linear designs were stylized floral shapes, which were inspired by European needlework designs. In the early nineteenth century, the Indians began to fill in the larger areas of the designs, covering spaces with rows of beads. The "filled in" floral designs resemble the European Berlin wool-work embroi-

dery that was popular in British and American needlework of the early 1800s.

"Berlin woolwork" or "Berlin work" was developed in Germany early in the nineteenth century. The designs, mostly of large flowers, and meant for canvas embroidery or needlepoint, were mass produced on squared paper and hand colored to complete the directions. Berlin was the center for dyeing wool and gave the name to the needlework. In the Berlin work technique, thick woolen yarn was stitched in layers to create a raised and fully covered area. Beads were also used, stitched one at a time over and over to create the same raised effect. In the middle of the nineteenth century, thousands of these designs were available in Europe and America and were included in publications such as *Godey's Lady Book* and *Peterson's Magazine*. An example of a partially completed canvas of Berlin work is shown.

What is the "lazy-stitch"?

Most people associate this term with a technique used in Indian beadwork. The original term, which is truly derogative, "lazy-squaw-stitch," was used by the Euro-Americans in the early nineteenth century to describe the Indian beadwork that applies rows upon rows of beads to create a raised effect and to fill in the spaces of the design. Apart from the term's derogatory denotation, the hours, days, and sometimes months required to embroider an object with hundreds of thousands of tiny beads, no matter what technique is used, is hardly a "lazy" effort. Many experts in Native American beadwork now refer to this technique as the "lane-stitch."

The technique itself produces solidly beaded areas. It involves a sufficient number of beads strung on the thread to cross the area of the design. The beads are then stitched to form a row, or "lane." Each lane of beads is aligned and attached by thread next to one another to cover the area, creating a corduroy effect.

Other stitches or beading techniques that were also used by various Indian tribes include "embossed" beading, the "spot" or "couched" stitch, weaving, and netting. Embossed beading refers to the technique of applying rows of beads on top of one another to create a thick beaded area. This beadwork was used on the beaded pin cushions and souvenirs from the Niagara Falls area at the end of the nineteenth and into the beginning of the twentieth century. The spot or couched stitch is accomplished using a long beaded thread to follow the form of the design and stitching or tacking it in place with another thread and needle every few beads.

What is a "spirit" bead?

Many of the purses and other beadwork made by the Native Americans contained one bead or more that was an obvious error to the color scheme, sometimes called a "spirit" bead. An explanation for this is that the beadworker intended this "error" to express humility—only God can create a perfect work of art. This custom is observed in the embroidery and beadwork of other cultures.

How can the date of a Native American beaded bag be established?

Indian beadwork on bags remained popular throughout the nineteenth century. In the early twentieth century, pieces of old beadwork were re-worked onto bags. Today, both antique and contemporary American Indian beadwork is highly prized and sought after by collectors throughout the world.

In order to authenticate the date of antique beadwork, it is necessary to consult an expert or to do some strenuous research in libraries, museums, (studying artifacts, paintings, daguerreotypes, and photographs), and in private collections. However, many artifacts in museums are not dated.

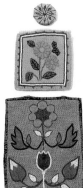

Opposite page:
Crocheted coin purse, turquoise, crystal and charcoal glass seed beads, nickel top, Indian chief, patent 1906. c. early 1900s. *Author.* $90-100.

Group: crocheted and embroidered on canvas and leather, floral motif. c. early 1900s. *Author. Top:* $90-100. *Middle:* $700-750. *Bottom:* $800-1000.

Detail.

Detail.

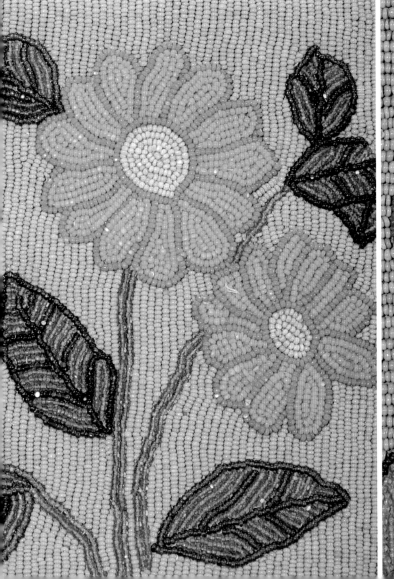

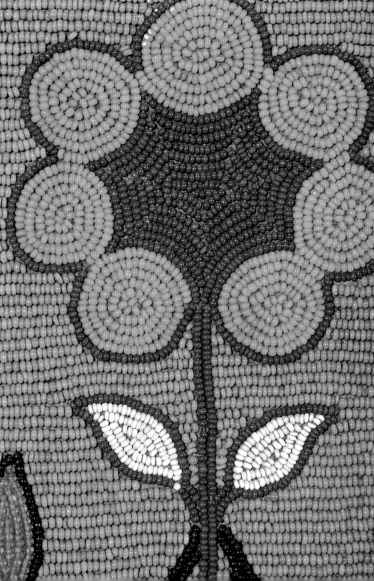

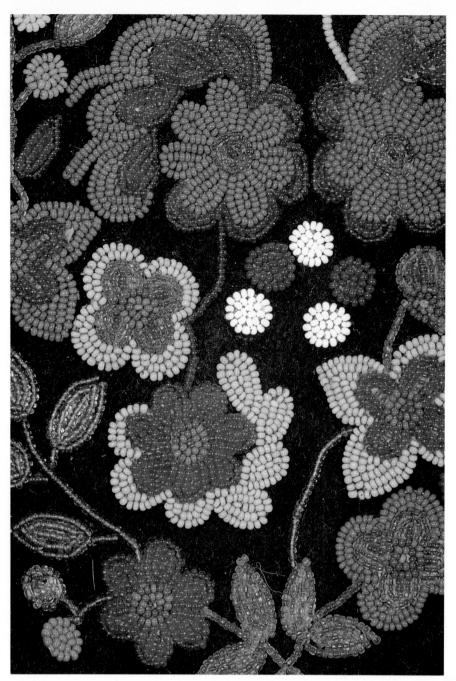

Detail.

The following guidelines for northeastern (Iroquois or "Woodland") Native American beadwork may be helpful:

Last half of the 1700s: Small glass beads threaded on wool yarns were incorporated with traditional materials such as dyed porcupine quills and woven plant fiber on tanned hide; geometric, linear patterns.

Late 1700s or early 1800s: Small glass beads were sewn onto bags of commercially made woolen fabric in red, black, and brown, and in similar patterns to the linear designs done in quill-work, but with stylized floral elements.

Early to middle 1800s: Larger seed beads were used to execute Euro-American style floral patterns based on Berlin wool work; U-shaped bags and hexagons became prevalent; often bags were made from a single, folded piece of fabric with the flap continuous on the back, and of the materials of velveteen, silk, and wool, and glazed or unglazed cotton.

Embroidered on black wool felt, floral motif, Chippewah Indian. c. 1920s. *Author.* $900-1000.

1850s to 1870s: Patterns continued to evolve into clear floral designs unique to the Iroquois and became part of the Iroquois cultural identity; U-shaped bags continued in popularity, with added, separate flaps on both faces, flanking a top opening; often bags were made of wool, silk, and glazed or unglazed cotton.

1880s to the early 1900s: Production of beaded bags began to die out, and were no longer associated with the Iroquois. Eventually they became items for sale in antique stores and identified as "Victorian" or "Indian."

Paraphrased information from
Bagging the Tourist Market
by D. G. Harding, April 1994

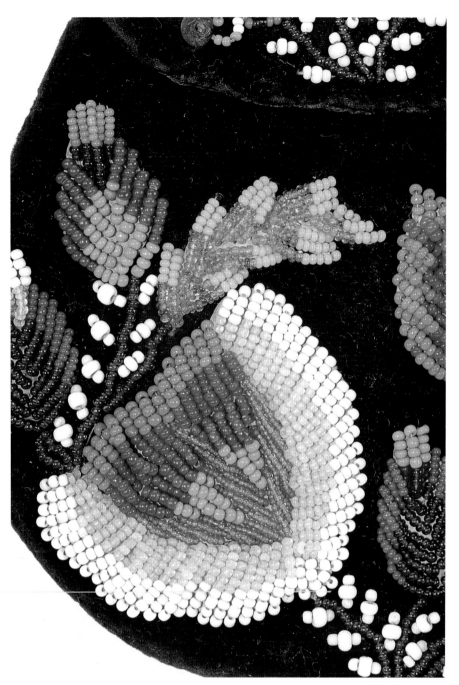

Detail.

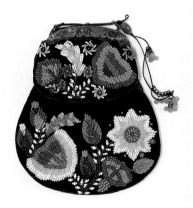

Embroidered on black velvet, floral motif, press button closure, cord handle with Peking glass beads. c. early-to-mid 1800s. *Author.* $275-375.

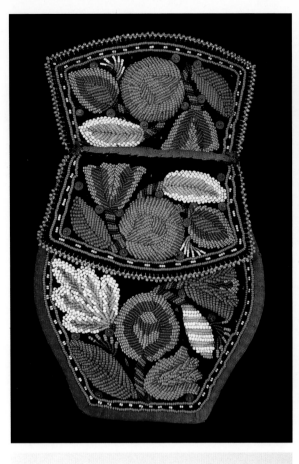
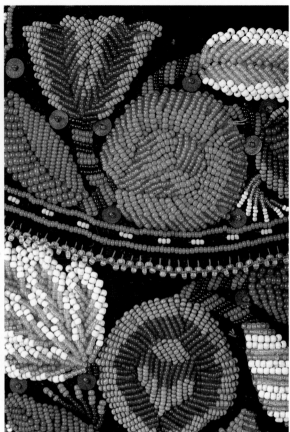
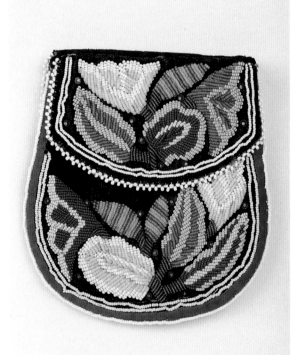
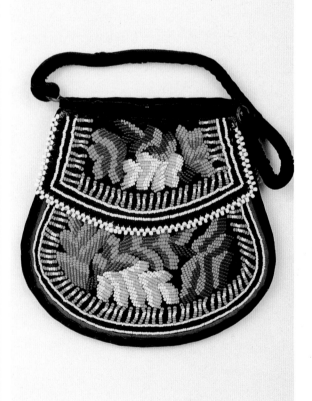

Top left: Embroidered on black velvet, floral motif. c. early-to-mid 1800s. *Courtesy Madeleine Parker.* $275-375.
Top right: Detail.
Bottom left: Embroidered on black wool, floral motif. c. mid 1800s. *Author.* $275-375.
Bottom right: Embroidered on black velvet, floral motif, velvet handle. c. late 1800s to early 1900s. *Courtesy Deborah Gulyas of Renaissance Parlour.* $275-375.

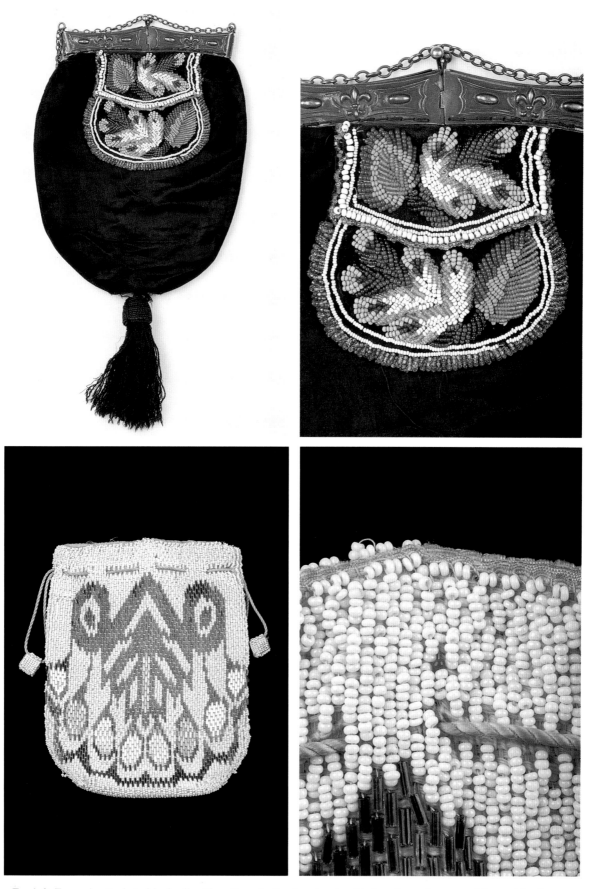

Top left: Framed reticule in black silk with antique Indian beadwork added as decoration, possibly an old coin purse. c. early 1900s. *Author.* $90-150.
Top right: Detail.
Bottom left: Bead embroidered bag, inspired Indian motif. c. 1920s. *Courtesy Cathy Brotherton.* $90-125.
Bottom right: Detail. Illustrates "spirit" bead.

Chapter 4
Embroidered Bags

"... To an embroiderer, a fragment covered with stitchery can be every bit as fascinating as a complete article. The minute detail of each stitch is of paramount importance: what type of stitch, where does it come from..."
from *Treasures from the Embroiderers' Guild Collection,* edited by E. Benn

When did bead embroidery become popular for decorating bags?

Bead embroidery became popular for decorating ladies' bags when the reticule became a popular fashion accessory. At the beginning of the nineteenth century, ladies' skirts were slimming and did not have sufficient fullness to hide pockets. A bag, called a reticule or indispensable, was necessary to carry such things as scents, writing implements, and letters. The fabrics and frames for these bags did not need to be sturdy or heavy. Silks and light fabrics were used to match the color of a dress or a jacket. Like the old pockets of the seventeenth century, these reticules were embroidered with silk threads, golden wire, and glass and steel beads.

How are bead embroidered bags dated?

Beadwork of the eighteenth century was elaborate, but not necessarily available to a wide spectrum of society. The Industrial Revolution brought about a larger middle class that desired beautiful fashions, once reserved for the rich. A period of austerity followed after the French Revolution and the Napoleonic wars; however, bead embroidered bags were easy to design and make at home, so they became the "fancywork" of the new leisured ladies.

Most of the patterns were simple. Early in the nineteenth century, cabbage-shaped blossoms, leaves, and baskets of flowers were popular. In the 1830s and 1840s, bags were made in silk or velvet. They were usually flat, drawstring, with a square, round, or flared base, and they were embroidered with cut-steel beads that were made in France.

A reprint (LACIS) of the *Priscilla Beadwork Book* has an illustration of a black velvet bag with steel beads that is very similar to the bags shown in this chapter that date to the early nineteenth century. The book published in 1912 did not date the bag (listed as "No. 1518"), but referred to it as being "old."

Bags embroidered with beads continued to be made throughout the nineteenth century and well into the twentieth century. In the late 1940s and through the 1950s, bags embroidered with a tambour stitch were exported from France and Belgium and, eventually, from Japan. This technique allowed beads to be attached to the fabric with a continuous chain stitch, making it easier to cover the entire fabric of the purse with beads.

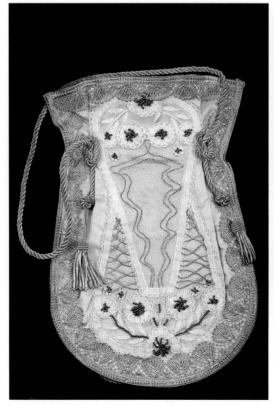
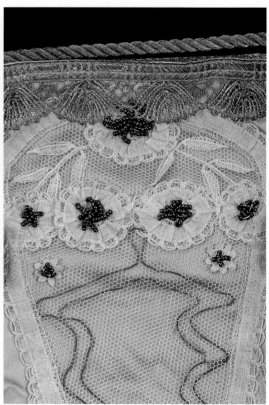

Left: Cream satin and lace, embroidered, floral design, charcoal glass beads, silver thread, silk cord drawstring. c. late 1800s. *Author.* $125-175.

Right: Detail.

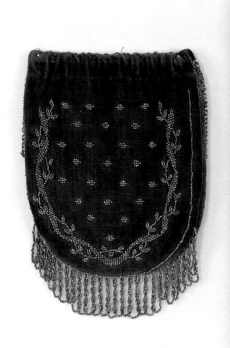

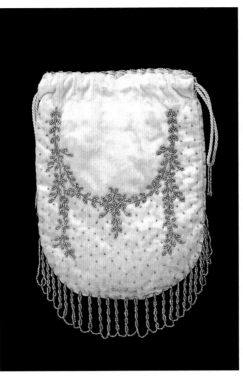

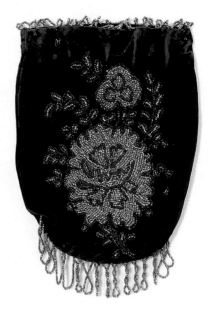

Gray velvet, embroidered, silver steel beads, laurel wreath design, twisted entwined thread, drawstring. c. mid-to-late 1800s. *Courtesy Paulette Batt.* $75-100.

Cream panné velvet, embroidered, garland design, gold steel beads, silk cord drawstring. c. mid-to-late 1800s. *Courtesy Joanne Haug, Reflections of the Past.* $125-175.

Black velvet, embroidered, floral design, silver steel and cut-jet beads, twisted fringe, drawstring. c. late 1800s to early 1900. *Courtesy Sally Smith.* $90-150.

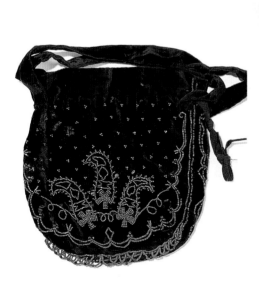

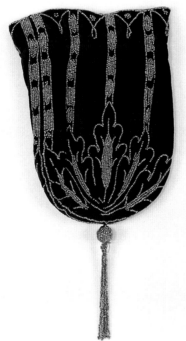

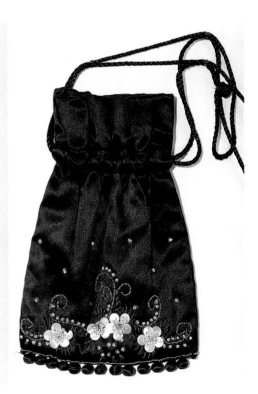

Black velvet, embroidered, stylized design, cut-steel beads, looped fringe, drawstring. c. late 1800s. *Courtesy Ursuline College Historic Costume Study Collection .* $90-150.

Black velvet, embroidered, Art Nouveau design, silver cut-steel beads, 3-1/2 inch tassel, drawstring. c. 1900. *Courtesy Paulette Batt.* $75-100.

Black satin, embroidered, silver steel, crystal, seed beads and mother-of-pearl, paillettes, silk ball fringe, drawstring. c. late 1800s. *Courtesy Ursuline College Historic Costume Study Collection.* $75-125.

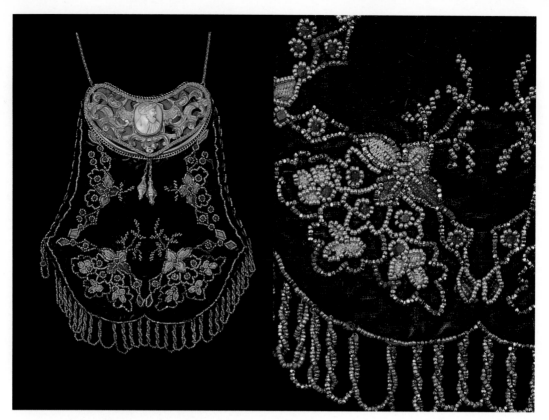

Green velvet, embroidered, floral design, gold
and silver steel beads, red glass beads, crocheted
silk thread, gold-tone closure, Greek cameo.
c. mid 1800s. *Courtesy Ursuline College
Historic Costume Study Collection.* $350-400.

Detail.

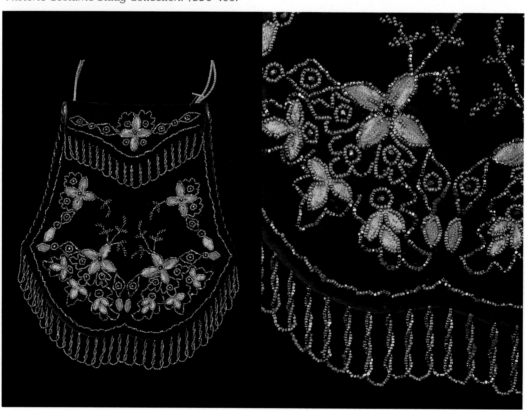

Maroon velvet, embroidered, floral design with
gold and silver steel beads, crocheted silk
thread, envelope closing. c. mid 1800s.
*Courtesy Ursuline College Historic Costume
Study Collection.* $150-200.

Detail.

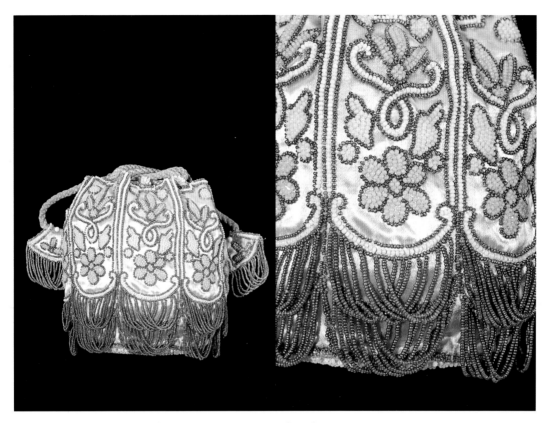

Cream satin, embroidered, floral design, silver, white, and pink glass beads, draped fringed, silk thread drawstring, label "Michel Swiss, 16 Rue de la Pax, Paris." c. 1930s. *Courtesy Lenore Hollander Bletcher.* $125-175.

Detail.

Detail.

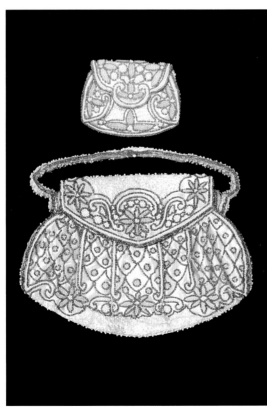

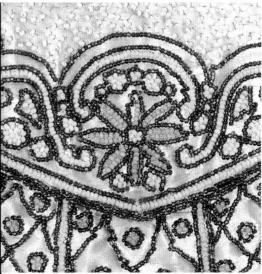

Top: coin purse, envelope closure, label "Michel Swiss, 16 Rue de la Pax, Paris." c. 1930s. *Courtesy Lenore Hollander Bletcher.* $25-30. *Bottom:* white satin, tambour stitched, floral and lattice design, silver steel, white and pastel glass beads, bead embroidered handle, envelope closure. c. 1930s. *Courtesy Ursuline College Historic Costume Study Collection.* $75-100.

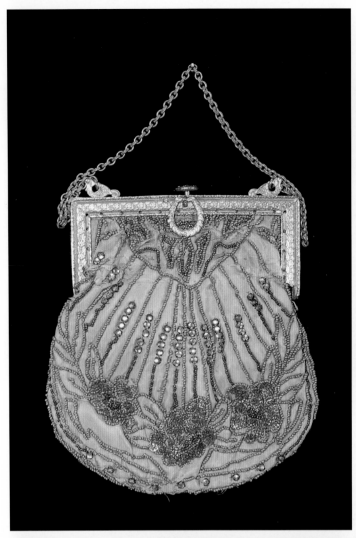

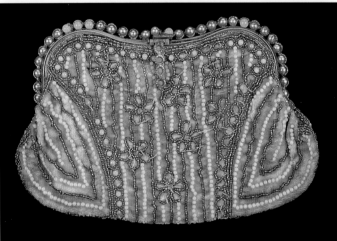

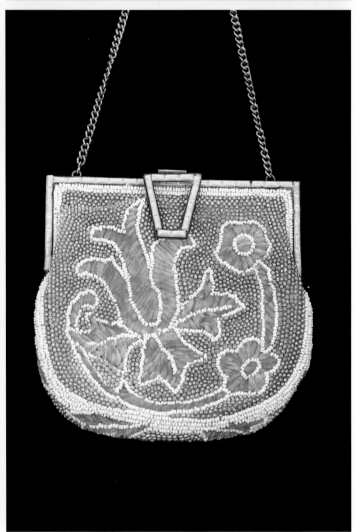

Top left: Green silk, embroidered, floral design, gold steel beads and rhinestones, gold-tone frame with dolphins. c. late 1800s. *Courtesy Lenore Hollander Bletcher.* $100-250.

Bottom left: Cream panné velvet, embroidered, floral design, silver steel and silver beads, pearl frame. c. 1920s. *Courtesy Anna Greenfield.* $50-75.

Top right: Cream satin, embroidered, gold-filled bugles, feather design, gold-toned frame, amber glass bead on clasp. c. 1930s. *Courtesy Linda Bowman, Legacy Antiques and Vintage Clothing.* $75-100.

Bottom right: Cream pleated velvet, tambour stitched, orchid design, white beads and pearls, enameled frame. c. 1920s. *Courtesy Bunni Union.* $150-200.

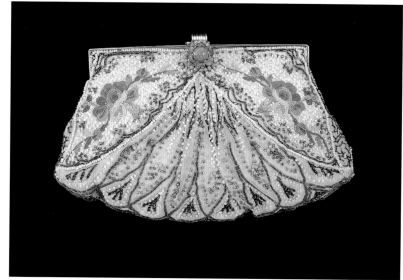
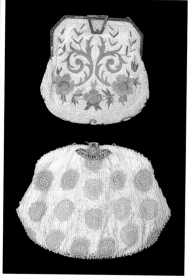
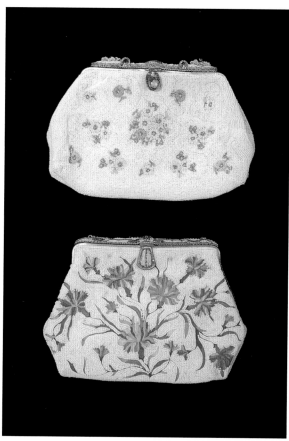
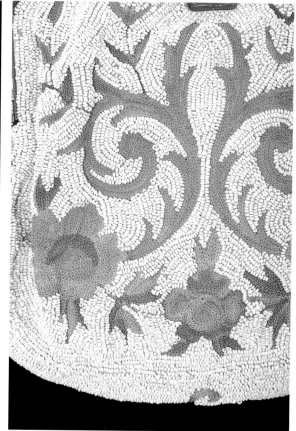

Top left: Cream silk, embroidered, floral pattern, gold-filled bugles, silver-lined and mother-of-pearl glass beads, silk thread tambour stitched, jade colored bead clasp, French. c. 1920s. *Courtesy Martha Cordes Towns.* $150-250.

Bottom left:
Top: white netting, tambour stitched, floral design, pastel micro beads, painted 'courting scene' on two porcelain ornaments. *Bottom:* white netting, tambour stitched, carnations design in silk thread, white beads, gold-tone, enameled floral frame, beaded clasp. c. 1950s. *Courtesy Sylvia Reitman.* $100-175 each.

Top right:
Top: white netting, tambour stitched, floral design in silk thread, white micro beads, jeweled frame and clasp. *Bottom:* white satin, tambour stitched swirls, pink, white, and pearl beads, rhinestone clasp. c. 1920s. *Courtesy Sandy Osborn.* $75-125 each.

Bottom right: Detail.

All photos below are details.

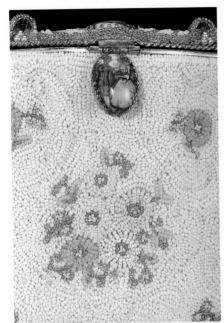

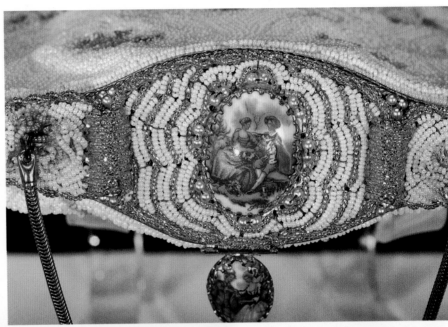

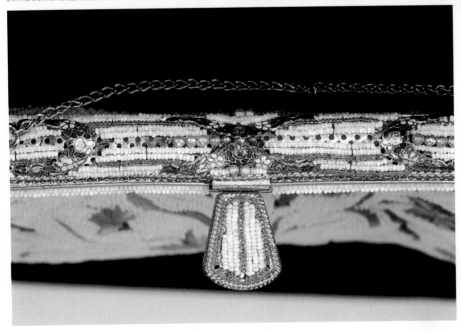

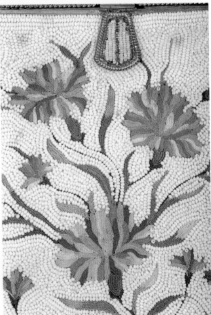

Top: white netting, tambour stitched, stylized design in silk thread, white micro beads. *Bottom:* white netting, tambour stitched, stylized design, white and pastel seed beads. c. 1950s. *Courtesy Pearl Schwartz Fishman.* $75-100 each.

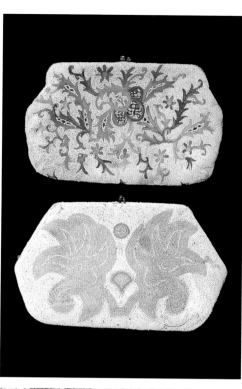

White, open weave cotton, clear crystal beads, swirl designs, pearls, gold thread. c. 1950s. *Courtesy Joyce Glickman.* $35-40.

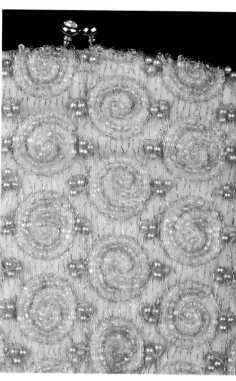

Detail.

Detail.

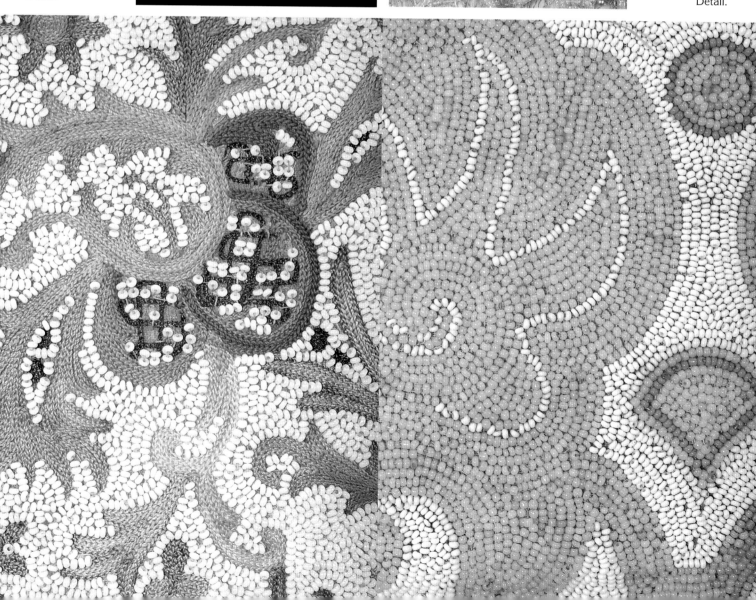

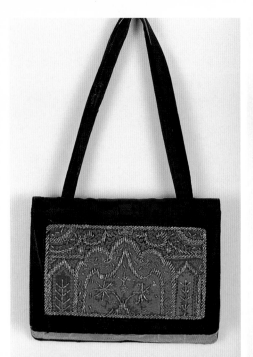
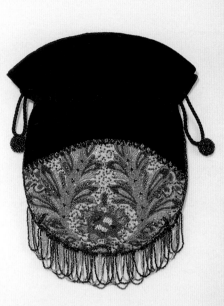
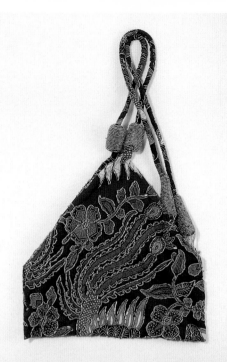
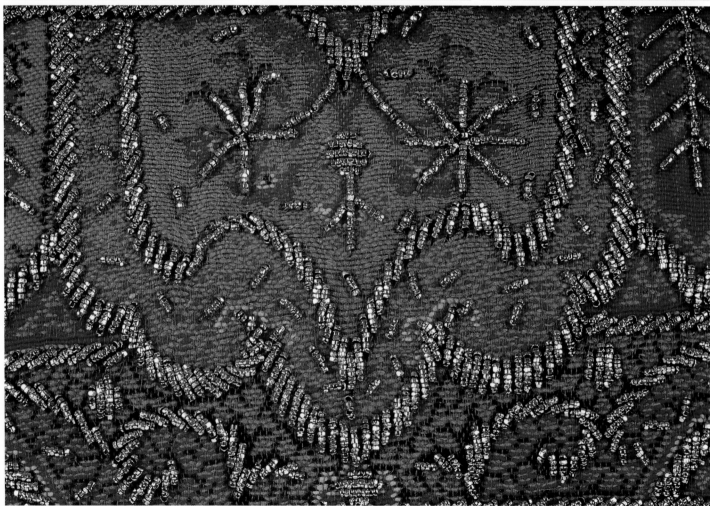

Top left: Black faille, applied antique tapestry, embroidered, silver steel beads, envelope closure. c. 1940s. *Courtesy Ruth G. Kyman.* $75-100.

Bottom: Detail.

Top center: Black velvet, inset floral patterned cotton, embroidered, multi-color glass beads, looped fringe, drawstring, Italian. c. 1980s. *Courtesy Emma Lincoln.* $75-100.

Top right: Blue floral patterned silk, embroidered, gold beads, bead wrapped cords, drawstring, Indonesian. c. 1990s. *Courtesy Emma Lincoln.* $50-75.

Black and paisley ethnic shawl, embroidered, pastel pearls, black sequins, envelope closure. c. 1950s. *Courtesy Anna Greenfield.* $75-100.

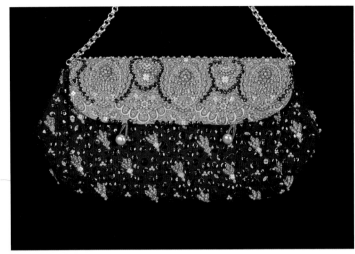

Blue linen, embroidered, leaf design, white beads, drawstring. c. 1950s. *Courtesy Linda Bowman, Legacy Antiques and Vintage Clothing.* $75-100.

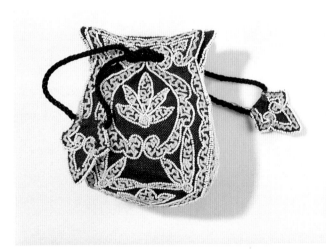

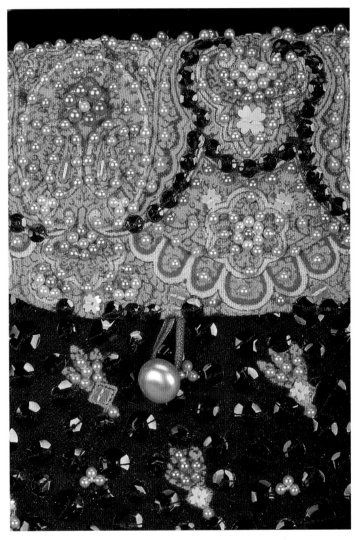

Detail.

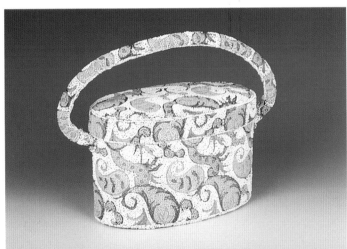

White silk, tambour stitched, paisley design, white and pastel glass beads, pearls, silk thread, oval box frame. c. 1940s. *Courtesy Nancy C. Goldberg.* $250-350.

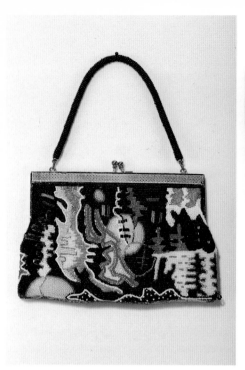

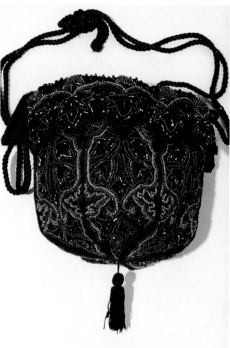

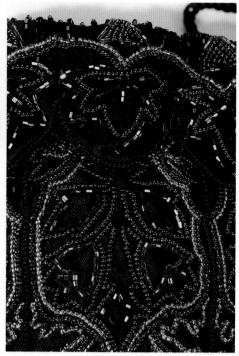

Black, tambour stitch, abstract design, multi-color seed and bugle beads. c. 1950s. $125-175.

Black satin, embroidered, stylized design, multi-color glass beads and black bugles, silk tassel, drawstring. c. 1980s. *Courtesy Eileen Sullivan Ptacek.* $50-100.

Detail.

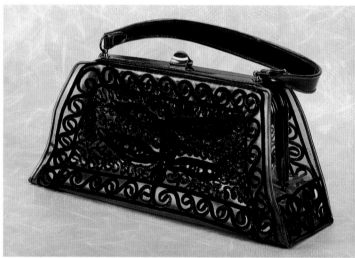

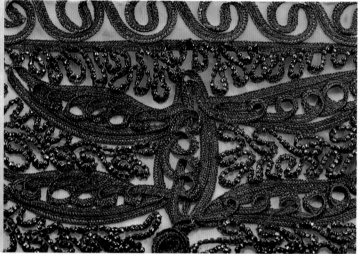

Clear vinyl, black cut glass beads, black braid, scroll design. c. 1950s. *Courtesy Anna Greenfield.* $75-125.

Detail.

Chapter 5
Monochromatic Bags

"It is not at all surprising that the vogue of making beaded bags is so great, when one can realize the possibility of creating things of exquisite beauty with a few beads and some silk thread."
from *How to Make the New Beaded Bags and Chains* (HIAWATHA book), 1924

When did beaded bags of monochromatic colors come into fashion?

In the early twentieth century, the beaded bags imported to the United States from Europe had elaborate patterns and were difficult and time consuming for the amateur beadworker to duplicate. Instructions and designs were written for monochromatic beaded "finger purses" as shown in a reprint of the *Priscilla Beadwork Book*, 1912.

By the 1920s, beads on apparel and beaded purses were at the height of their fashion. Instruction books of the time show numerous patterns for monochromatic "swag" purses. The "HIAWATHA" company published books and carried beads, bag frames, cords, and thread for the purpose of making these bags.

Pattern for crocheted bag, *The HIAWATHA Book*, page four. c. 1924. *Author.*

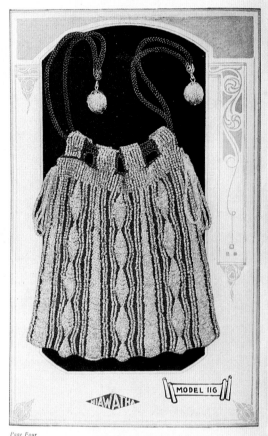

Page Four

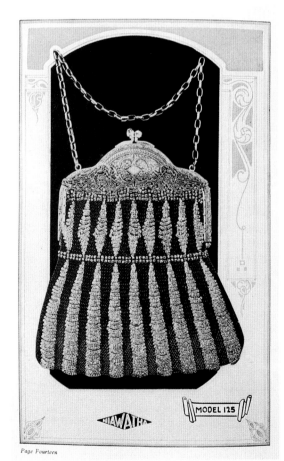

Left: Pattern for crocheted bag, *The HIAWATHA Book*, page fourteen. c. 1924. *Author.*

Right: Pattern for crocheted bag, *The HIAWATHA Book*, page twenty-four. c. 1924. *Author.*

Page Fourteen

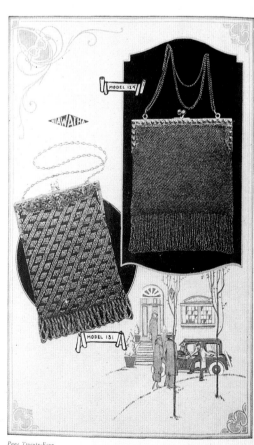

Page Twenty-Four

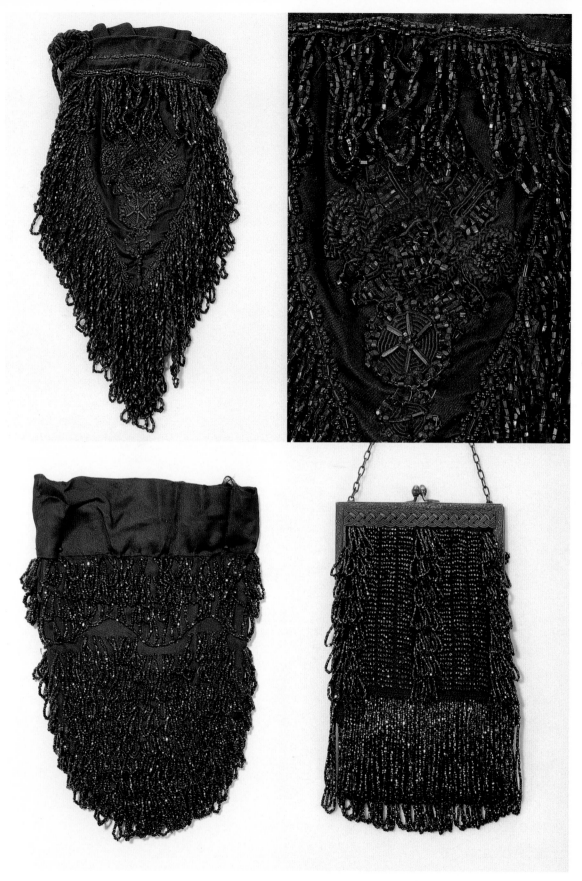

Top left: Black silk, embroidered, jet beads, drawstring, 9-inch length. c. mid-to-late 1800s. *Courtesy Veronia Trainer.* $200-250.
Top right: Detail.
Bottom left: Black silk, embroidered, iridescent beads, drawstring, 6-inch length. c. 1890s. *Courtesy Edythe Swartz Phillips.* $100-125.
Bottom right: Black, crocheted, black cut beads, woven love-knot design on frame, 8-inch length. c. early 1900s. *Courtesy Veronica Trainer.* $200-225.

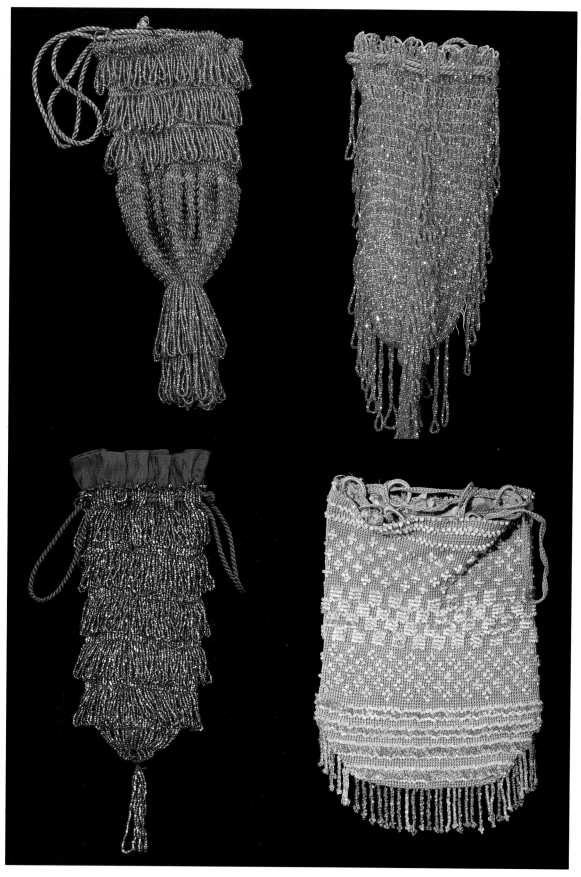

Top left: Bronze, crocheted, cut beads, three rows of looped fringe at the top, double looped tassel, drawstring, 7-inch length. c. early 1900s. *Author.* $100-125.

Top right: Pink, crocheted, cut beads, drawstring, 12-inch length. c. early 1900s. *Courtesy Veronica Trainer.* $200-250.

Bottom left: Black silk, gold cut beads, five rows of looped fringe, looped tassel, drawstring, 9-inch length. c. 1890s. *Courtesy Ursuline College Historic Costume Study Collection.* $125-175.

Bottom right: Gray, crocheted, white and crystal beads, straight fringe, drawstring, 7-inch length. c. 1930s. *Author.* $100-125.

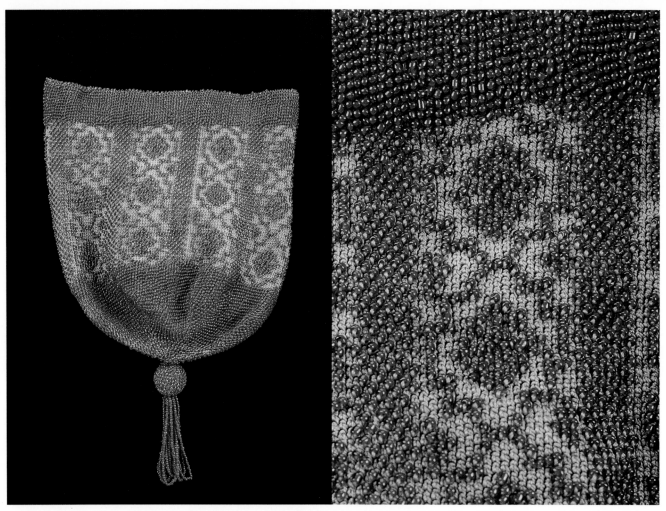

Beige, crocheted, red seed beads, beaded ball looped fringe, unframed, 8-3/4 inch length. c. early 1900s. *Courtesy Anna Greenfield.* $100-125.

Detail.

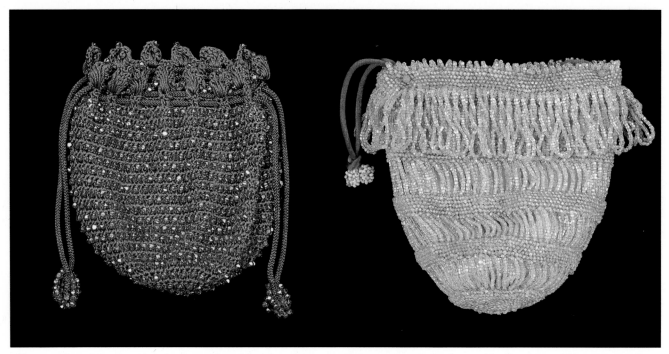

Blue, crocheted, facet cut beads, drawstring, 4-inch length. c. 1920s. *Courtesy Ursuline College Historic Costume Study Collection.* $50-100.

Pink, crocheted, dyed crystal bugles, looped fringe, drawstring, 5-inch length. c. early 1900s. *Courtesy Paulette Batt.* $50-100.

Left: blue, knit, blue and charcoal beads, 4-inch looped fringe, beaded handles, 6-inch length. c. 1920s.

Middle: green, knit, green cut beads, looped fringe and tassel, drawstring, 7-inch length. c. 1915.

Right: blue, knit, blue cut beads, 4-inch looped fringe, beaded handle, 6-inch length. c. 1920s. *Courtesy Anna Greenfield.* $75-100 each.

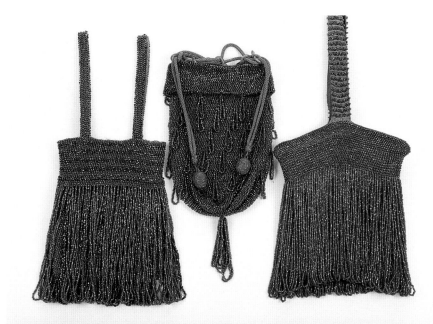

Left: red, crocheted, red cut beads, drawstring, 4-inch length.

Right: pink, crocheted, dyed crystal beads, child's drawstring, 6-inch length. c. early 1900s. *Courtesy Veronica Trainer.* $100-125 each.

Left: beige, crocheted, blue cut beads, beaded ball, looped fringe and tassel, drawstring, 7-inch length.

Right: gray, crocheted, blue cut beads, two rows of looped fringe, drawstring, 5-inch length. c. late 1800s to early 1900s. *Courtesy Bunni Union.* $75-100 each.

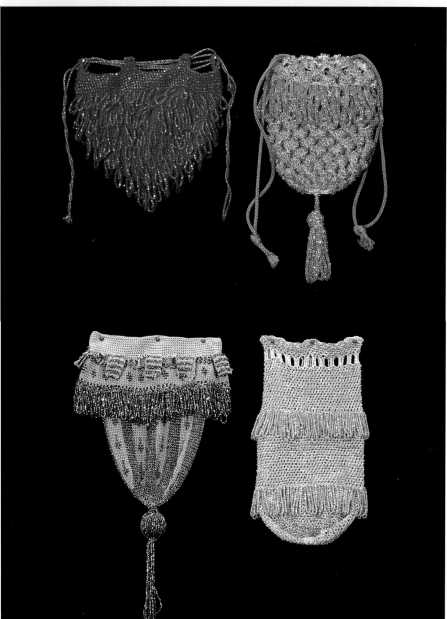

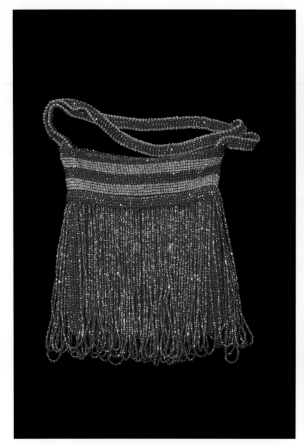

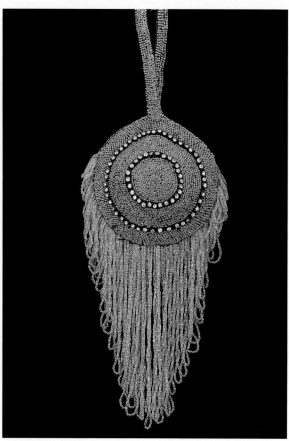

Red crocheted, red and crystal seed beads, 4-inch looped fringe, loom-woven handle, 6-inch length. c. 1920s. *Author.* $100-125.

Black crocheted, clear crystal seed beads and diamantè, 6-inch looped fringe, crocheted handle, 11-inch length. c. 1920s. *Courtesy Bunni Union.* $100-150.

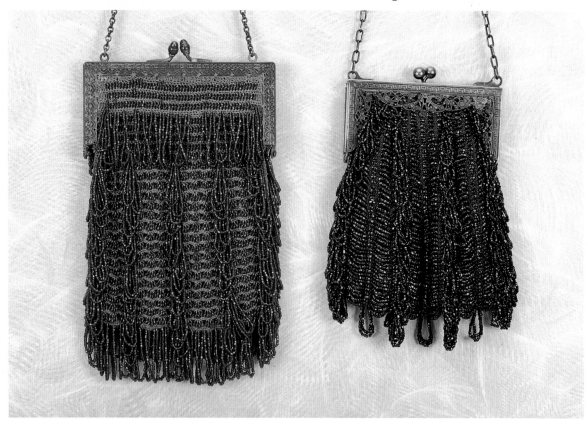

Left: tan, crocheted, cut bronze glass beads, descending looped fringe, brass frame, 7-inch length.
Right: brown, knit, cut beads, cascading looped fringe, brass filigree frame, 6-inch length. c. early 1900s.
Courtesy Anna Greenfield. $75-100 each.

Detail.

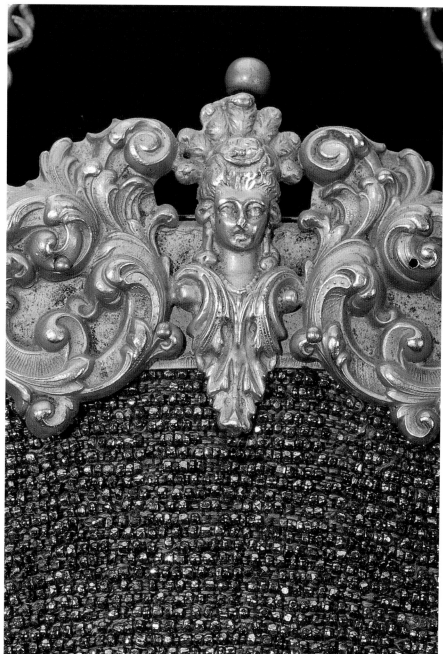

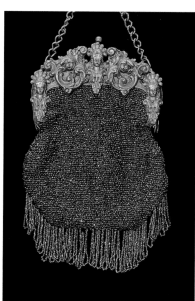

Black, knitted chatelaine, cut jet beads, German silver frame with three busts of women in eighteenth-century costume, wigs, and feather plumbs as crowns, looped fringe in silver cut-steel beads, 7-inch length. c. late 1800s. *Courtesy Veronica Trainer.* $275-300.

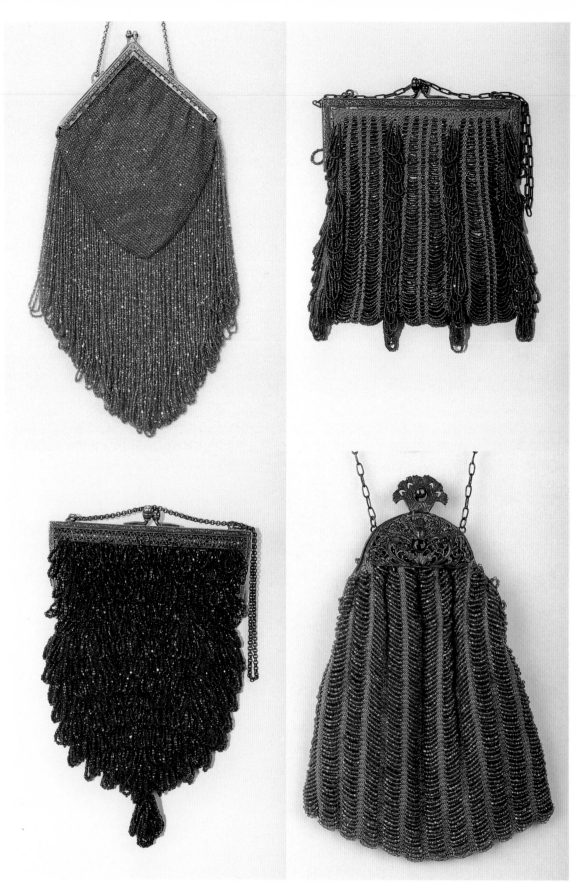

Top left: Turquoise, crocheted, cut beads, 6-inch looped fringe, silver-tone frame, 13-inch length. c. early 1900s. *Courtesy Veronica Trainer.* $200-250.

Bottom left: Blue, crocheted, cut beads, looped fringe and tassel, silver filigree frame, 6-inch length. c. early 1900s. *Courtesy Sandra Burdette Mills.* $100-200.

Top right: Tan, knitted, blue cut beads in swag, silver-tone frame, 7-inch length. c. 1908. *Courtesy Cheryl Dietz Stankus.* $100-200.

Bottom right: Tan, knitted, turquoise cut beads in swag, silver-tone filigree frame, 10-inch length. c. early 1900s. *Author.* $175-200.

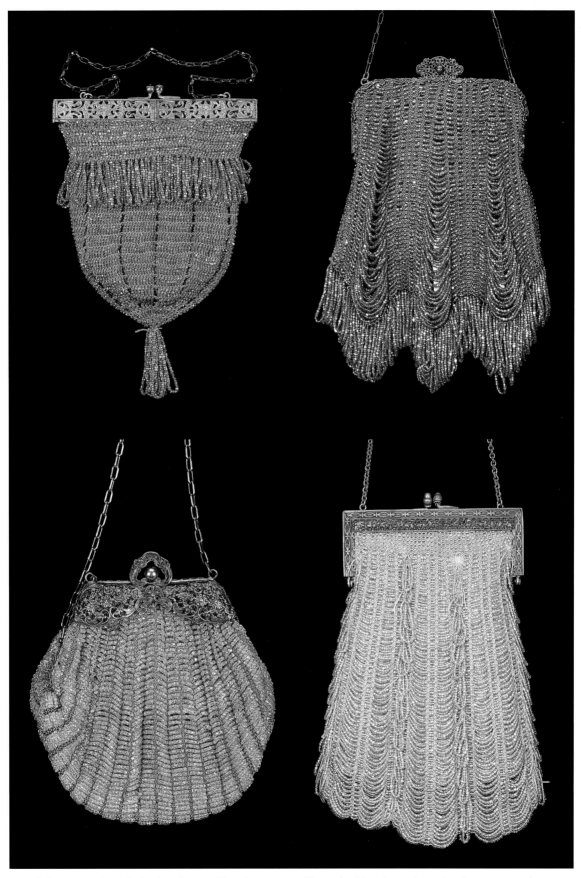

Top left: Tan, crocheted, dyed pink crystal beads, looped fringe and tassel, brass filigree frame opens to form a square, 7-inch length. c. late 1800s. *Courtesy Pamela F. LaMantia.* $125-150.

Bottom left: Gray, knitted, crystal cut beads, German silver filigree frame, 5-inch length. c. late 1800s. *Courtesy Anna Greenfield.* $125-175.

Top right: Blue, knitted, cut beads in swag and scalloped bottom looped fringe, German filigree frame, 10-inch length. c. early 1900s. *Courtesy Veronica Trainer.* $175-225.

Bottom right: Cream, knitted, blue cut crystal in swag, brass frame, 10-inch length. c. 1910. *Courtesy Ursuline College Historic Costume Study Collection.* $100-125.

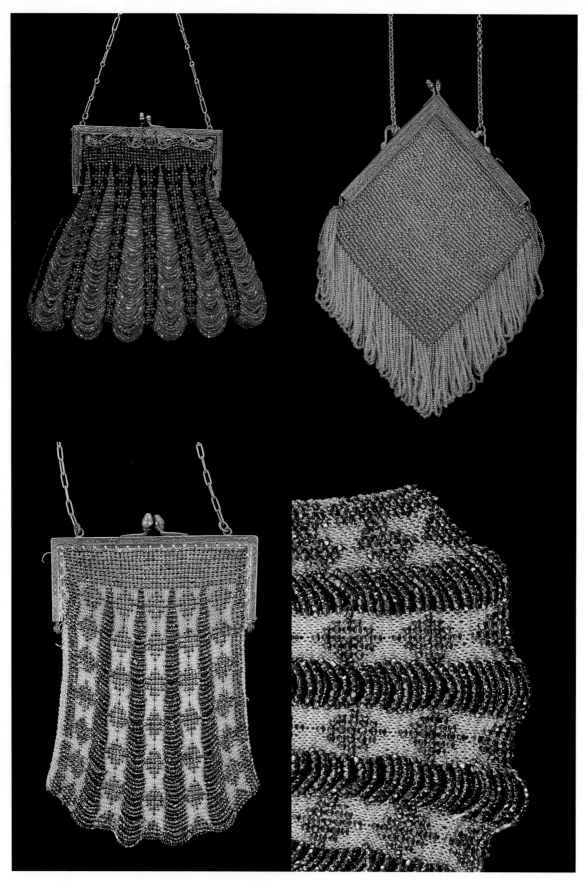

Top left: Black, orange cut crystal beads in swag, filigree handle, 5-inch length. c. late 1800s.
Courtesy Bunni Union. $125-175.
Top right: Yellow crocheted, glass seed beads, brass frame, 8-1/2 inch length. c. early 1900s. $100-150.
Bottom left: Blue, knitted, cut beads in swag, brass frame, 7-inch length. c. early 1900s.
Courtesy Janet King Mednik. $150-200.
Bottom right: Detail. (rotated 90 degrees)

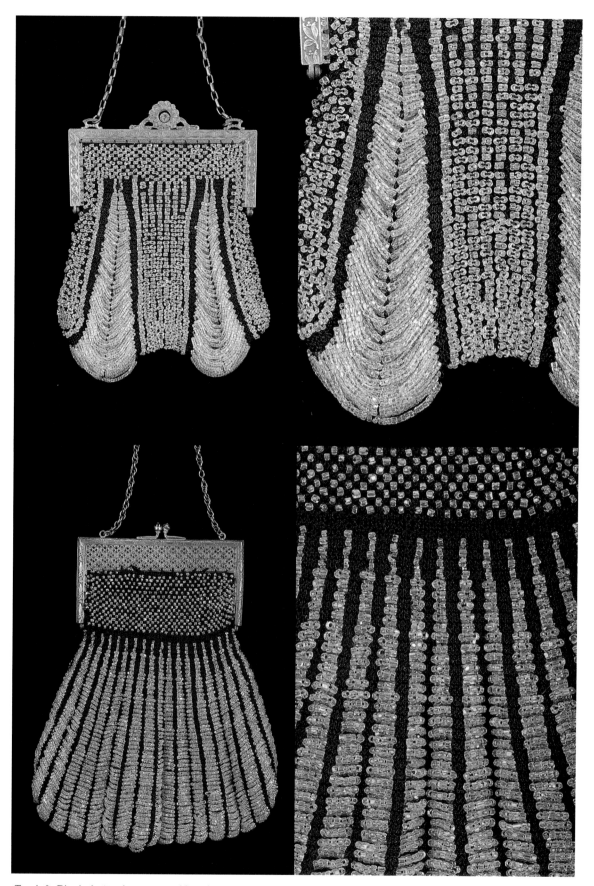

Top left: Black, knitted, cut crystal beads, swags creating tear drops, German silver frame, 7-inch length. c. early 1900s. *Courtesy Anna Greenfield.* $175-200.
Top right: Detail.
Bottom left: Black, knitted, cut crystal beads, flared body, German silver filigree frame, 7-inch length. c. early 1900s. *Courtesy Anna Greenfield.* $125-150.
Bottom right: Detail.

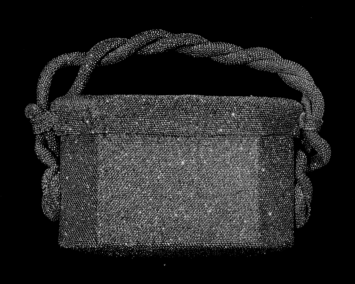

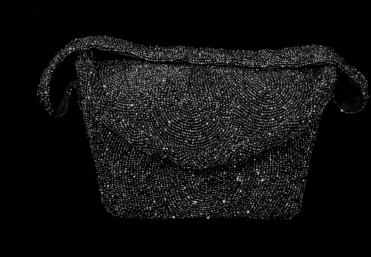

Gold, cut-steel beads, hatbox design, twisted beaded handle, 6-inch height; six months to complete, Rose Golub Schulman, designer. c. 1940s. *Courtesy Tobe Schulman, The Cleveland Plain Dealer.* $175-200.

Gunmetal gray, embroidered, cut beads, envelope closure, beaded handle, 6-inch height, label K. & G. Charlet - New York. c. 1940s. *Courtesy Anita Singer.* $75-125.

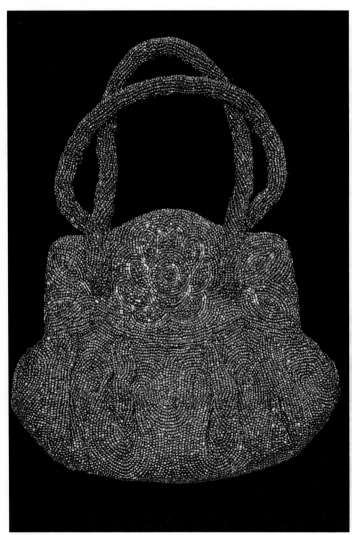

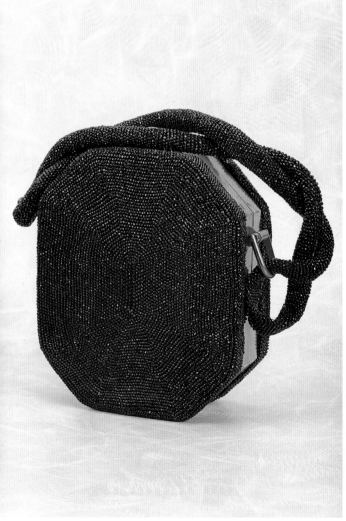

Gold, embroidered, cut and bugle beads, floral pattern, beaded handles, 6-inch height. c. 1940s. *Author.* $75-125.

Black, embroidered, cut beads, octagon shaped box, brass frame, beaded handle, 6-inch height. c. 1950s. *Courtesy Anita Singer.* $125-150.

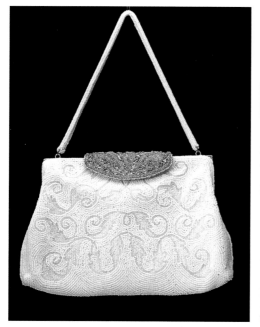
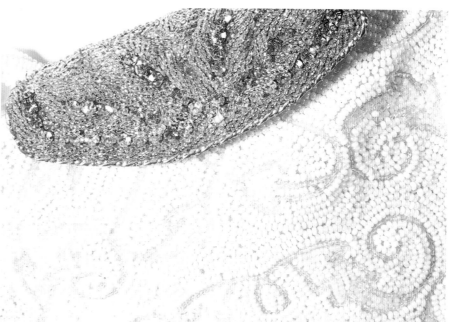
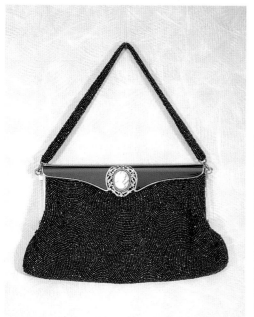
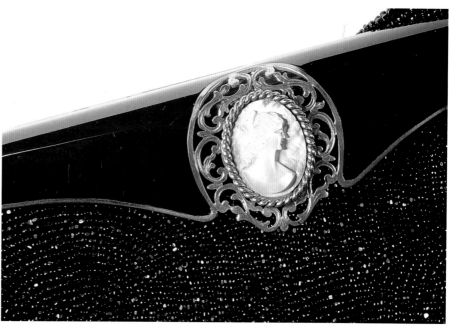

Top left: White, embroidered, crystal seed bead, rhinestone and beaded clasp, 6-inch height. c. 1950s. *Courtesy Anna Greenfield.* $75-100.

Top right: Detail.

Bottom left: Black embroidered, cut beads, beaded handle, cameo clasp. c. 1950s. *Courtesy Anna Greenfield.* $75-100.

Bottom right: Detail.

Chapter 6
Floral Drawstring Bags

*"In eastern lands they talk in flowers,
And they tell in a garland their loves and cares;
Each blossom that blooms in their garden bowers,
On its leaves a mystic language bears."*
from "The Sentiment of Flowers,"
James G. Percival, 1840

Why are floral designs so prevalent on beaded bags?

Flowers have always been a popular subject in the arts of ancient cultures. Specific flowers, such as the rose and the lily, symbolized virtues and were found in drawings dating back to the Egyptian and Greek civilizations. It is quite common for artists of all cultures to attempt to copy the perfection and beauty of nature, but the Arabic (Persian) and Turkish cultures created a *language* with flowers.

Florigraphy became a very popular means of communication in Europe by the late eighteenth century, and throughout the Romantic period in the nineteenth century. Its popularity may have inspired the floral designs found on the bags of the middle to the late nineteenth century. In addition, women's "fancywork" was usually restricted to subjects of nature (as it had been for hundreds of years). The most satisfying reason of all might be that flowers are so beautiful that their images make perfect subjects for ornamentation and decorative designs.

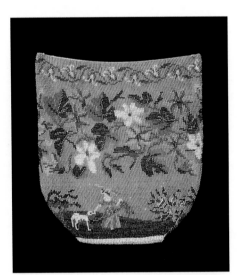

How did the language of flowers become popular in Europe?

The following accounts present an indication of the development of customs surrounding the language of flowers and its popularity.

On a trip to Constantinople in 1718, Lady Mary Wortley Montagu wrote to a friend and sent a "Turkish Love Letter," which was in the form of a purse. The purse contained different objects, such as a pearl, as well as flowers. Each of these items had a meaning or a message:

"… there is no flower without a verse belonging to it; and it is possible to quarrel, reproach, or send letters of passion, friendship, or civilty, or even the news without even inking your fingers."

When Lady Montagu returned to England, she introduced a "language of flowers" to society, and it became a tradition with the young English romantics of her time.

In France, Aubrey de la Mottraie introduced the language of flowers and described the tradition in this way:

"…each of them [have] their particular Meaning explain'd by certain Turkish verses, which the young Girls learn by Tradition of one another."

Art historians suggest that the depictions of flowers in art and decorations of the nineteenth century be examined not only for their aesthetic beauty, but also for any messages that may have been intended.

Do some of the floral designs in this chapter contain messages?

Yes. However, often because there are several different dictionaries describing the sentiments that the flowers represent and each dictionary has variations, accurately interpreting the messages intended is difficult. In addition, the meanings or sentiments ascribed to the flowers are sometimes different depending on the country of origin, or the language of the dictionary. Users of the language had the same difficulties when they attempted to decode a love message they received in the form of a bouquet or drawing. To be sure of the intended meaning, the same dictionary would need to be used.

In these chapters, amateur attempts have been made using three different dictionaries to decode the possible messages of the flowers illustrated.

The first bag featured in this chapter is a good example. It is an early bag, with three sections of designs, and a loom-woven bead handle. The purse is knitted using the smallest of beads, which are probably Italian.

The top section is knitted in blue forget-me-nots, pink roses accented with red, and purple and yellow pansies:

Forget-me-nots—*"Do not forget"*
Roses—*"I love you"*
Pink roses—*"If you love me, I will show you my love"*
Pansies—*"Think of me and I will think of you"*

The middle and largest section is knitted in blue forget-me-nots, one large pink rose, blue morning glories, purple and yellow pansies, and a yellow marigold with a green center.

Opposite page: Knitted, unframed, baby blue and multi-color fine beads, "Little Bo Peep" with lamb, 7-inch length. c. early-to-mid 1800s. *Courtesy Veronica Trainer.* $350-400.

Knitted, blue, clear crystal and multi-color fine beads, loom-woven beaded handle, floral design, originally a drawstring, 8-inch length. Language of flowers: Forget-me-nots—Do not forget [that]; Rose—I love you [and]; Rosebud—I confess it; Pink rose—If you love me, you will find it out; Pansies—Think of me and I will think of you; Morning Glory—[Warning!] I am a coquet and a flirt [and]; Marigold—I am jealous! c. early-to-mid 1800s. *Courtesy Veronica Trainer.* $450-500.

Detail.

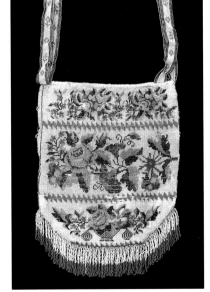

Forget-me-nots—"*Do not forget*" [that]
Rose—"*I love you*" [and]
Rose bud—"*I confess it*" [love]
Pink rose—"*If you love me, I will show you my love*"
Pansies—"*Think of me [and] I will think of you*"
Morning glory—[Warning!] "*I am a coquet and a flirt*" [and]
Marigold—"*I am jealous!*"

The three main themes are love (rose), affection (morning glory), and jealousy (marigold). Note the green center of the marigold (as in "green with jealousy"), which gives further strength to that sentiment! A marigold with a green center can also be found depicted on the next to last purse featured in this chapter. Here, the bottom section of the design offers the same message as the top section, with the same flowers together in a basket-like container.

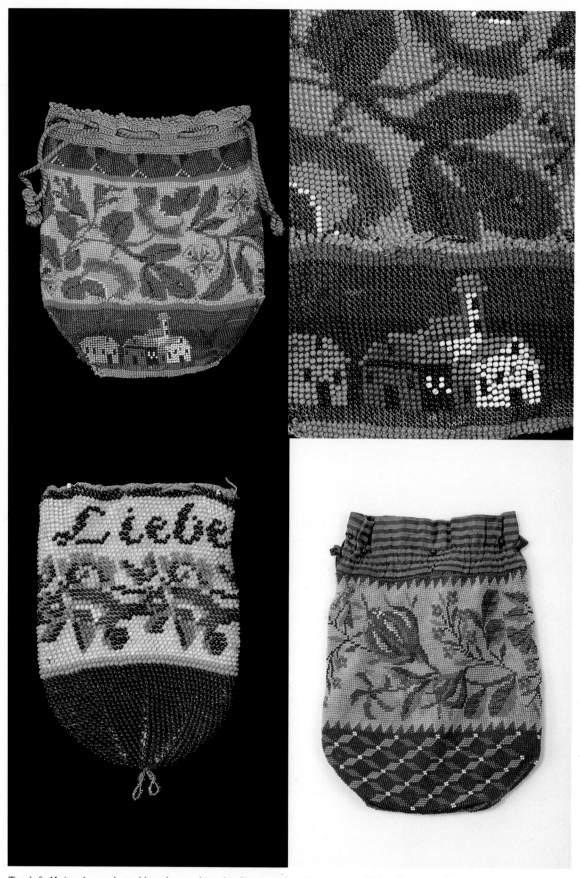

Top left: Knitted, crocheted header, multi-color fine seed beads, roses and blue flowers, village design, 6-inch length. c. early-to-mid 1800s. *Courtesy Anna Greenfield.* $250-300.
Top right: Detail.
Bottom left: Knitted, multi-color fine seed beads, roses and blue flowers, "*Liebe*" German word for "love," 3-inch length. c. early-to-mid 1800s. *Courtesy Veronica Trainer.* $100-150.
Bottom right: Knitted, silk header, multi-color fine beads, floral and geometric design, 6-inch length. c. early-to-mid 1800s. *Courtesy Bunni Union.* $225-250.

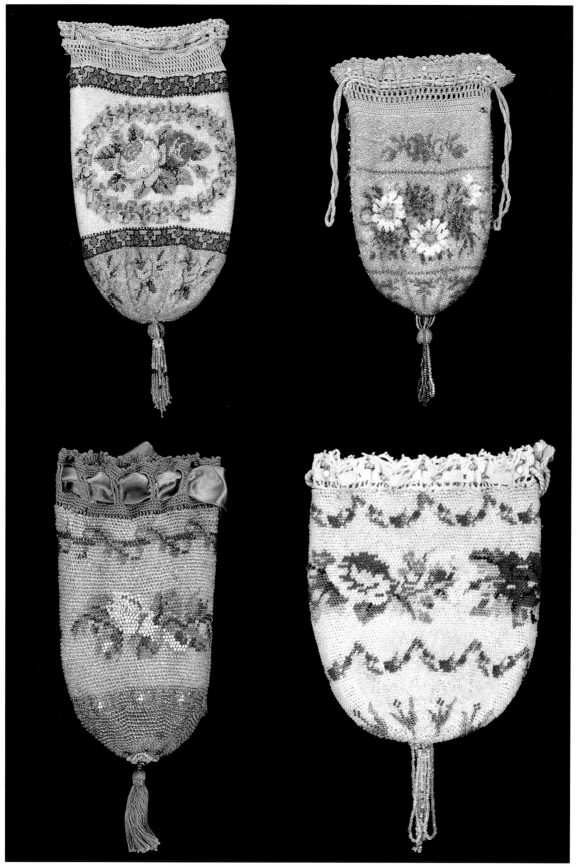

Top left: Knitted, crocheted header; cream, pink, and lavender fine cut beads, multi-color beaded tassel, 8-inch length.
Language of flowers: Red Rose—I love you [and];
Pink Rose—if you love me, I will show you my love;
Rosebuds—I am young, beautiful and innocent [and];
Violets—I am faithful! (Faithfulness is emphasized with a circle of violets around "love.") c. late 1800s. *Courtesy Veronica Trainer*. $350-400.

Top right: Knitted, crocheted header, gold-filled fine rocailles, multi-color tassel, 8-inch length. Language of flowers: *(top section)* Red Rose—I love you [and]; Pink Rose—if you love me, I will show you my love; Pink Rosebud—I confess my love [for you]; Red Rosebud—I am young, beautiful and innocent. *(Center section)* White Daisies—I am inno-cent; Bachelor Buttons—I am hopeful that love will come. c. mid-to-late 1800s. *Courtesy Bunni Union.* $350-400.

Knitted, crocheted header, mauve, lavender, red fine seed beads, roses and green vines, green silk tassel, 8-inch length. c. mid-to-late 1800s. *Courtesy Paulette Batt.* $275-325.

Knitted, crocheted header, clear cut crystal fine beads, red and pink roses with blue forget-me-nots, looped tassel, 8-inch length. c. early 1900s. *Courtesy Paulette Batt.* $275-325.

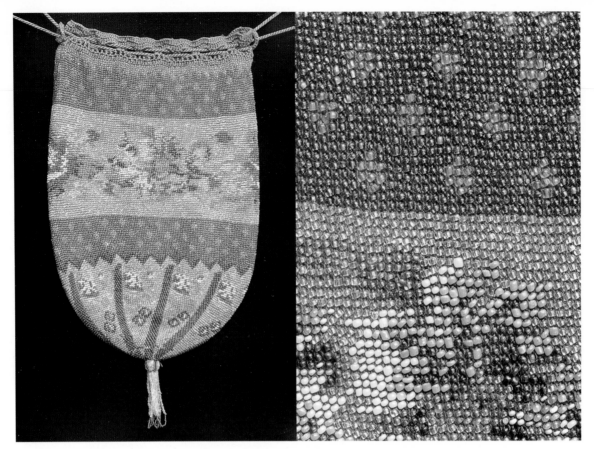

Knitted, crocheted header, lavender, purple and yellow fine seed beads, 9-inch length. c. late 1800s. *Author.* $350-400.

Detail.

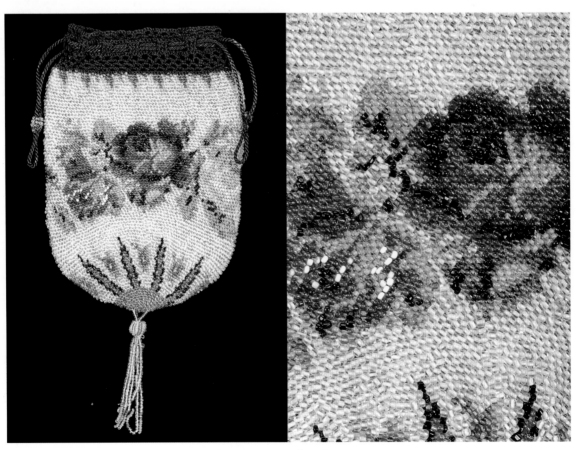

Knitted, crocheted header, clear crystal red, pink, green beads, roses, looped tassel, 8-inch length. c. 1915. *Courtesy Anna Greenfield.* $225-250.

Detail.

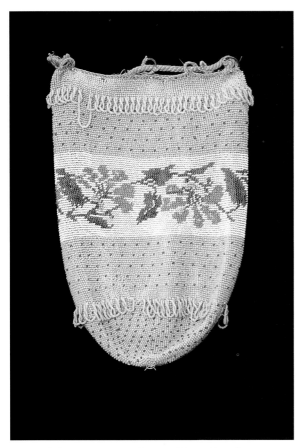

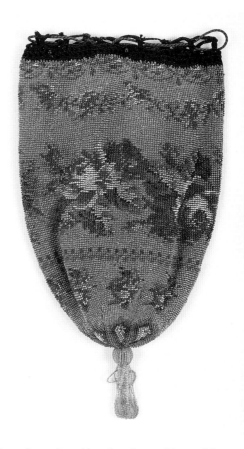

Knitted, fine cut green, white, gold seed beads, flowers, 7-inch length. c. early 1900s. *Courtesy Bunni Union.* $200-250.

Knitted, crocheted header, clear gold-toned fine beads, rose pattern, looped tassel, 9-inch length. c. late 1800s. *Courtesy Ruth G. Kyman.* $275-325.

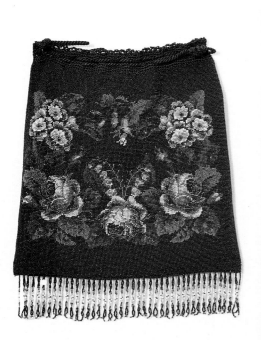

Bottom left: Knitted, crocheted header, gold steel, black, gray, silver, rust fine beads, rose, primrose, and lily-of-valley, 10-1/4 inch length. Language of flowers: Primrose—Sadness has come to me in my youth; White Roses—I am in despair; Rose (placed downward)—Someone dear to me has died; Forget-me-nots—Remember me [and] I will remember you; Lily-of-the-Valley—[This is my] hope that happiness will return. (The black background, the brown leaves, and the sentiment of the flowers reinforce the theme of mourning.) c. mid-to-late 1800s. *Courtesy Veronica Trainer.* $300-375.

Bottom right: Detail.

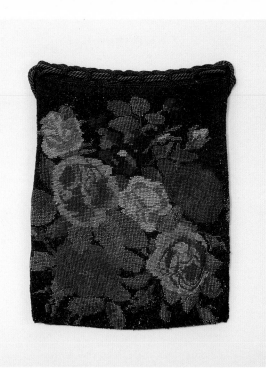

Knitted, crocheted header, black cut
and multi-color seed beads, roses and
pansies, 10-inch length. c. late 1800s.
Courtesy Veronica Trainer. $350-375.

Opposite page:
Detail.

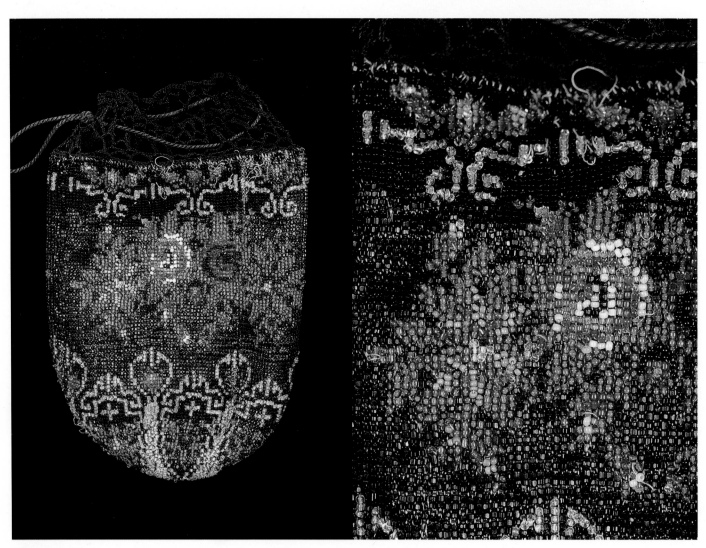

Crocheted, black cut and multi-color seed beads, roses and
bachelor buttons, 6-inch length. c. early 1900s. *Courtesy Anna
Greenfield.* $175-200.

Detail.

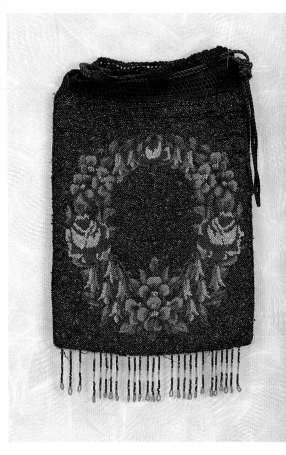

Top left: Knitted, crocheted header, iridescent cut beads, wreath of roses, violets, purple bells, 9-inch length. Language of flowers: Red Roses—I love you; Blue Pansies—Think of me, I will think of you; Fuchsias—You are engraved on my heart. c. 1920s. *Author.* $225-300.

Top right: Detail.

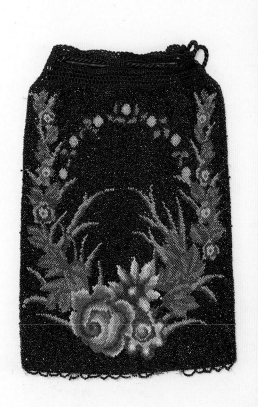

Bottom left: Knitted, crocheted header, black cut beads and multi-color fine beads, rose, daisy and primrose, 9-inch length. Language of flowers: Red Rose—I love you; Blue Bachelor Button—I am hopeful that love will come; Marigold (note green center)—[Warning!] I am jealous!; Pansies—Think of me, I will think of you; Roses in Grass—A great deal is to be gained by good company. c. early 1900s. *Author.* $300-325.

Bottom right: Detail.

Chapter 7
Floral Framed Bags

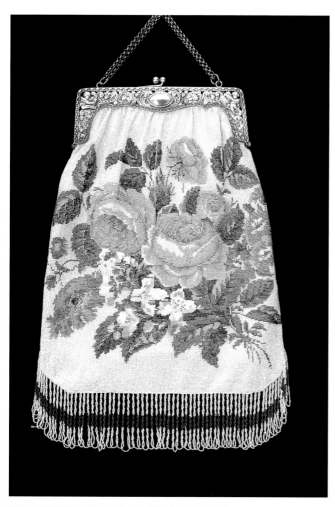

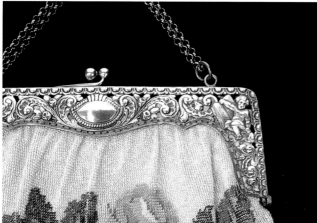

*"God does not send us strange flowers every year.
When the spring winds blow o'er the pleasant places,
The same dear things lift up the same old faces."*
From a poem by Mrs. Whitney,
in *An Age of Flowers,* by D. L. Swarthout

Why was so much time and effort devoted to creating and preserving beautiful objects to honor the beauty of nature during the nineteenth century?

Middle class women of the Victorian era had more leisure time to pursue personal artistic interests than women living before or since that era. They copied flowers and fruits in wax, painted them on canvas, and knitted beautiful floral designs

Top: Roses, apple blossom, blue, and orange floral, fine clear and multi-color seed beads, German silver filigree frame with two angels, twisted interlocked fringe, 14-1/2 inch length. c. late 1800s. *Courtesy Veronica Trainer.* $650-800.

Bottom: Detail.

Detail.

on their bags. During the Victorian era, a period from the 1840s to the turn of the nineteenth century, many believed that aesthetic gratification of the soul and the eye was very important. It was thought that children who grew up in homes surrounded by beautiful objects, lush gardens, and in an atmosphere devoted to the appreciation of art, literature, and nature would become compassionate and generous adults.

Is there a difference in age between the drawstring and the framed floral bags?

The exact date of each of these bags is difficult to determine. In an effort to maintain and reuse these beautiful bags, many of them were originally drawstring bags, which were altered to framed bags at a later time. Also, drawstring and framed reticules were in fashion during the same times.

The following descriptions may be helpful. *Framed bags* of the early nineteenth century were made with French pinchbeck or cut-steel. Many times, these early framed bags can be identified by their plunger-like closures. The interlocking twist closure is a later creation. The *chatelaine bag*, such as the one featured in this chapter with a magnolia design, was a popular fashion during the 1850s to the early 1900s. The size of the beads and the complexity of the design can indicate the date. Tiny, "fine" beads were commonly used on knitted bags made in the 1800s. In addition the more difficult and intricate patterns and designs often indicate a nineteenth century bag.

The majority of the beautifully framed floral designed bags in this book are constructed with fine (tiny) seed beads that were made in Italy, France, or Bohemia. Most of them are dated approximately from the 1860s to 1900. The less complex patterns are more modern in age, made in the early twentieth century when beaded bags were again popular.

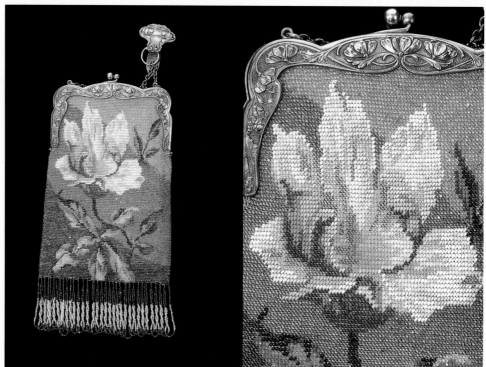

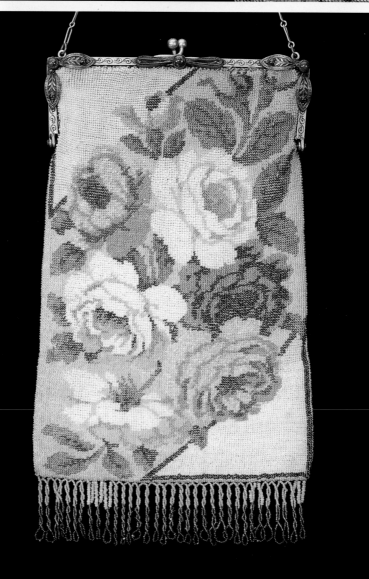

Top left: Magnolia, fine cut green, pink rose beads, German silver chatelaine frame, twisted interlocked fringe, 9-inch length. c. late 1800s. *Courtesy Veronica Trainer.* $550-650.

Top right: Detail.

Roses, fine multi-color seed beads, German silver and brass frame, cabochon blue and red gemstones, twisted fringe, 10-inch length. c. late 1800s. *Courtesy Veronica Trainer.* $650-800.

Opposite page: Detail.

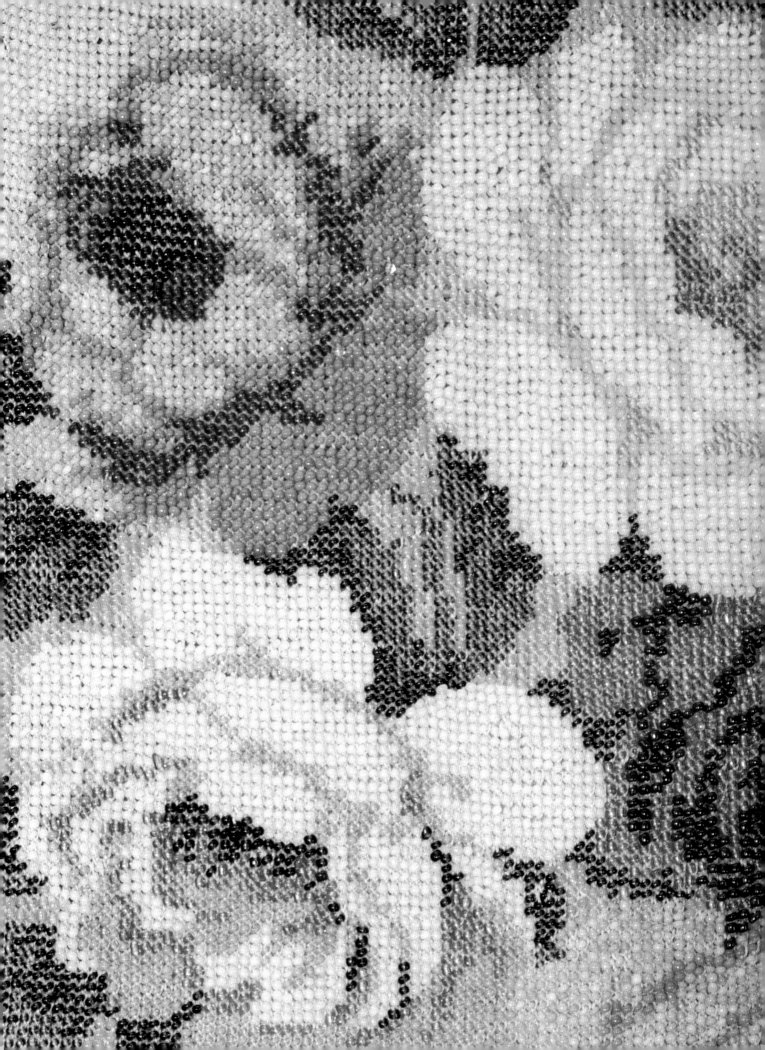

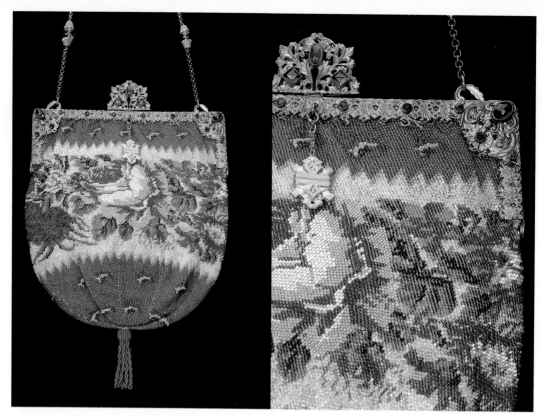

Roses, fine cut crystal and multi-colored seed
beads, brass jeweled filigree frame and chain
handle, twisted fringe tassel, 8-inch length.
c. mid-to-late 1800s. *Courtesy Veronica Trainer.*
$550-600.

Detail.

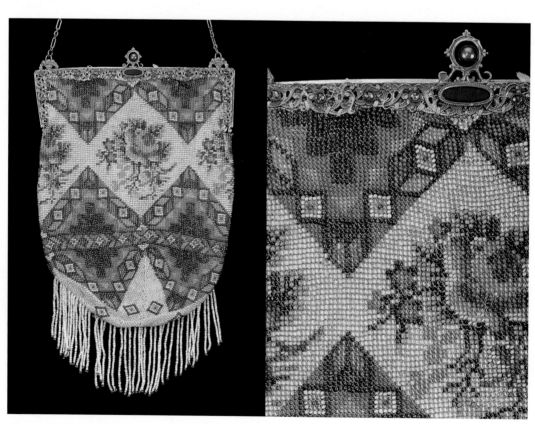

Roses, fine seed beads, brass jeweled and
enameled frame, straight fringe, 10-inch length.
c. late 1800s to early 1900s. *Courtesy Frances
Dickenson.* $550-600.

Detail.

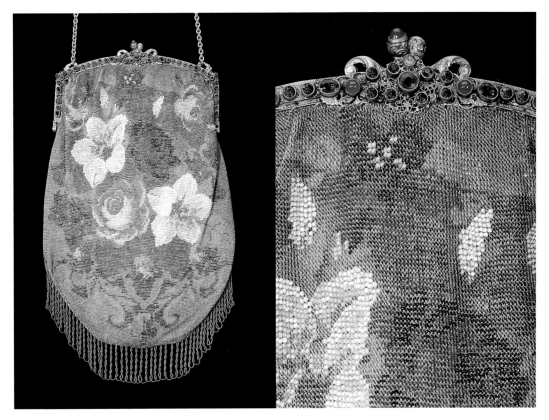

Lilies, roses, and violets, fine multi-color seed beads, brass jeweled filigree frame, twisted entwined fringe, 13-1/2 inch length. c. late 1800s. *Courtesy Veronica Trainer.* $600-750.

Detail.

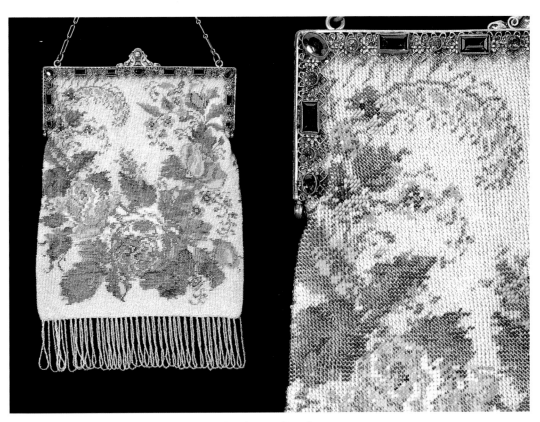

Roses and forget-me-nots, fine clear crystal and multi-color seed beads, brass jeweled filigree frame, entwined fringe, 11-inch length. c. late 1800s. *Courtesy Veronica Trainer.* $550-600.

Detail.

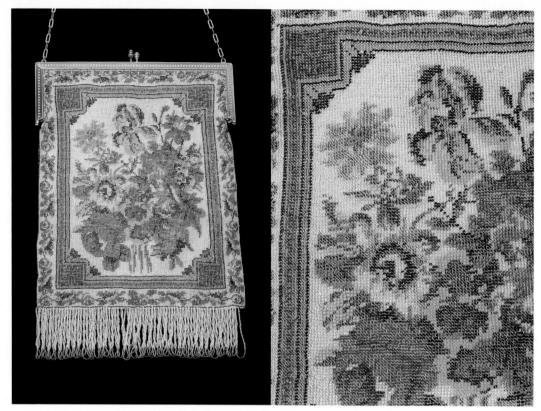

Irises, roses, and pansies, fine multi-color seed beads, brass frame, twisted entwined fringe, 10-inch length. c. late 1800s. *Courtesy Veronica Trainer.* $600-700.

Detail.

Tulip, daffodils, roses, and chrysanthemum, fine multi-color seed beads, brass jeweled enameled frame, and handle, faux jade clasp, looped fringe, 10-inch length. Language of Flowers: Variegated Tulip—My eyes tell me [that]; White Rose—I am worthy of love [but]; Daffodil—I am worried about unrequited love. Yellow Chrysanthemum—I am jealous; Magnolia—[of the] magnificence of nature. c. late 1800s. *Courtesy Veronica Trainer.* $600-750.

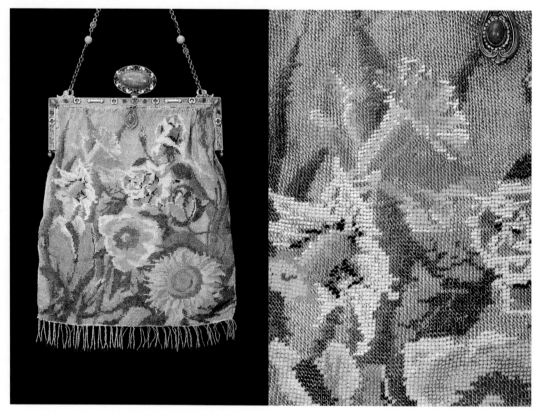

Detail.

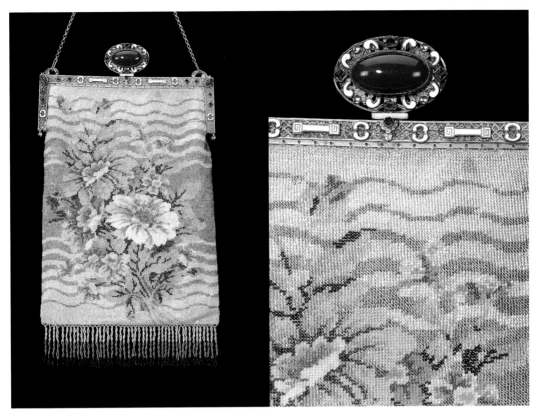

Bouquet, fine multi-color seed beads, brass jeweled enameled frame, carnelian cabochon clasp, twisted fringe, 10-inch length. c. late 1800s. *Courtesy Veronica Trainer.* $600-750.

Detail.

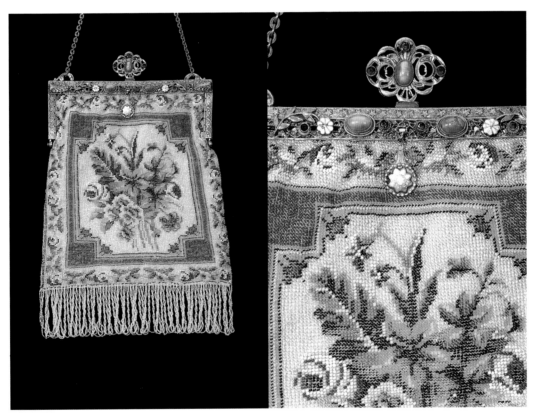

Bouquet, fine multi-color seed beads, brass jeweled enameled filigree frame, faux jade cabochon clasp, twisted entwined fringe, 10-inch length. c. late 1800s. *Courtesy Veronica Trainer.* $600-750.

Detail.

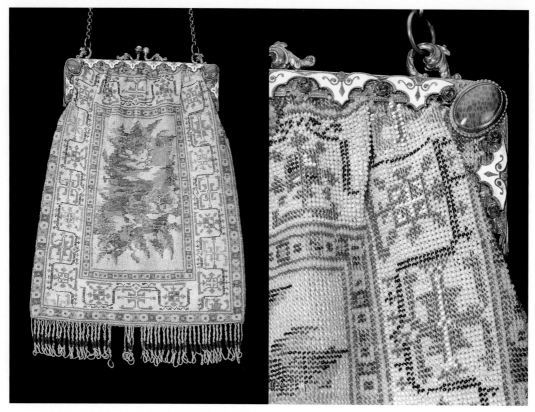

Bouquet, fine multi-color seed beads, brass jeweled enameled frame, twisted entwined fringe, 11-1/2 inch length. c. late 1800s. *Courtesy Veronica Trainer.* $600-750.

Detail.

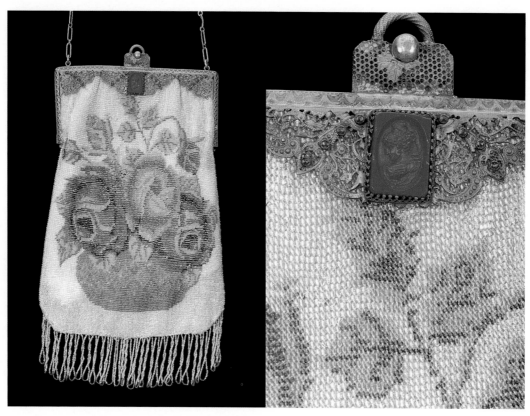

Roses in a bowl, fine multi-color seed beads, jeweled Trinity plate filigree frame, red celluloid cameo, twisted fringe, 10-inch length. c. late 1800s. *Courtesy Bunni Union.* $600-750.

Detail.

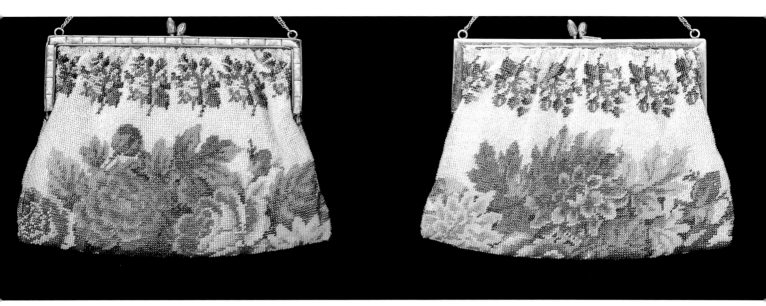

Bouquet, fine multi-color seed beads, brass jeweled frame, 5-1/2 inch length; this bag was constructed from one folded piece of completed beadwork. (This purse is made from one rectangle of knitted beadwork folded.) Beadwork: c. late 1800s. Frame: c. 1920s. *Courtesy Bunni Union.* $225-300.

Reverse side of beaded bag.

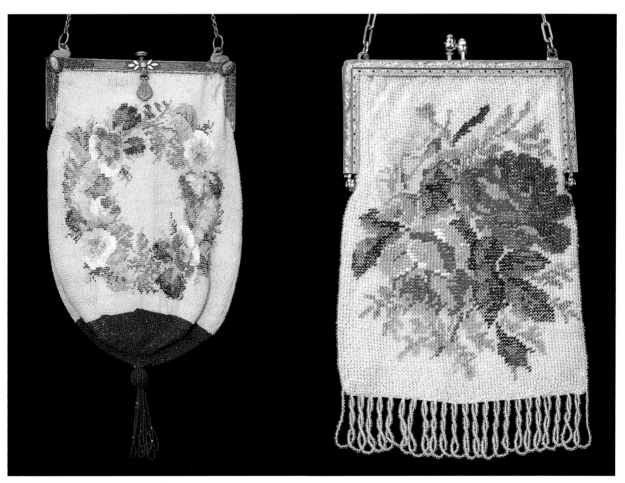

Floral wreath, fine cut multi-color seed beads, brass jeweled enameled frame with two swans and faux jade cabochons, looped tassel, 8-inch length. c. mid 1800s. *Courtesy Veronica Trainer.* $500-550.

Roses, clear crystal beads, and red, yellow, green seed beads, brass frame, entwined fringe, 7-inch length. c. late 1800s to early 1900s. *Courtesy Veronica Trainer.* $375-450.

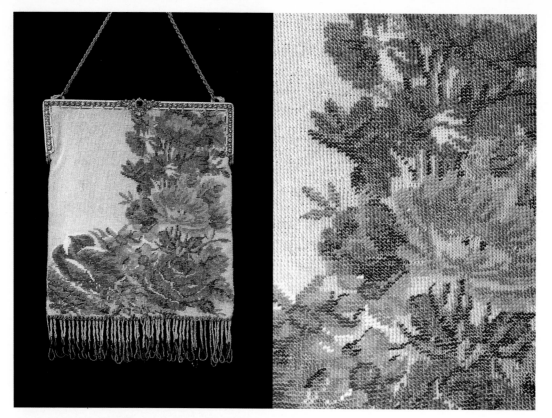

Pansies, climbing roses, and daisies, fine multi-color seed beads, brass jeweled enameled frame, twisted entwined fringe, 10-inch length. c. late 1800s to early 1900s. *Courtesy Veronica Trainer.* $550-600.

Detail.

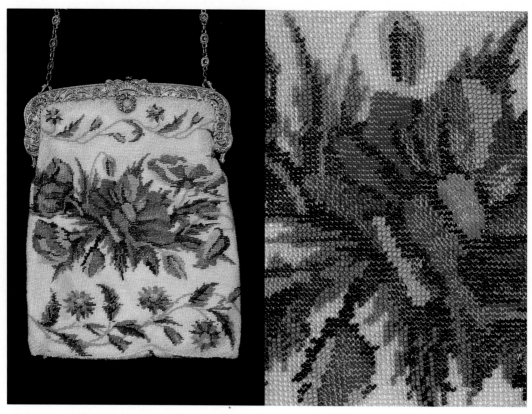

Poppies and blue flowers, fine multi-color seed beads, brass frame, 6-inch length. c. late 1800s. *Author.* $550-600.

Detail.

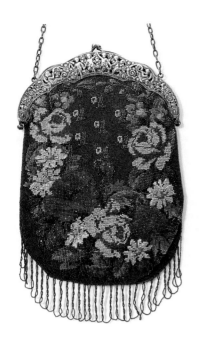

Poppies, roses, daisies, fine multi-color seed beads, silver frame with nymphs, twisted entwined fringe, 9-inch length. c. late 1800s to early 1900s. *Courtesy Veronica Trainer.* $550-600.

Detail.

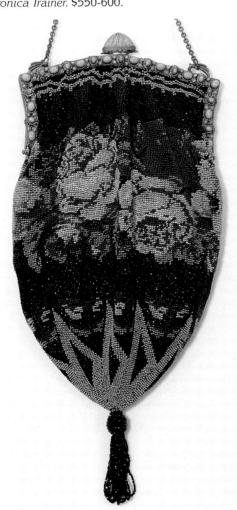

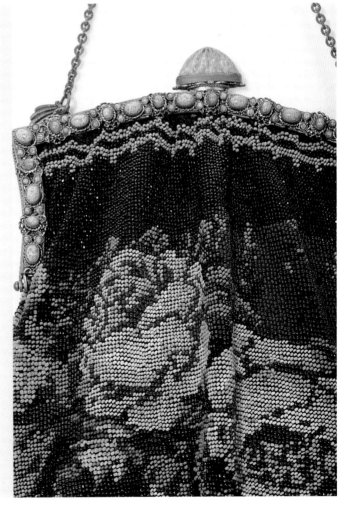

Roses, fine cut black and multi-color beads, brass jeweled encrusted frame, faux jade clasp, 11-inch length. c. late 1800s. *Courtesy Veronica Trainer.* $550-600.

Detail.

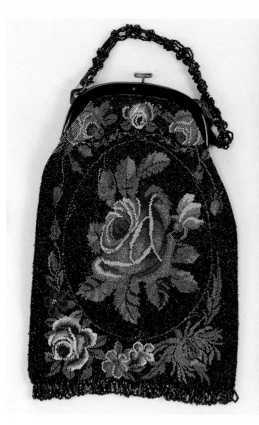

Roses, fine cut black and multi-color seed
beads, Bakelite frame, looped fringe, 12-inch
length. c. early 1900s. *Courtesy Paulette Batt.*
$550-600.

Detail.

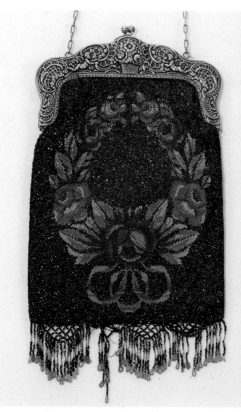

Floral wreath, iridescent blue and multi-color fine
seed beads, German silver frame with angels,
netted fringe, 13-inch length. c. early 1900s.
Courtesy Veronica Trainer. $450-500.

Detail.

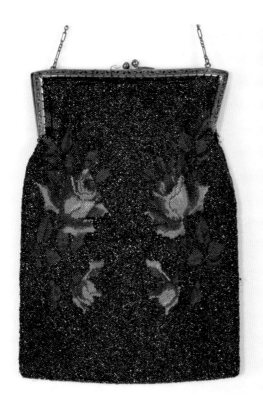

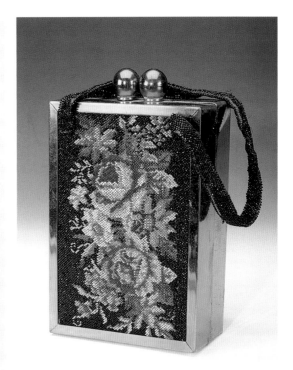

Roses, tambour embroidered on black lawn, cut black, yellow, green seed beads, brass frame, 11-inch length. c. early 1900s. *Courtesy Paulette Batt*. $400-450.

Roses, pansies, forget-me-nots, and daisies, tambour stitched on net, fine black cut and multi-color seed beads, brass box frame, crocheted beaded handle, 8-inch height. c. 1940s. *Courtesy Bunni Union*. $250-300.

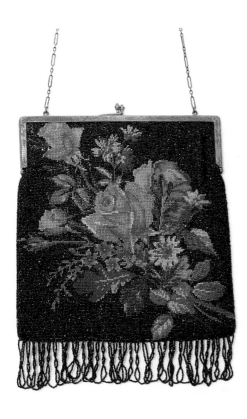

Roses, daisies, and blue flowers, fine cut black and multi-color seed beads, silver frame with blue sapphire cabochon clasp, entwined fringe, 9-inch length. c. early 1900s. *Courtesy Veronica Trainer*. $500-550.

Detail.

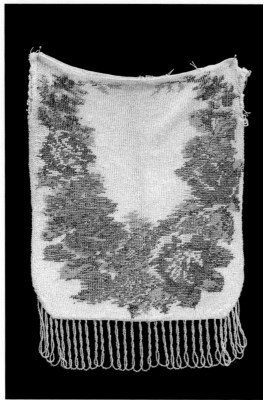
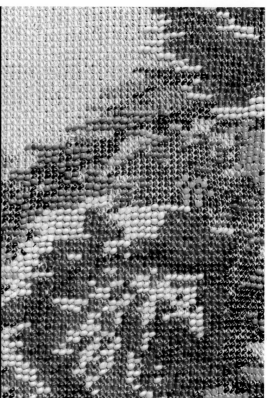

Roses, violets, and yellow and blue flowers, fine clear and multi-color seed beads, requires frame, entwined fringe, 9-1/2 inch length. c. early 1900s. *Author.* $350-400.

Detail.

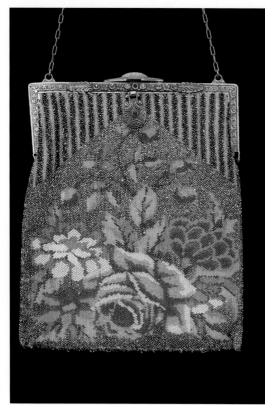

Rose, and blue and orange stylized flowers, silver cut-steel and fine multi-color glass seed beads, brass jeweled frame, 9-inch length. c. early 1900s. *Courtesy Ursuline College Historic Costume Study Collection.* $500-550.

Detail.

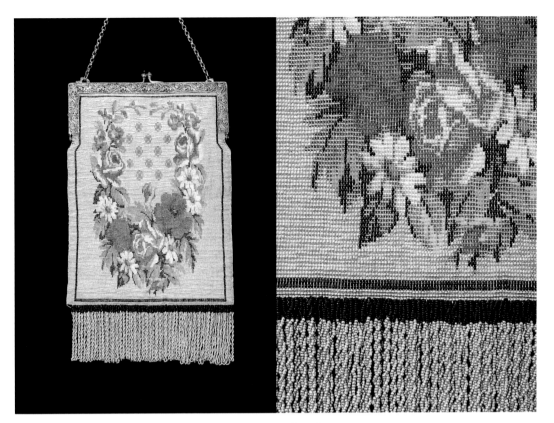

Daisies, roses, poppies, and violets, metal beads and fine multi-color glass seed beads, German silver filigree frame, sapphire cabochon clasp, twisted fringe, 14-inch length. c. early 1900s. *Courtesy Veronica Trainer.* $600-750.

Detail.

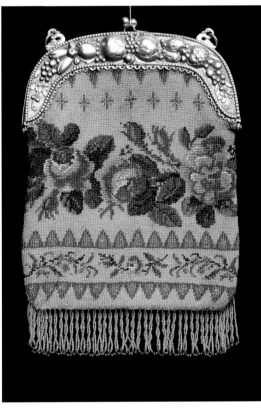

Roses, fine multi-color seed beads, German silver embossed frame, two swans, twisted entwined fringe, 11-inch length. c. mid-to-late 1800s. *Author.* $600-750.

Detail.

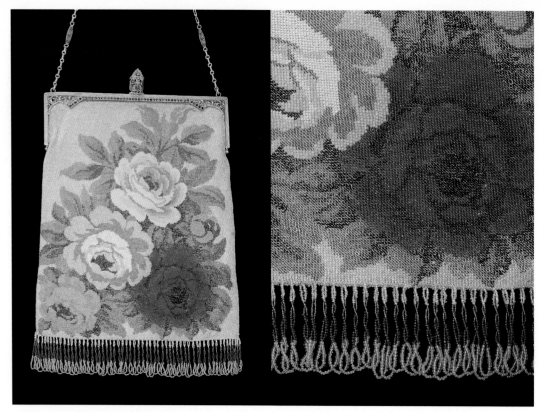

Roses, fine multi-color seed beads, jeweled Trinity plate filigree frame and chain, jeweled filigree clasp, twisted entwined fringe, 12-inch length. c. late 1800s to early 1900s. *Courtesy Veronica Trainer.* $650-800.

Detail.

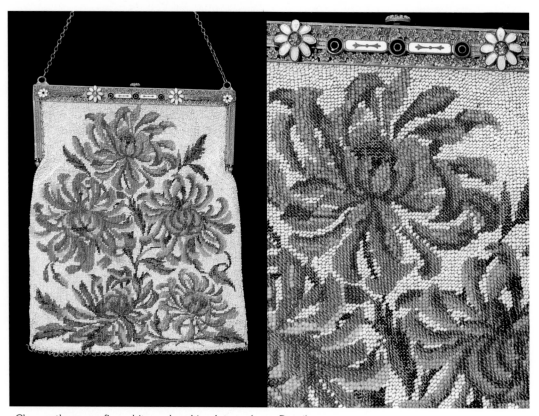

Chrysanthemum, fine white and multi-color seed beads, brass jeweled enameled frame, looped fringe, 10-inch length. c. late 1800s. *Courtesy Veronica Trainer.* $650-800.

Detail.

Chapter 8
Stylized Floral Bags

. . . a rose is a rose

Does a stylized floral pattern give a specific date to a purse?

The simplicity of the patterns, the size of the beads, and the style of the frame can all help date a beaded bag.

In the early twentieth century, beadwork again became popular. Women's needlecraft publications contained illustrations of the elaborate beaded bags of earlier centuries. As an example, the Priscilla Beadwork Book, originally published in 1912, shows black and white illustrations and instructions for beaded bags dated as early as 1760. In addition, "new" patterns were introduced that were easier for the amateur beadworker to make. The designs for these patterns, many of which are floral, have simpler lines, making the flowers difficult to identify.

Celluloid frames that appear to be original to the purse identify the item as from the turn of the nineteenth century. Also designs depicting a basket of flowers were popular at the turn of the century. Large sized beads, sometimes referred to as "Czech" beads, were imported in quantity during the 1920s.

For the most part, however, determining exact dates is almost impossible without some kind of documentation or exact comparison. The blue, drawstring bag with a basket of flowers surrounded by laurel leaves in this chapter could be a purse from the mid to late nineteenth century. For one thing, it is an early type of construction, made with small beads and fabric (silk) binding on the top to form the header with silk ribbon drawstrings. The floral pattern, despite its stylized appearance, is tempting to translate: bachelor buttons, pink roses, bay laurel leaves, and wreaths.

"I am hopeful for love. If you love me, I will show you my love. I will be true until death. Our love will give us glory."

Detail.

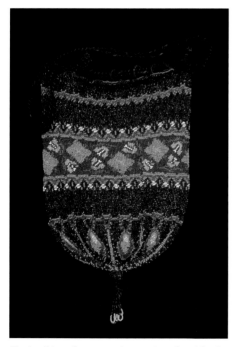

Embroidered on net, drawstring, fine black cut beads, maize, blue, and white seed beads, tassel, 8-inch length. c. mid 1800s. *Courtesy Anna Greenfield.* $125-175.

Detail.

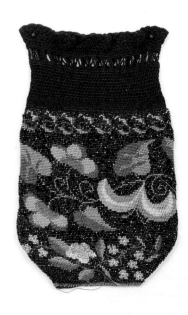

Crocheted, drawstring, fine black cut, golden steel, blue seed beads, 7-inch length. c. mid 1800s. *Author.* $100-150.

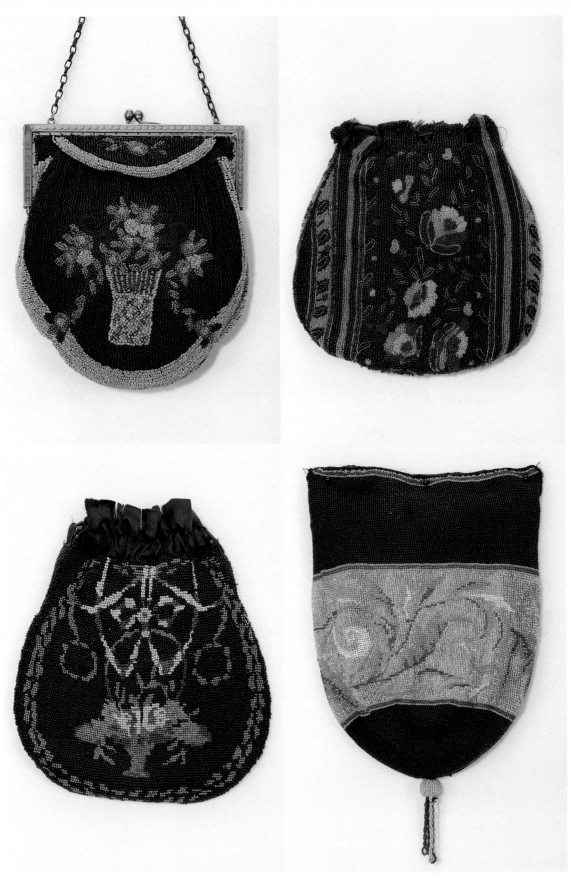

Top left: Embroidered on net, blue, beige and multi-color seed beads, floral basket, silver-tone frame, 7-inch length. c. early 1900s. *Courtesy Bunni Union.* $150-200.

Bottom left: Embroidered on net, drawstring, silk header, navy and multi-color seed beads, floral basket, 7-inch length. c. late 1800s. *Courtesy Bunni Union.* $150-175.

Top right: Embroidered on net, drawstring, blue, pink, brown, and green seed beads, 6-inch length. c. early 1900s. *Courtesy Bunni Union.* $100-125.

Bottom right: Knitted, fine blue, gray beads, unframed, twisted entwined tassel, 9-inch length. c. late 1800s. *Courtesy Bunni Union.* $150-175.

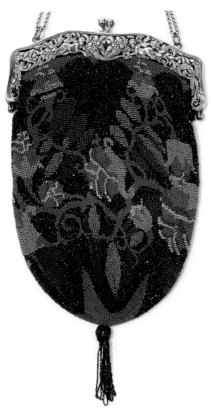

Knitted, fine black cut beads, brick, red, golden, and green seed beads, silver filigree frame with birds, mermaids, and cornucopia, looped tassel, 11-1/2 inch length. c. late 1800s. *Courtesy Veronica Trainer*. $275-350.

Detail.

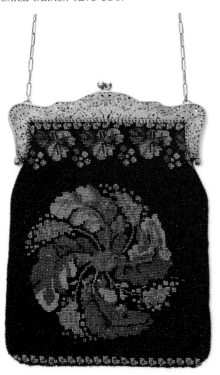

Knitted, black, lavender, rust, green, and yellow seed beads, German silver filigree frame with leaves and flowers, 9-1/4 inch length. c. late 1800s. *Courtesy Veronica Trainer* . $250-325.

Detail.

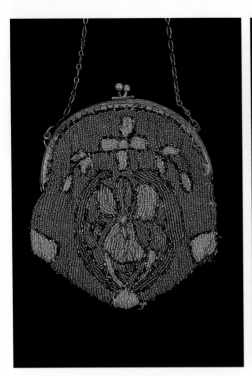

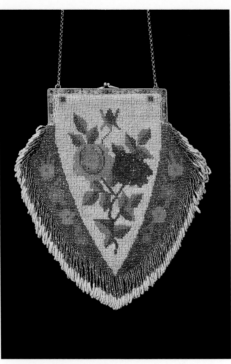

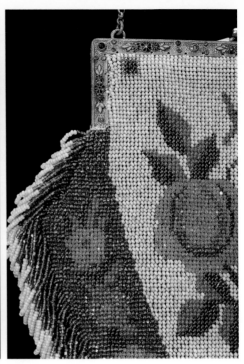

Embroidered on net, black bugles coral, green, blue, and pink translucent beads, brass frame, 4-inch length. c. early 1900s. *Courtesy Anna Greenfield.* $150-200.

Embroidered on net, fine red, golden cut beads, green, white, and lavender, seed beads, enamel brass and jeweled frame, 11-inch length. c. early 1900s. *Courtesy Veronica Trainer.* $350-400.

Detail.

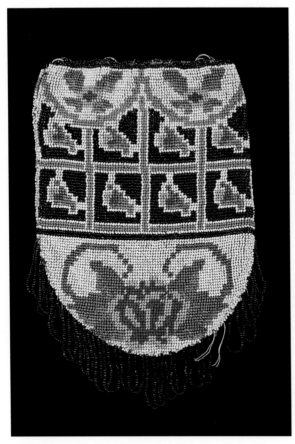

Embroidered, open weave cotton, black, white, blue, red, pink, and green seed beads, gold-tone and clear translucent beads, drawstring looped fringe, 8-1/2 inch length. c. late 1800s to early 1900s. *Courtesy Anna Greenfield.* $175-225.

Detail.

Top left: Embroidered and follows warp on open weave cotton, multi-color translucent and opaque beads, silver-tone frame, needle woven lattice pattern, hanging fringe, 14-inch length. c. early 1900s. *Courtesy Beth Ries.* $250-350.

Top right: Detail.

Center left: Knitted, fine pink translucent, pastel seed beads, sterling silver frame, looped fringe, 10-inch length. c. late 1800s to early 1900s. *Courtesy Veronica Trainer.* $850-900.

Center right: Detail.

Bottom leftr: Knitted, fine multi-color beads, gold rocailles, unframed, entwined fringe, 9-inch length. c. early 1900s. *Courtesy Veronica Trainer.* $250-350.

Bottom right: Embroidered on net, lavender, pink, and translucent beads, brass frame, looped fringe, 10-inch length. c. early 1900s. *Courtesy Bunni Union.* $200-275.

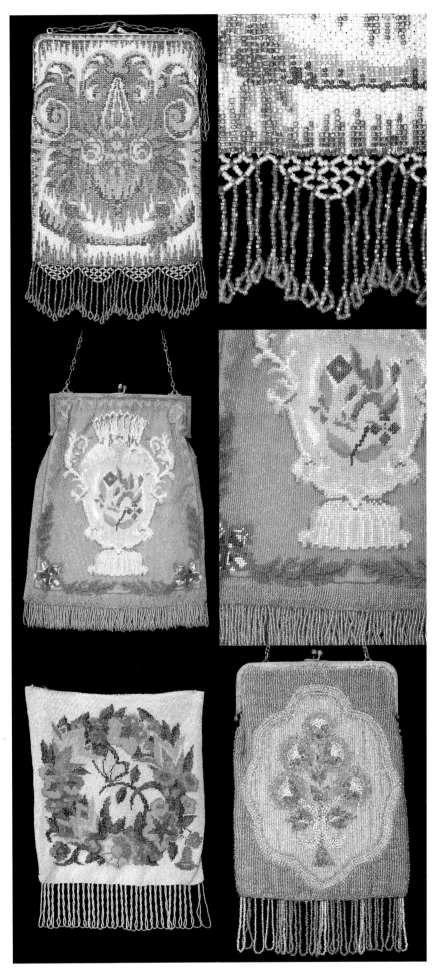

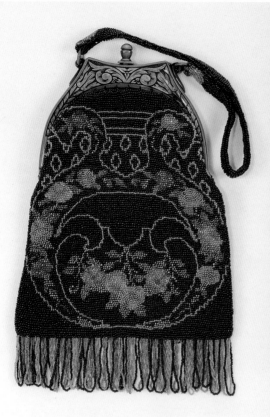

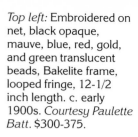

Top left: Embroidered on net, black opaque, mauve, blue, red, gold, and green translucent beads, Bakelite frame, looped fringe, 12-1/2 inch length. c. early 1900s. *Courtesy Paulette Batt.* $300-375.

Top right: Embroidered on net, orange, toast, and cream beads, Bakelite frame, 7-inch length. c. early 1900s. *Courtesy Emma Lincoln.* $200-250.

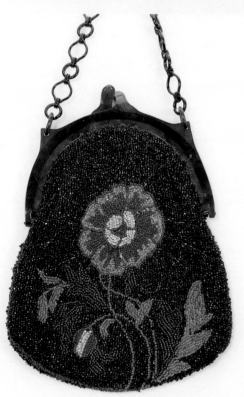

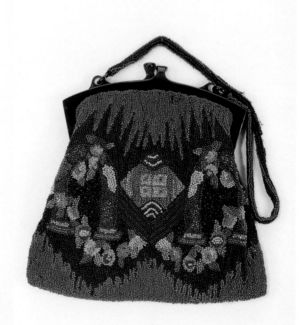

Bottom left: Embroidered on net, black cut, red, orange, and green translucent and opaque beads, Bakelite frame, 7-inch length. c. early 1900s. *Courtesy Bunni Union.* $200-250.

Bottom right: Embroidered on net, mauve and crystal cut beads, black, rust, blue, and yellow beads, Bakelite frame, 9-inch length. c. early 1900s. *Courtesy Paulette Batt.* $225-300.

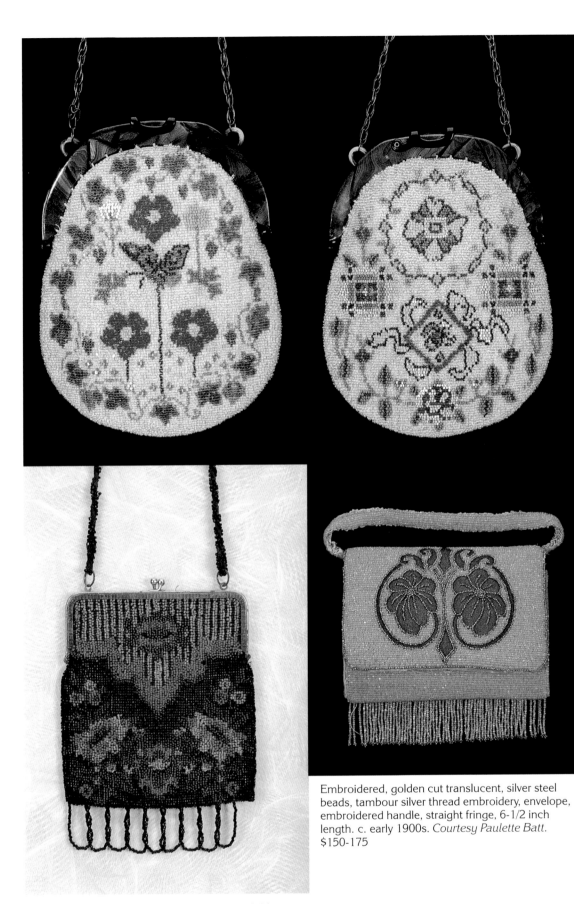

Top left: Embroidered on canvas, crystal, red, purple, and green translucent beads, yellow, blue, and white seed beads, Bakelite frame, 8-inch length. c. early 1900s. *Courtesy Paulette Batt.* $350-500.

Top right: Reverse side.

Embroidered, golden cut translucent, silver steel beads, tambour silver thread embroidery, envelope, embroidered handle, straight fringe, 6-1/2 inch length. c. early 1900s. *Courtesy Paulette Batt.* $150-175

Embroidered on net, black cut, golden, crystal, blue, and green translucent beads, silver-tone frame, entwined fringe, 9-inch length. c. early 1900s. *Courtesy Anna Greenfield.* $150-175.

Chapter 9
Birds on Bags

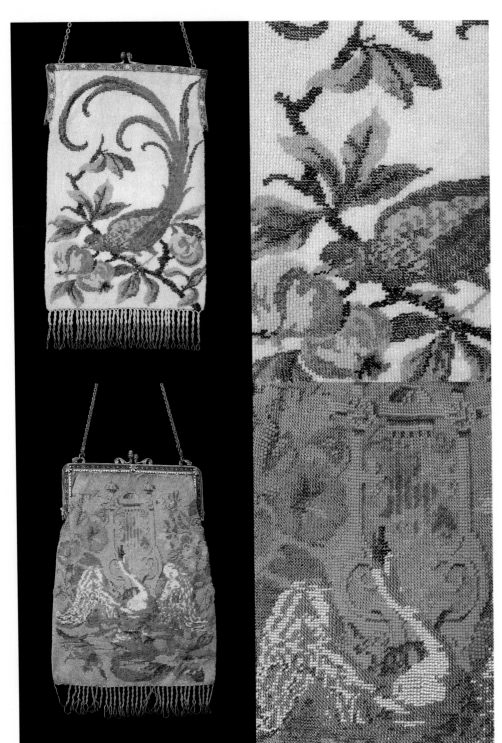

Top left: Knitted, fine crystal, and multi-color seed beads, long-tailed bird possibly Quetzal, brass enamel flowers with carnelian cabochon corners, twisted entwined fringe, 10-inch length. c. late 1800s. *Courtesy Veronica Trainer.* $600-850.

Top right: Detail.

Bottom left: Knitted, fine translucent green, and multi-color seed beads, swan and lyre, brass enameled frame with turquoise stones in clasp, twisted entwined fringe, 11-inch length. c. late 1800s. *Courtesy Veronica Trainer.* $600-850.

Bottom right: Detail.

*"Art thou the bird whom man loves best,
The pious bird with the scarlet breast,
Our little English robin?"*
from *The Redbreast Chasing the Butterfly*
by William Wordsworth, 1770-1850

Are designs of birds on bags prevalent?

Beaded bags with intricate and difficult designs of birds are difficult to find and should be considered treasures. All of the bags in this chapter are made with fine (tiny) Italian, French, or Bohemian beads. The items are estimated to date from the mid 1800s to the end of the nineteenth century.

In some cases, historical events and artistic movements had bearing on the designs that appeared. For example, Queen Victoria was proclaimed Empress of India in 1876. The peacock, which had been a favorite Indian motif, influenced many British artists, writers, and designers of the time, such as Walter Crane, a designer, artist, and writer or the late nineteenth century. James McNeill Whistler painted his famous "Peacock Room" in 1877. During this period, peacocks were used as designs on fabric, ceramics, room screens, needlework, and, shown in the examples here, on beaded purses.

Other birds created in beads can be described as "exotic," foreign, or unusual in their own right, such as the Quetzal of the first bag. The decorative arts of the nineteenth century combined a mixture of design influences, romantic, aesthetic, and exotic.

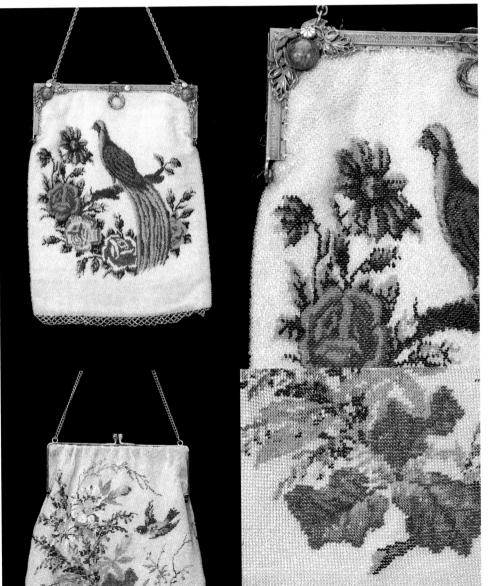

Top left: Knitted, fine cut crystal beads, bird of paradise, brass enameled frame, cabochon jade glass stones, woven net fringe, 10-inch length. c. late 1800s. *Courtesy Veronica Trainer.* $650-800.

Top right: Detail.

Bottom left: Knitted, fine crystal, and multi-color seed beads, finch in flight, brass frame with carnelian cabochon stones in clasp, twisted entwined fringe, 11-1/2 inch length. c. late 1800s. *Courtesy Bunni Union.* $500-550.

Bottom right: Detail.

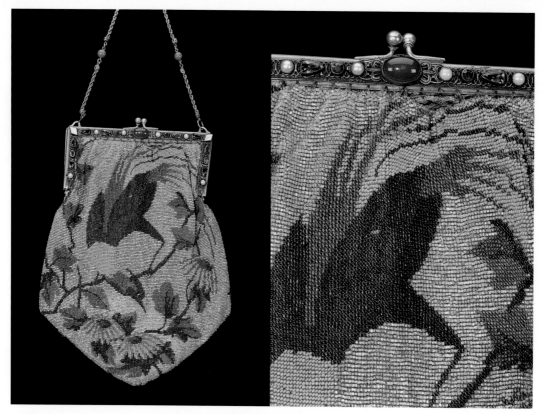

Knitted, fine cut crystal, yellow, green, and purple
seed beads, exotic bird, brass enameled, jeweled
frame, bead on handle, 10-inch length. c. late
1800s. *Courtesy Veronica Trainer.* $700-850.

Detail.

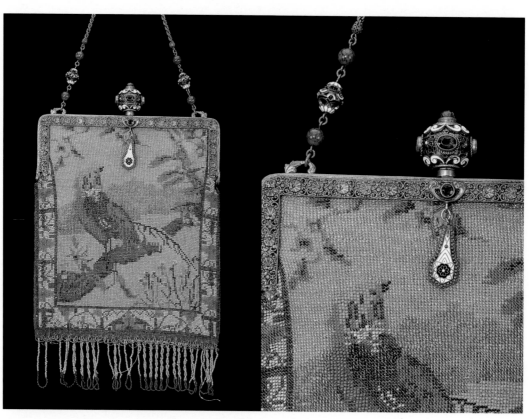

Knitted, multi-color seed beads, red-breasted bird,
brass enameled, jeweled frame and handle,
twisted entwined fringe, 10-inch length. c. late
1800s. *Courtesy Veronica Trainer.* $700-850
(if restored, $1000).

Detail.

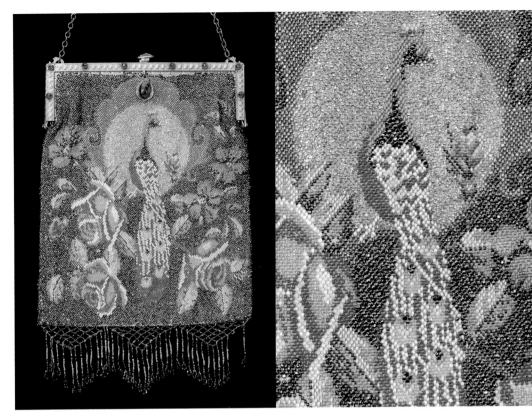

Knitted, fine cut black, and multi-color seed
beads, peacock, brass jeweled frame and clasp,
netted and hanging fringe, 12-inch length.
c. late 1800s. *Courtesy Veronica Trainer.*
$700-850 (if restored, $1000).

Detail.

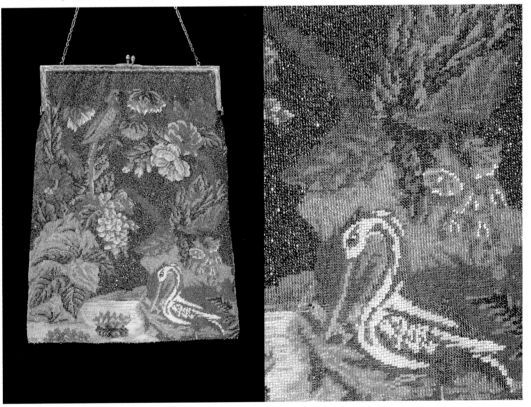

Knitted, fine cut black, and multi-colored seed
beads, crane and bird of paradise at a lily pond,
silver plated frame, 10-inch length. c. late
1800s. *Courtesy Veronica Trainer.* $850-1000.

Detail.

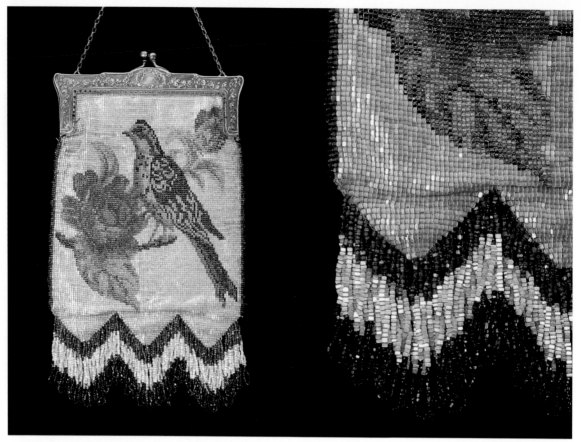

Knitted, mother-of-pearl, cut, and multi-color beads, bird on a perch, German silver frame, chevron looped fringe, 14-inch length. c. late 1800s. *Courtesy Veronica Trainer*. $850-925.

Detail.

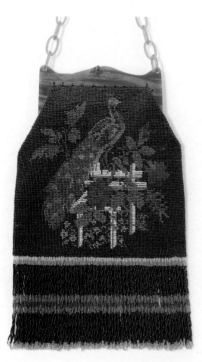

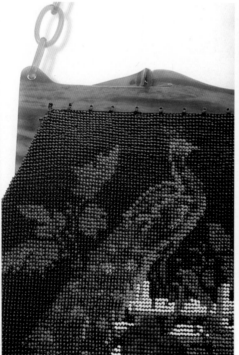

Knitted, black, multi-color opaque, and translucent seed beads, peacock on a white fence, Bakelite frame and handle, 3-1/2 inch length. c. early 1900s. *Courtesy Veronica Trainer*. $650-800.

Detail.

Detail.

Chapter 10
Figures on Bags

"[The Victorian] designers who stood in awe of tradition dipped indiscriminately into all of them: They filched from the Egyptian, the Greek and Roman. They borrowed from the Byzantine, the Saracenic and the Gothic, and appropriated wholeheartedly from the Renaissance..."
from *Decorative Art of Victoria's Era*
by F. Lichten

Did the bags with masculine themes have a specific purpose?

The first four bags illustrated in this chapter have "masculine" themes—farming, hunting, equestrian, and smoking. These bags or pouches were made by the Victorian woman specifically for her man to store and carry tobacco. Queen Victoria commissioned paintings and prints to memorialize the accomplishments of her beloved Prince Albert as a hunter. The pouch featuring a hunter aiming his gun at birds in flight on one side and a captured stag on the other may have been influenced by the artistic themes of the time. All of these pouches are from the early nineteenth century. Bags with similar designs can be found in museum collections.

The bag with the turban donned, cross-legged, long pipe-smoking gentleman is most unique. The Turkish theme on this tobacco pouch may have been inspired by the cultural exchange that occurred when Great Britain allied with Turkey to fight the Crimean War, 1853-1856.

What are some of the other "themes" depicted on these purses?

Notice the drawstring bag with the black beaded background and white bead figures. Each side of this purse shows a familiar fairy tale scene, one of *Cinderella* trying on the glass slipper and the other of *Sleeping Beauty* in her canopy bed with the prince approaching to wake her with a kiss.

Two of the most beautiful bags shown in this book are seen in this chapter. Knitted from the finest Italian seed beads, both bags depict women at work, who are dressed in eighteenth-century fashions. In one, a woman is at an open window busy at a spinning wheel. A white bird has landed on the window seat next to her, coaxed by the plate of food or water that she has set out for it.

The design of the second bag beautifully depicts the roles of mother and laborer. It shows two women and a child. The woman in the foreground, dressed in a wonderful, intricate plaid skirt, looks toward the wheat field and sharpens her scythe at the grinding wheel. The other woman holds a child. Other designs in this chapter portray mythical, biblical, and romantic themes.

What are the young women doing in the last three bags in this chapter?

The last three bags feature two young girls, arm in arm, dressed in eighteenth-century costume (often found on beaded bags in the middle to the late nineteenth century). Some collectors call them "The Butterfly Hunters." A close examination, however, and a comparison with Victorian prints and etchings, suggests that the two have been canoeing and are taking a spirited stroll in the woods collecting flowers for their hair. The object that one of the maidens is carrying over her shoulder (judging from its shape and the fact that it is decorated with a pattern) might better be identified as an oar or paddle.

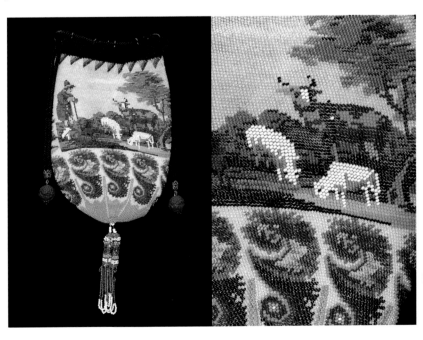

Knitted, crocheted header, fine multi-color seed beads, farmer with dog, goat, sheep, and cow, rosewood beads on drawstring, woven tassel with looped fringe, (possibly tobacco pouch), 8-1/2 inch length. c. early-to-mid 1800s. *Courtesy Veronica Trainer.* $600-800.

Detail.

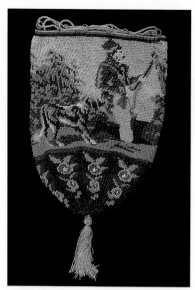

Knitted, ribbon header, fine multi-color seed beads, soldier with gun, dog in foreground, drawstring, silk tassel, (possibly tobacco pouch), 9-inch length. c. early-to-mid 1800s. *Courtesy Veronica Trainer*. $600-800.

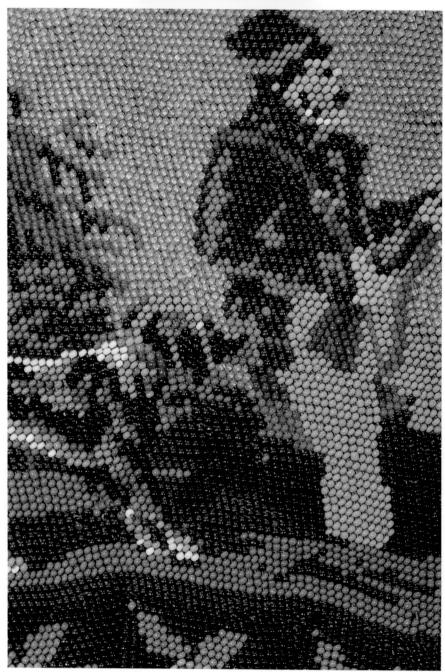

Detail.

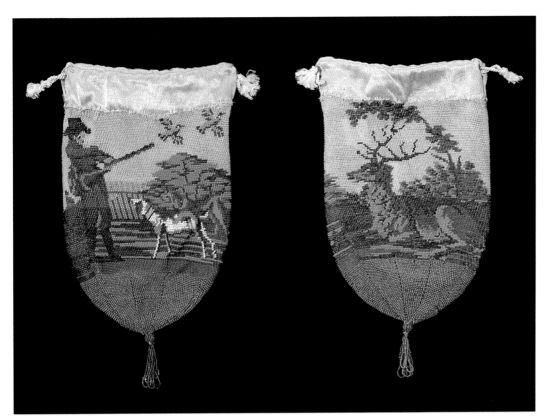

Left: Knitted, silk header, fine multi-color seed beads, *Jäger* huntsman with gun, two dogs in foreground, two game birds in flight, silk drawstring, looped beaded fringe, (possibly tobacco pouch), 9-inch length. c. early-to-mid 1800s. (Similar bag in Victoria and Albert Museum, London, England). *Courtesy Veronica Trainer.* $600-800.

Right: Detail.

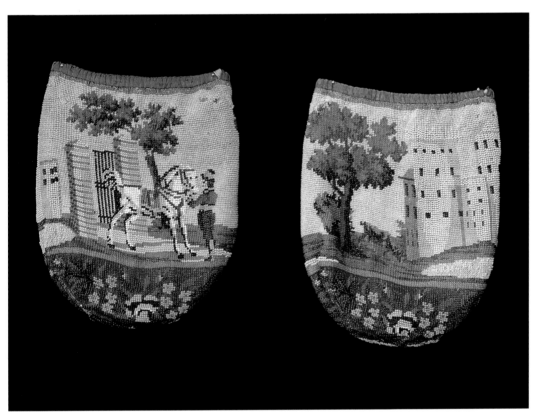

Knitted, ribbon header, fine multi-color seed beads, French pink château, iron, gate, white horse, stableman, drawstring, 7-inch length. c. early-to-mid 1800s. *Courtesy Veronica Trainer.* $600-800.

Reverse side: chateau and goat.

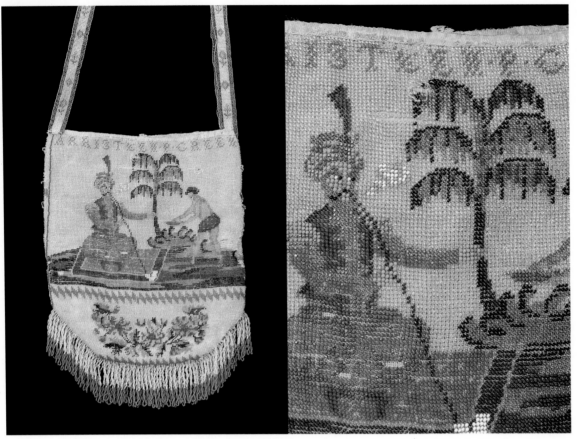

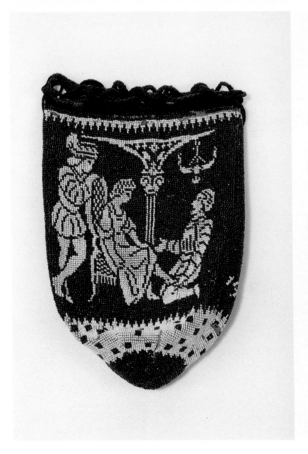
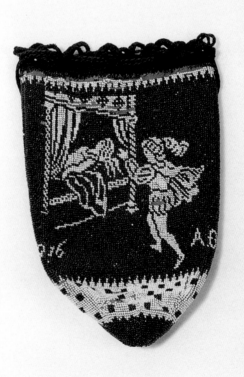

Top left: Embroidered on silk, fine multi-color seed beads, sultan sitting on a carpet with Turkish hashish pipe, servant in foreground, palm tree in background, letters on front, woven bead handle, twisted entwined fringe, (possibly tobacco pouch), 10-inch length. c. mid-to-late 1800s. *Courtesy Veronica Trainer.* $600-850.

Top right: Detail.

Bottom left: Embroidered, open weave cotton, crocheted header, fine black and white seed beads, fairy tale depicting glass slipper, prince, page, and girl, drawstring, "AD 1916" worked in beads, 7-inch length. c. early 1900s. *Courtesy Veronica Trainer.* $500-600.

Bottom right: Reverse side: fairy tale depicting sleeping girl on canopy bed, prince approaching.

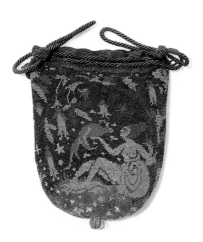

Knitted, drawstring, crocheted header, fine multi-color seed beads, reclining nude holding red bird, missing tassel, 7-inch length. c. early 1900s. *Courtesy Veronica Trainer.* $400-550.

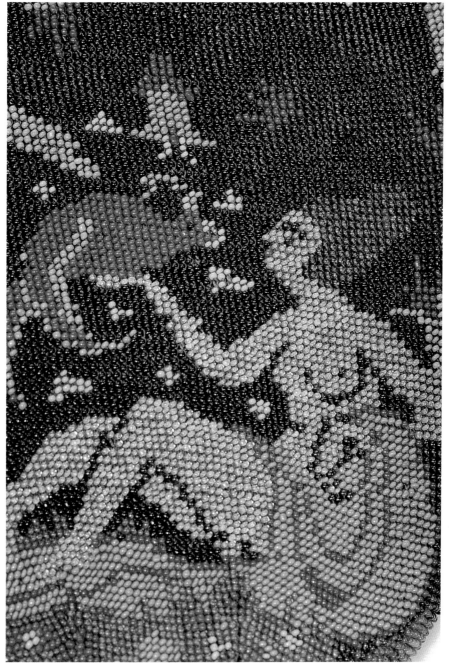

Detail.

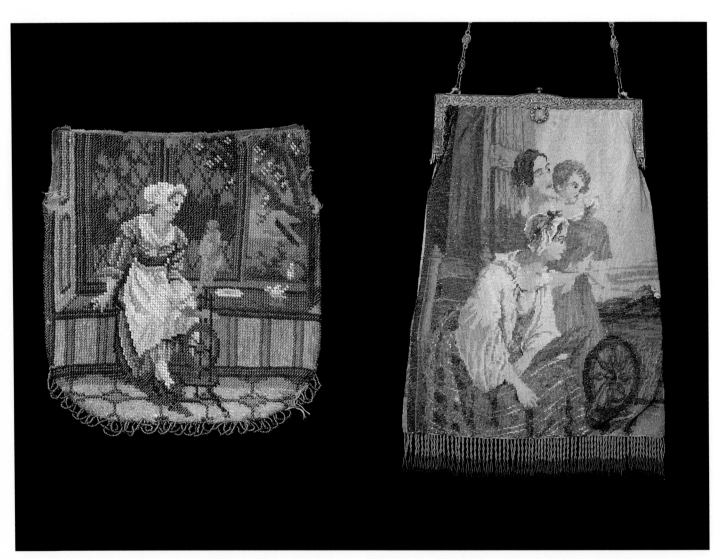

Embroidered, fine translucent, opaque seed beads, spinning wheel, lady sitting in a window seat, white bird has come through an open window to feed from a white tray, unframed, looped fringe, 9-inch length. c. mid-to-late 1800s. *Courtesy Veronica Trainer.* $600-850.

Knitted, fine seed beads, woman in a plaid skirt sharpening a scythe at a grinder, woman holding a child, wheat field, and mountain with snow cap in background, brass frame, twisted entwined fringe, 13-inch length. c. mid-to-late 1800s. *Courtesy Veronica Trainer.* $1200-1500.

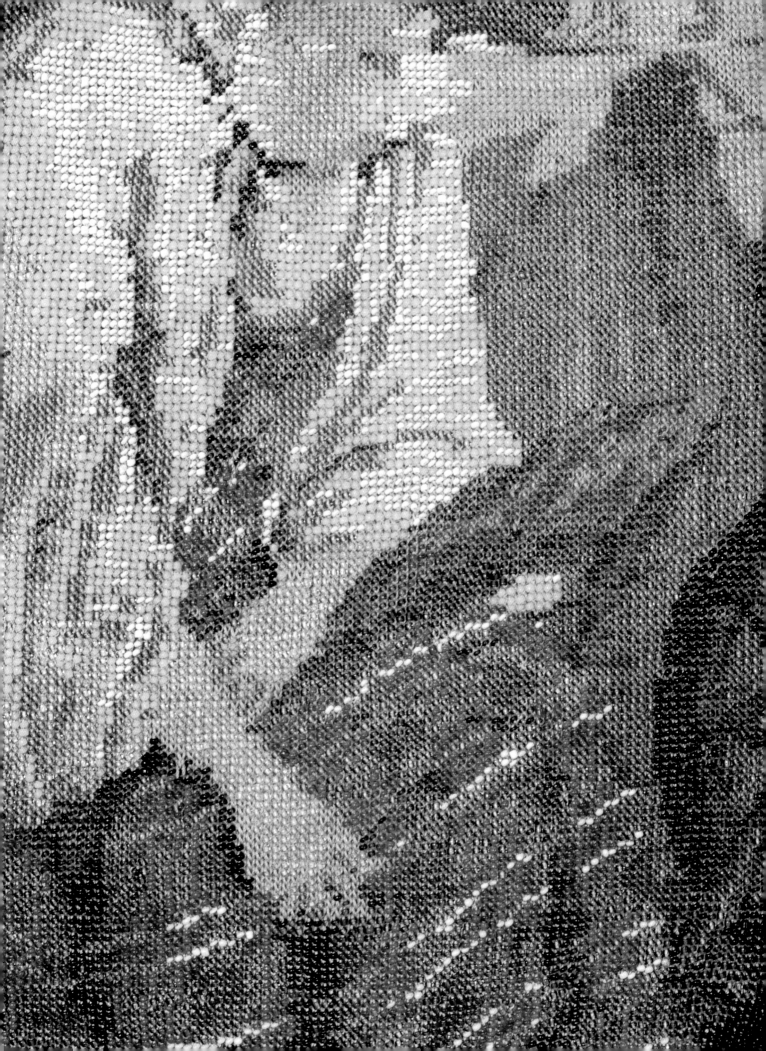

Knitted, fine multi-color beads, streets of Switzerland, a woman and girl with gold braids in foreground, soldier and mountain in the background, coat of arms over door, fountain in right corner, brass frame and handle with cabochon jade, ruby glass stones, twisted entwined fringe, 11-inch length. c. mid-to-late 1800s. *Courtesy Veronica Trainer.* $1000-1200.

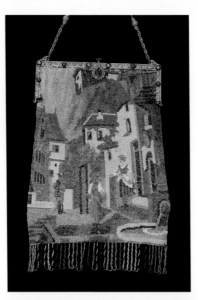

Detail.

Detail.

Knitted, fine multi-color French cut-steel beads, canoe paddle over the shoulder of girl strolling with friend, carved swan on the front of the canoe, water in the background, brass frame and handle, chevron fringe, 12-inch length. c. mid-to-late 1800s. *Courtesy Bunni Union*. $600-800.

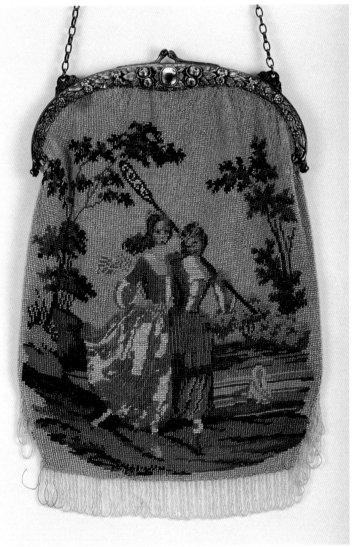

Knitted, fine multi-color glass seed beads, canoe paddle over the shoulder of girl strolling with friend, carved swan on the front of the canoe, water in the background, silver frame, twisted entwined fringe, 11-inch length. c. late 1800s. *Courtesy Ruth G. Kyman*. $600-800.

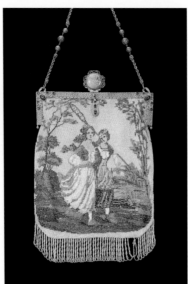

Knitted, fine multi-color seed beads, canoe paddle over the shoulder of girl strolling with friend, carved swan on the front of the canoe, brass jeweled frame and clasp, jade and carnelian cabochons, twisted entwined fringe, 10-inch length. c. late 1800s. *Courtesy Veronica Trainer.* $750-800.

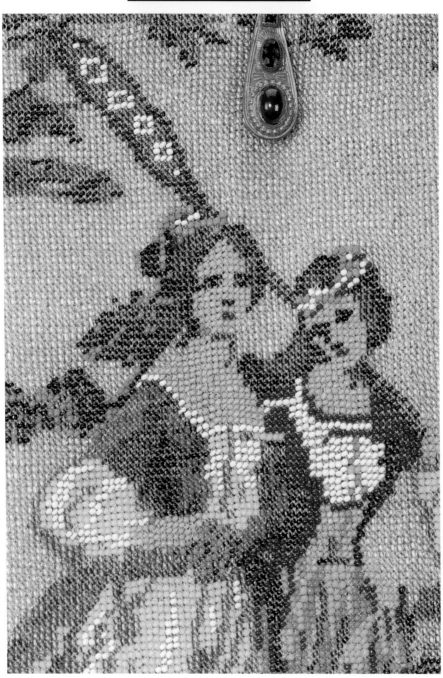

Detail.

Knitted, fine multi-color seed beads, desert scene with woman drawing water from a well, man with a hook staff resting by the well, palm trees in foreground, oasis and mountain in the background, sterling silver frame, twisted entwined fringe, 11-inch length. c. late 1800s to early 1900s. *Courtesy Ruth Marcus.* $1200-1500.

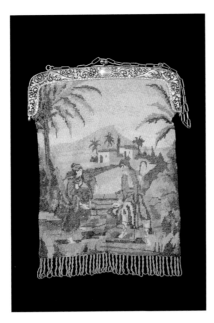

Detail.

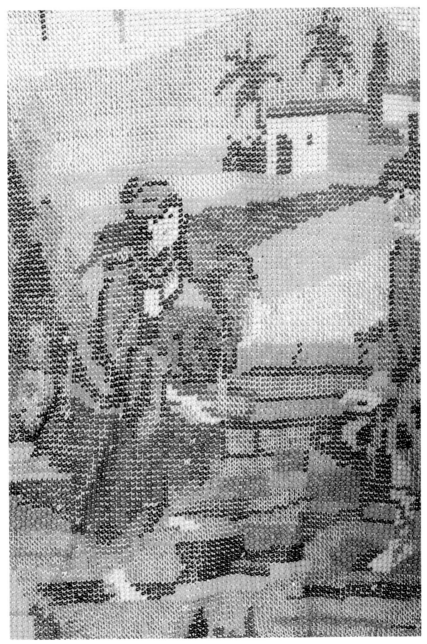

Detail.

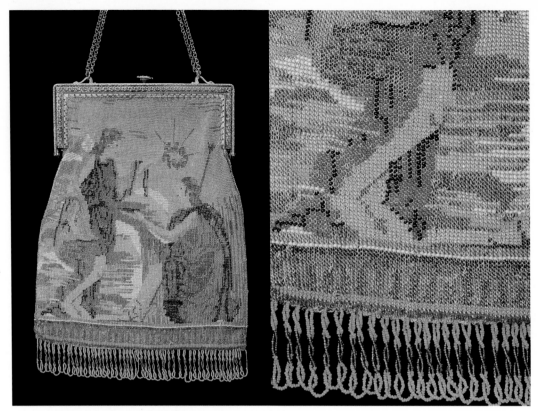

Knitted, fine multi-color seed beads, angel in blue robe presenting a victory garland of laurel, man on one knee with trident staff offering up a gift, brass frame, entwined looped fringe, 11-inch length. c. late 1800s. *Courtesy Veronica Trainer.* $850-1000.

Detail.

Knitted, fine multi-color seed beads, peasant woman with basket, beside open hearth and hanging kettle, feeding pigeons through an open window, brass frame with water lily, 10-inch length. c. late 1800s. *Courtesy Veronica Trainer.* $850-1000.

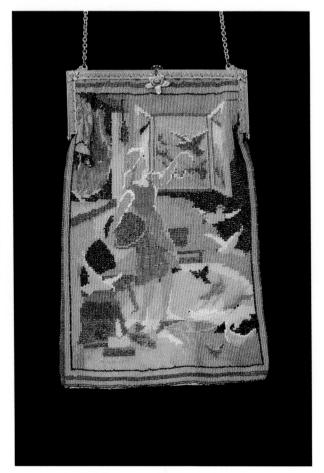

Opposite page: Detail.

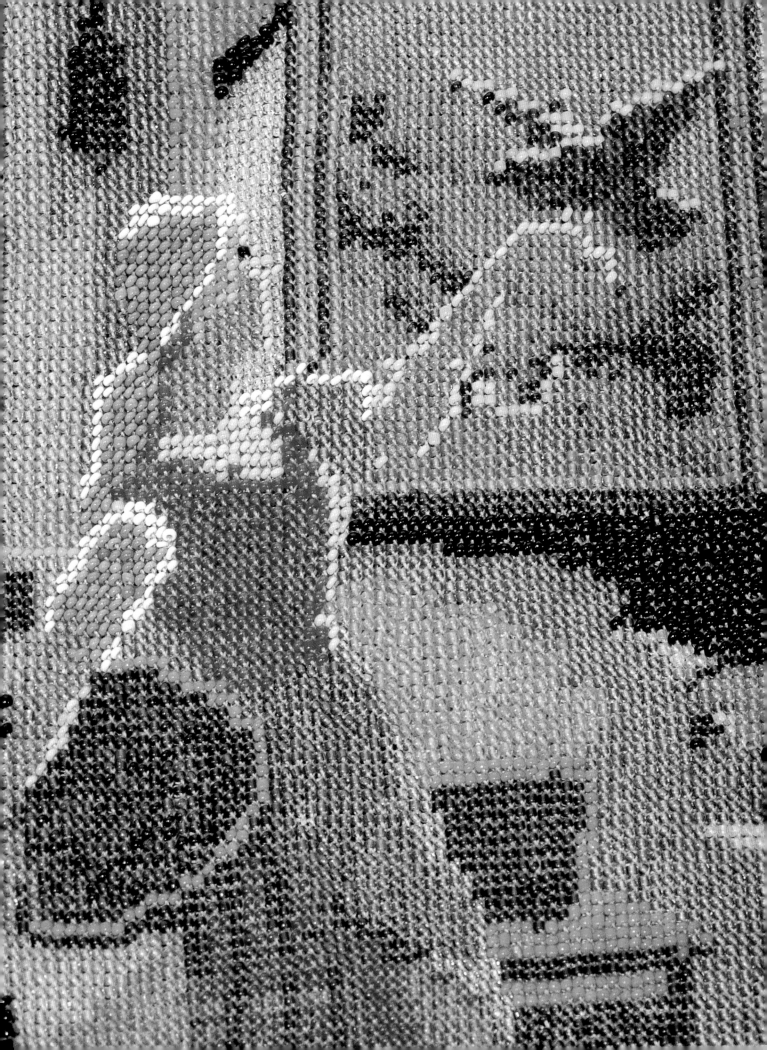

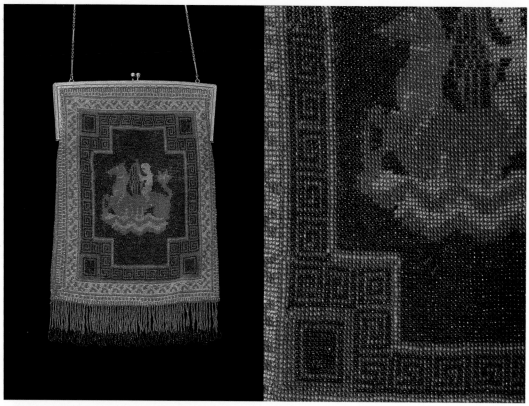

Knitted, fine brick red, pink, black, and crystal seed beads, mythological figure (possibly boundary between life and death), brass frame, entwined fringe, 11-inch length. c. late 1800s to early 1900s. *Courtesy Veronica Trainer.* $600-800.

Detail.

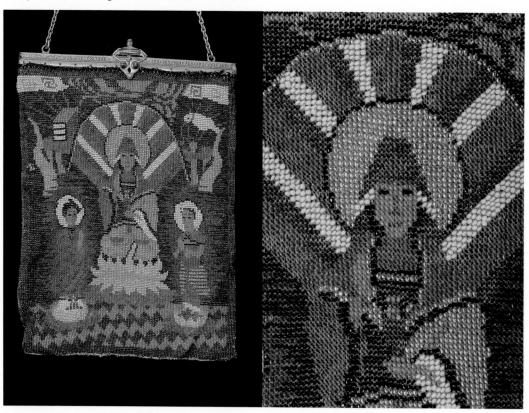

Knitted, fine multi-color seed beads, Egyptian ruler sitting on throne holding symbols of power, shepherds' crook and the grain flail indicating his authority over agriculture and animal husbandry, two servants in foreground, hinged brass frame opens to a square, 11-inch length. c. late 1800s to early 1900s. *Courtesy Veronica Trainer.* $1200-1500.

Detail.

Opposite page: Detail.

Chapter 11
Courting on Bags

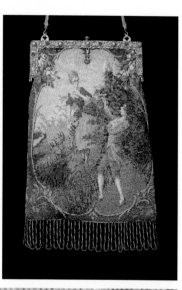

Knitted, fine multi-color seed beads, woman with ewe and lamb on a hillside, man offering fruit in foreground, eighteenth-century costume, brass jeweled frame, entwined looped fringe, 12-inch length. c. mid-to-late 1800s. *Courtesy Veronica Trainer.* $800-1000.

"Etiquette of Courtship: . . . Any gentleman who may continuously give special, undivided attention to a certain lady, is presumed to do so because he prefers her to others . . . It is also expected that the lady will herself appreciate the fact, and her feelings are likely to become engaged. Should she allow an intimacy thus to ripen upon the part of the gentleman, and to continue, it is to be expected that he will be encouraged to hope for her hand . . ."
from *Hill's Manual of Social and Business Forms,* chapter entitled "Courtship and Marriage," by T. E. Hill, 1882

Why are the courting figures of Victorian bags dressed in costumes from previous eras?

The Victorian ideal was to achieve a "gentility" of behavior and manner. Women admired the rich elegance of the prior centuries and incorporated these "old fashioned" costumes into their needlework. The decorative arts, furnishings, and fancywork of the nineteenth century were influenced by a number of historic cultural traditions. Two favorite themes were the Italian Renaissance period and that of Louis XIV in France—done to excess!

In a quest for "gentility," and social status the daughters of *nouveau riche* adapted an attitude of disdain for household affairs. A servant was a necessity, even in the most financially average families. These young maidens "got above themselves," or put on airs, as the familiar saying of the time put it. Sentimental novels helped to inspire romantic imaginations and books such as *Hill's Manual of Social and Business Forms* (quoted above), and periodicals such as *Godey's Lady's Book,* published monthly from 1837 to 1877, provided guidance and served as authorities in situations regarding taste, culture, and behavior.

Detail.

Knitted, fine multi-color seed beads, gentleman with a walking stick, arm in arm with woman conversing with the man, sleeve with lace ruffle engageantes, both figures wearing wigs, swans on pond, gazebo "onion" dome tower in background, early eighteenth-century costume, brass jeweled frame, entwined looped fringe, 14-inch length. c. mid-to-late 1800s. *Courtesy Veronica Trainer.* $800-1200.

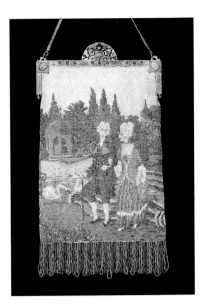

Detail.

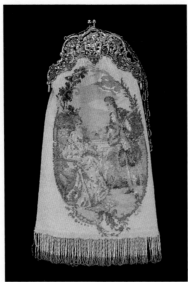

Knitted, fine multi-color seed beads, woman sitting in a chair, floral print gown, sleeve with lace ruffle engageantes, man playing a mandolin, blue sky and pond in the background, early eighteenth-century costume, silver frame with cherubs, entwined looped fringe, 14-inch length. c. mid-to-late 1800s. $800-1200.

Detail.

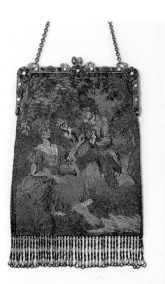

Knitted, fine multi-color seed beads, woman sitting on the ground, polonaise country-inspired overskirt, man on bended knee presents a nosegay bouquet and fruit, forest setting, early eighteenth-century costume, brass jeweled frame, carnelian cabochon stones, entwined looped fringe, 10-1/4 inch length. c. mid-to-late 1800s. *Courtesy Veronica Trainer.* $800-1000.

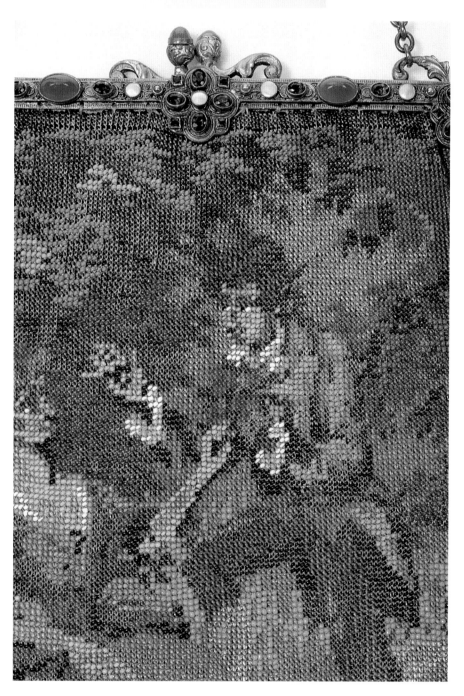

Detail.

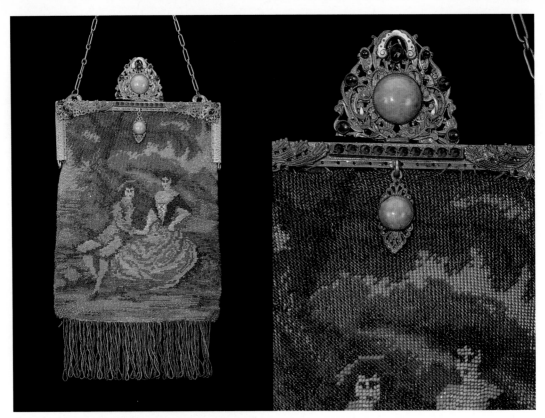

Knitted, fine multi-color seed beads, man wearing waistcoat, breeches, soft hat, woman wearing stomacher bodice and billowing skirt, sitting under a tree holding hands, early eighteenth-century costume, jeweled brass frame, entwined looped fringe, 12-inch length. c. mid-to-late 1800s. *Courtesy Veronica Trainer.* $800-1000.

Detail.

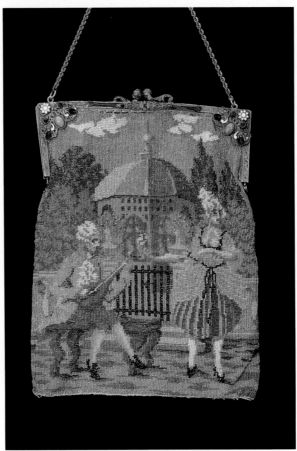

Knitted, fine multi-color seed beads, man wearing waistcoat, jabot, breeches, playing a mandolin, woman by black iron garden gate, both wearing wigs, orangeré (glass gazebo for growing oranges) in background, early eighteenth-century costume, enameled brass frame with jewels, 9-1/2 inch length. c. mid-to-late 1800s. *Courtesy Veronica Trainer.* $800-1000.

Opposite page: Detail.

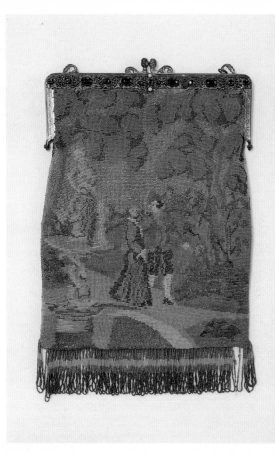

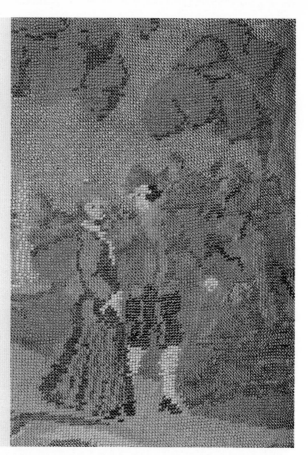

Top left: Knitted, very fine multi-color seed beads, man wearing waistcoat, breeches, soft hat, walking stick, woman wearing lace bodice and sleeve, couple strolling on garden path, statue in a fountain, eighteenth-century costume, brass jeweled frame, entwined looped fringe, 10-inch length. c. mid-to-late 1800s. *Courtesy Lenore Hollander Bletcher.* $800-1000.

Top right: Detail. Approximately 500 beads per square inch.

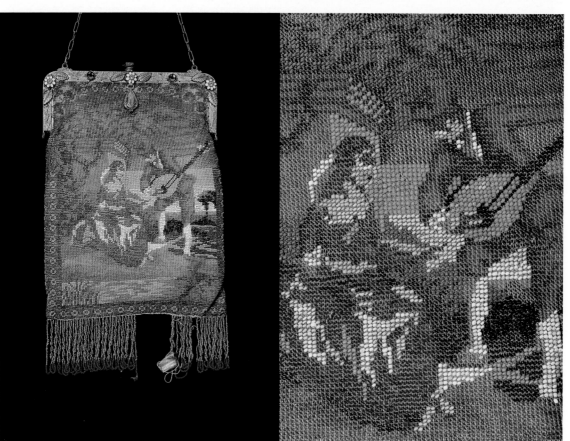

Bottom left: Knitted, fine multi-color seed beads, serenade, woman sitting on the ground near a pillar, man leaning playing the mandolin, eighteenth-century costume, brass jeweled and enameled frame with leaves, entwined looped fringe, 10-1/2 inch length. c. mid-to-late 1800s. *Courtesy Veronica Trainer.* $800-1000.

Bottom right: Detail.

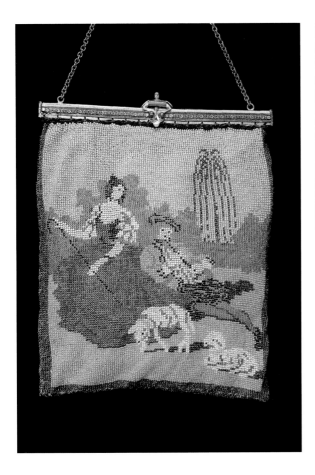

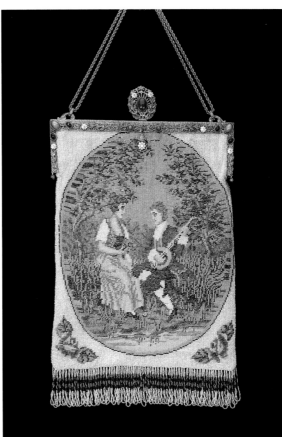

Top left: Knitted, fine multi-color seed beads, woman tending lambs, man playing flute, fountain in background, eighteenth-century costume, brass four corner opening frame, 8-3/4 inch length. c. mid-to-late 1800s. *Courtesy Veronica Trainer.* $800-1000.

Top right: Knitted, fine multi-color seed beads, woman seated at water's edge, holding a small bouquet, man seated beside her playing the mandolin, sky and trees in background, eighteenth-century costume, brass enameled and jeweled frame, fringe, 12-inch length. c. mid-to-late 1800s. *Courtesy Veronica Trainer.* $1000-1200.

Detail.

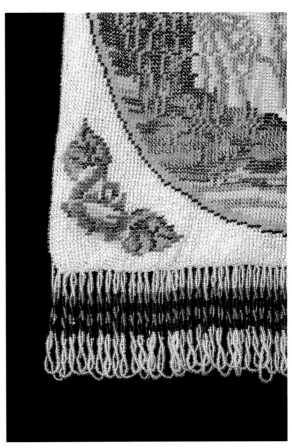

Detail.

Chapter 12
Venice on Bags

"A man who has not been in Italy, is always conscious of an inferiority."
from *Letter to Sir Joshua Reynolds, 11 April 1776,* by Samuel Johnson, 1709-1784

Of all the cities of the world, why is Venice, Italy, one of the few to have its scenes so easily recognized on beaded bags?

Venice has captured the imagination of tourists for hundreds of years because of the romance of its canals, bridges, and *palazzos*. For centuries, the islands of Venice and the neighboring island of Murano have been the recognized center of glassmaking. It is not surprising then that glass beaded bags with scenes of Venice exist, but rather how few of them there are and how little is known about the beadworkers who made them. Because these bags are very difficult to find, they are highly prized.

In the late nineteenth and the early twentieth century, American firms commissioned the production of Italian bags made of fine beads from glassmakers in Italy. A brochure from the Venetian G. Grilli glass factory, established in 1902, in Murano, Italy, refers to the manufacturing of *"...frangie, fiori, chincaglieria diversa in perle venetian,"* which translates to "Venetian beaded fringes, bead flowers, and various beaded knickknacks." (The publication is dated "the Grilli factory's twenty-second year of business," or 1924.) It also cites the factory's specialization in the production of beaded trims, decorations, and embellishments. In particular, reference is made to the production of ladies' beaded belts (*cinture*) and beaded handbags (*borse*). These beaded items were made up in the homes of women skilled in beadwork who were paid by the piece to complete a belt or a purse.

Most of the bags of fine Italian (Venetian) beads illustrated in this book were probably made during the nineteenth century, or at the very latest, the first decade of the twentieth century. The knitters and beadworkers who made these beautiful and intricate patterns, with such tiny beads, in such even stitches, were individuals who worked in their homes. Now long gone, any information about them and the tiny glass beads they fashioned into art is covered by dust somewhere in Venice.

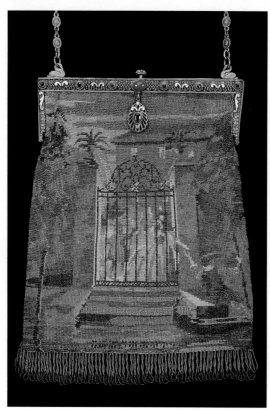

Knitted, fine multi-color seed beads, The Brenta Canal near Venice, Italy, *signorina* passing a message through the iron gate to a gondolier for delivery to her lover, male figure and villa in the background, eighteenth-century costume, brass enameled and jeweled frame, entwined looped fringe, 12-inch length. c. mid-to-late 1800s. *Courtesy Madelyn Winfield.* $1200-1500.

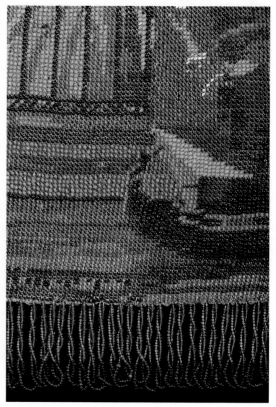

Detail.

Opposite page: Detail.

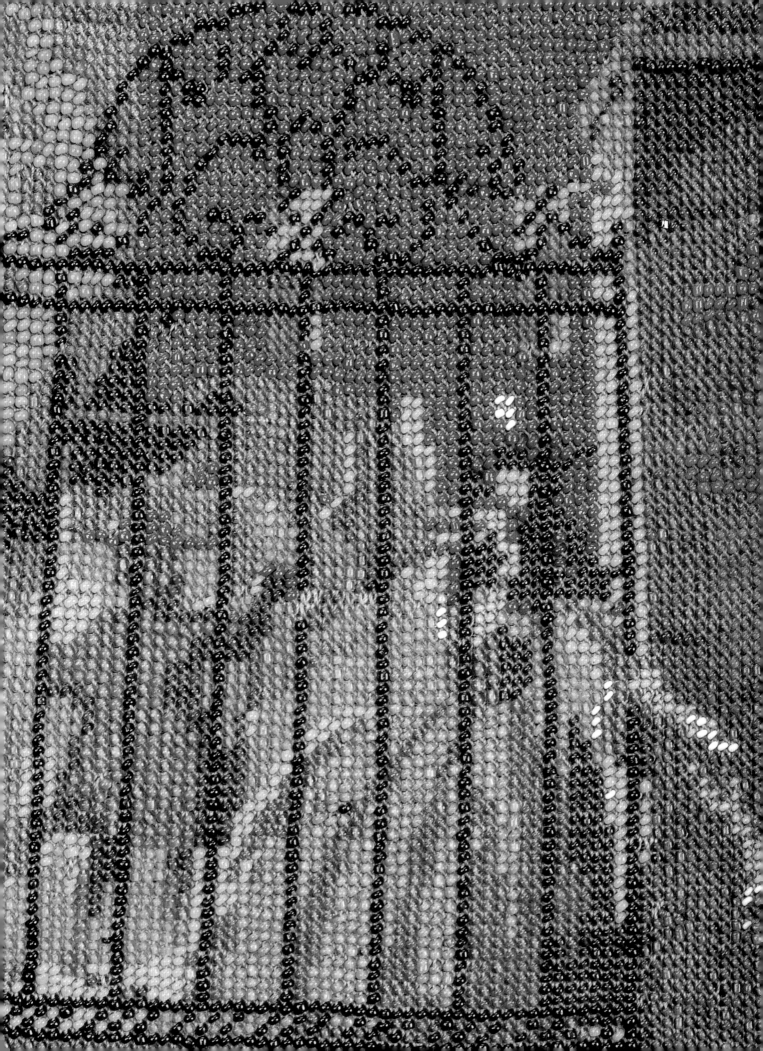

Knitted, fine multi-color seed beads, Rialto Bridge, Grand Canal, Venice, Italy, old covered gondola with a gondolier, brass frame, fringe, 12-inch length. c. mid-to-late 1800s. *Author.* $1200-1500.

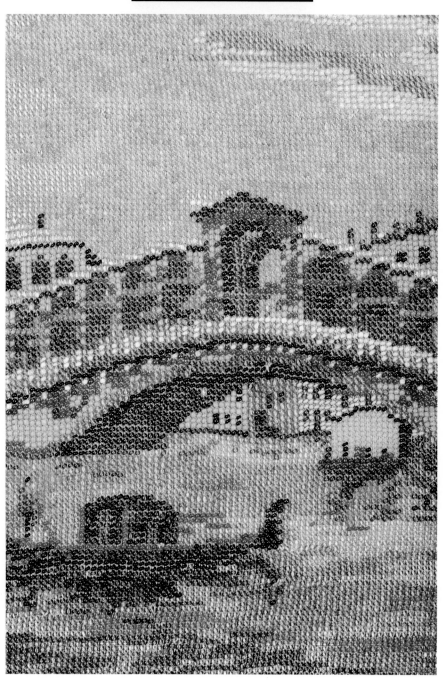

Detail.

Knitted, fine multi-color seed beads, Grand Canal, Palace of the Doge, Venice, Italy, open gondola with a gondolier, church of Santa Maria della Salute in the background, silver-tone frame, 10-inch length. c. late 1800s. *Courtesy Frankie Winfield.* $1200-1500.

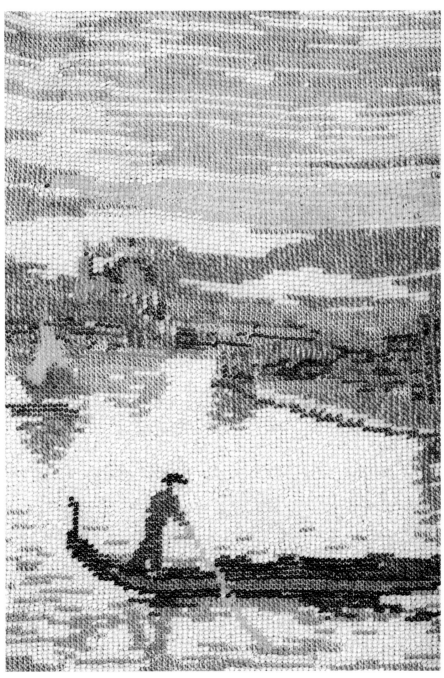

Detail.

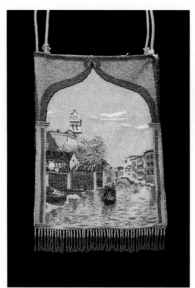

Knitted, fine multi-color seed beads, silk cord handles, small canal off Piazza San Marco, (Saint Mark's Square), Venice, Italy, covered gondola and gondolier, small walking bridge, Campanile bell tower in the background, silk cord frame, fringe, 11-1/4 inch length. c. mid-to-late 1800s. *Courtesy Veronica Trainer.* $1200-1500.

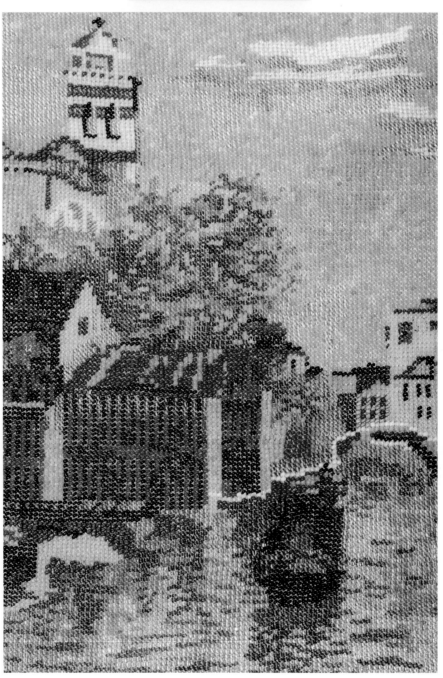

Detail.

Chapter 13
Scenes on Bags

"Americans of means and cosmopolitan tendencies…favored the European grand tour…in which they steeped themselves in the classical traditions of past and present."
"'…so completely and delightfully occupied in doing nothing'"
from *Showplace of America*
by J. Cigliano

In addition to visiting Europe, travelers voyaged to China, Japan, the Middle East, and India. Collectors' books of beaded bags such as *Vintage Purses at Their Best* by L. K. Schwartz (Schiffer Publishing Ltd.) show identifiable scenes of the Taj Mahal in India, and scenes of Switzerland and Japan.

What is the significance of the grottos in two of the scenic bags?

How did the nineteenth-century tradition of making long trips to foreign countries influence scenes on bags?

The manufacture of beaded bags with identifiable scenes of cities or places may have been inspired by the tradition of the European "Grand Tour," popular during the later part of the nineteenth century. Shaped by the successes of the Industrial Revolution, the newly affluent middle class of the nineteenth century had the means and the time to go wherever they wished and stay as long as they wanted. It was the fashion of the time, for example, to embark on a honeymoon journey that included a coach trip through Europe for a year or more. Couples would return to set up their household with a huge accumulation of trunks filled with European finery—which may have included beaded bags, recording the scenes and cities they had visited.

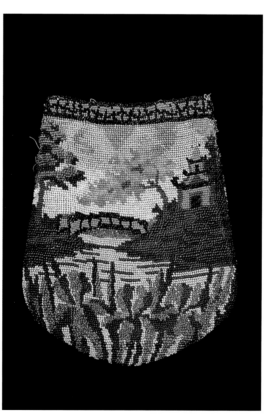

Embroidered seed beads on silk, pagoda, bridge, and blossoming tree in background, water and irises in foreground, unframed, 8-inch length. c. mid-to-late 1800s. *Courtesy Veronica Trainer.* $500-550.

These bags are worked in funereal or memorial Gothic motifs. Judging from the bright colors, it is obvious that they were not to be worn during the three-year Victorian mourning period. Mourning fashion dictated the use of black, grays, or heliotrope (a pale lavender color). The Gothic influence during the first half of the nineteenth century traces to the novels of Sir Walter Scott. The melancholic gloom of the ruins of an abbey were produced on walls, in etchings, and the designs of fabrics and wallpaper, as well as in beads on an early nineteenth-century purse.

The scene in the final bag of this chapter shows a memorial monument in the distance. The design of this bag incorporates black beads for the inside of the monument, and lavender beads to produce the shadows on the path. The use of yellow, red, and pink beads gives the effect of the autumn season, also indicative of a memorial theme.

Knitted, fine multi-color seed beads, castle snow scene (possibly the gates of old walled city, Nürenberg, Germany, famous for its Christmas market) figure carrying holiday tree in foreground, hammered Italian silver plate frame, fringe, 12-inch length. c. late 1800s. *Courtesy Bunni Union.* $800-1000.

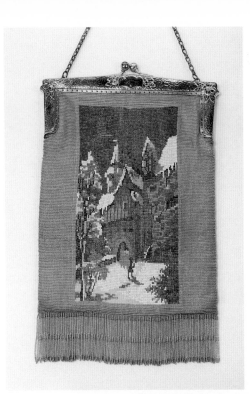

Detail.

Detail.

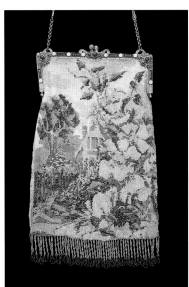

Knitted, fine multi-color seed beads, English cottage with climbing pink roses, garden gate, path, brass enameled jeweled frame, entwined looped fringe, 12-1/4 inch length. c. late 1800s. *Courtesy Veronica Trainer.* $1000-1200.

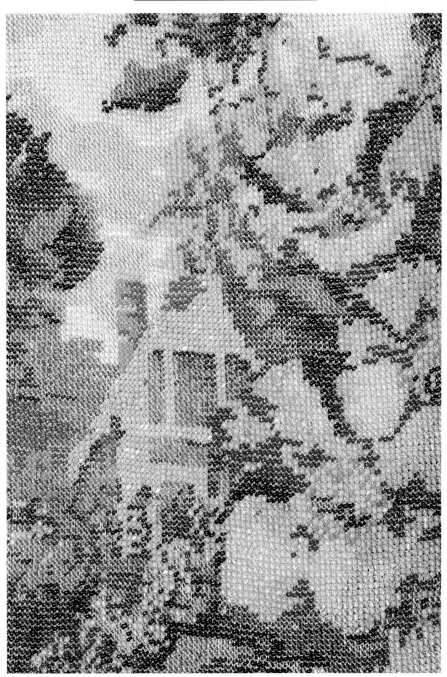

Detail.

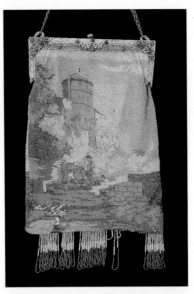

Knitted, fine multi-color seed beads, French countryside scene, eighteenth-century costume, peasant with children outside city gate with water in foreground, walled city structures in background, brass jeweled frame, with stones, fringe, 12-inch length. c. mid-to-late 1800s. *Courtesy Veronica Trainer.* $800-1000.

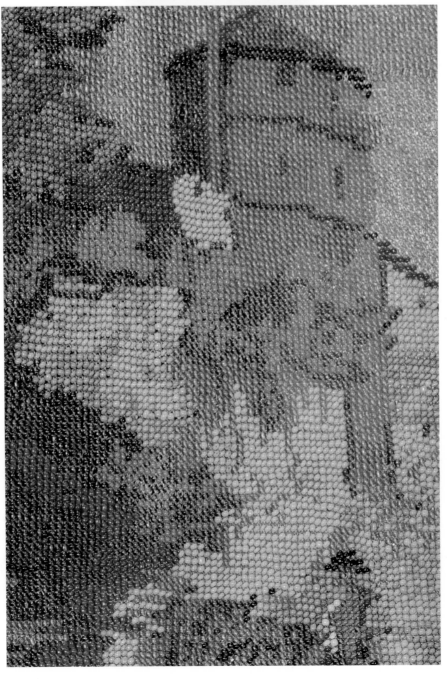

Detail.

144

Knitted, fine multi-color seed beads, German mill scene, swans in the fore-ground, sky and clouds in background, brass frame, label "Made in Italy," fringe, 12-inch length. c. late 1800s. *Courtesy Joanne Haug of Reflections of Things Past.* $800-1000.

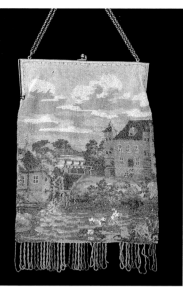

Label.

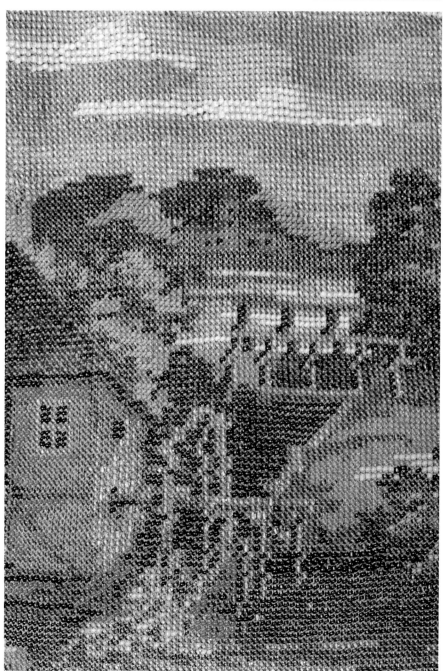

Detail.

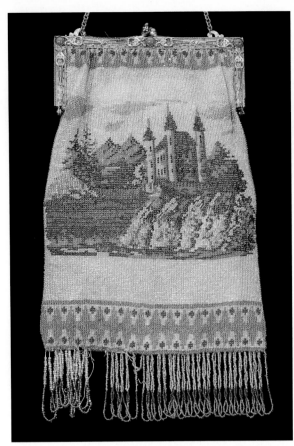

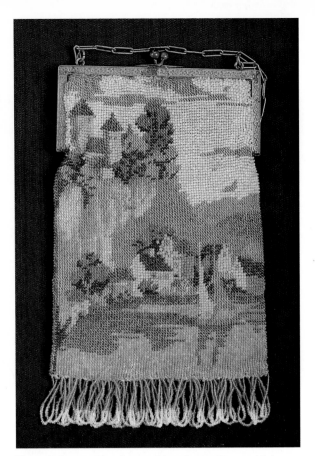

Knitted, fine multi-color seed beads, Alpine castle on a high bluff (possibly Neuschwanstein Castle), blue lake in foreground, mountain and sky in background, brass jeweled frame, fringe, 12-inch length. c. late 1800s. *Courtesy Veronica Trainer.* $800-1000.

Knitted, fine multi-color seed beads, castle on a high cliff, small village below, sailboat on the water in the foreground, sky and clouds in background, brass frame, fringe, 12-inch length. c. late 1800s. *Author.* $800-1000.

Loomed, multi-color seed beads, German scene on a river, German silver frame, twisted fringe, 10-1/2 inch length. c. late 1800s. *Courtesy Veronica Trainer.* $800-1000.

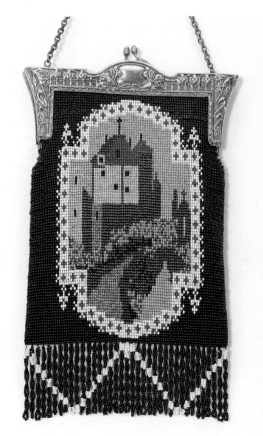

Opposite page: Detail.

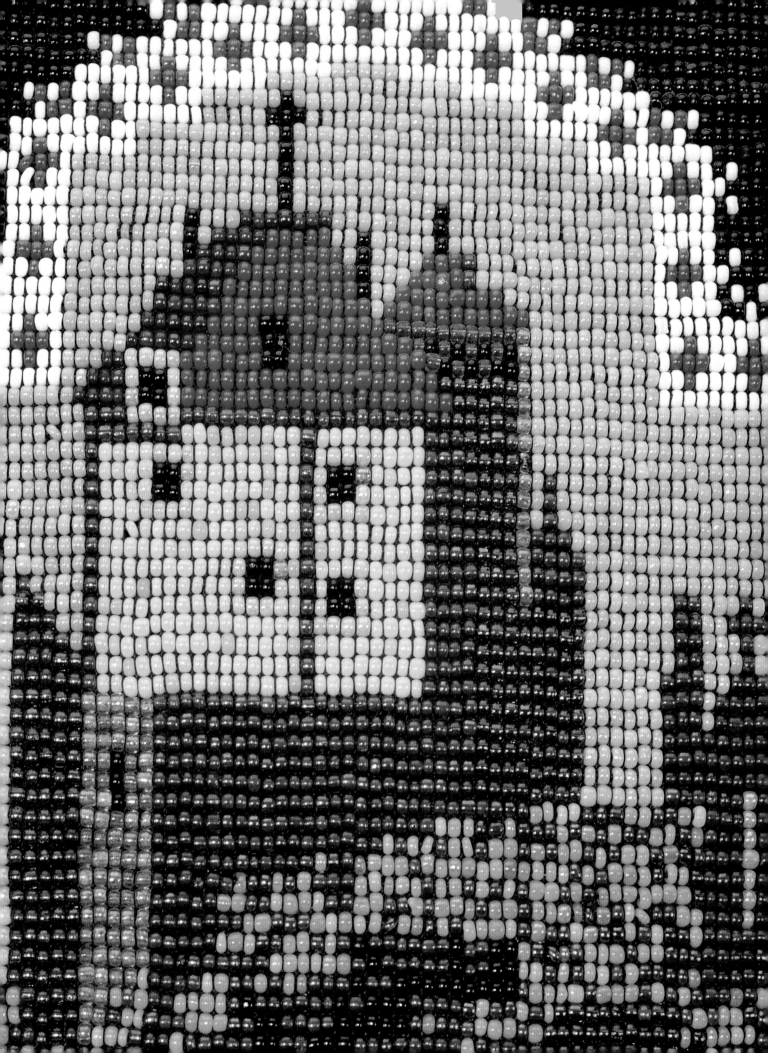

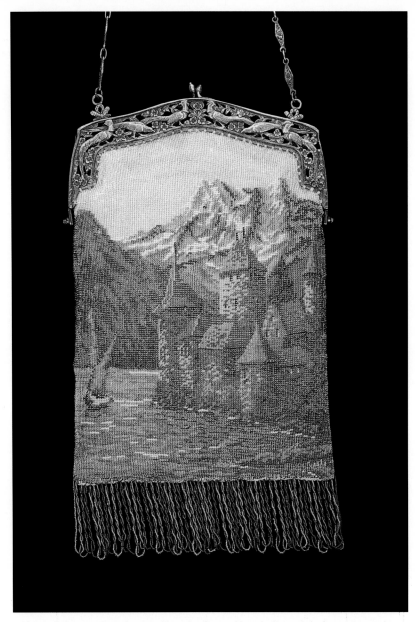

Knitted, fine multi-color seed beads, Swiss Alps, Italian silver frame signed "Fili Coppini" with pheasants, fringe, 13-1/2 inch length. c. late 1800s. *Courtesy Veronica Trainer.* $1500-1800.

Detail. Detail.

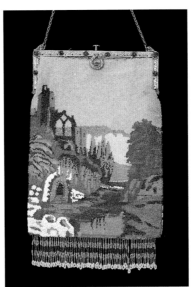

Embroidered on knitted silk, fine multi-color seed beads, funereal scene, grotto on a hillside with cathedral ruins in the background, brass jeweled frame, fringe, 12-inch length. c. mid-to-late 1800s. *Courtesy Veronica Trainer.* $800-1000.

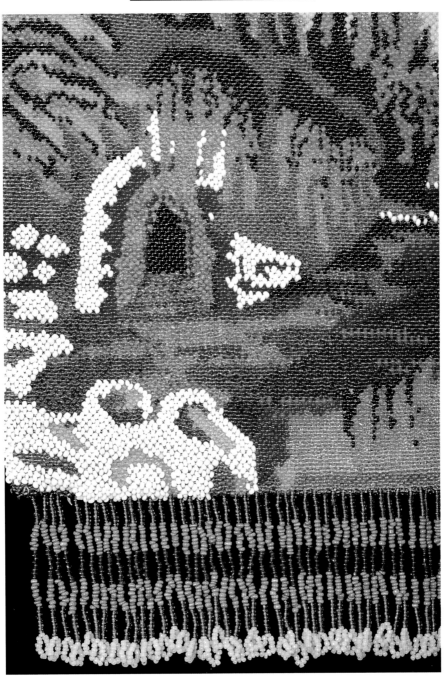

Detail.

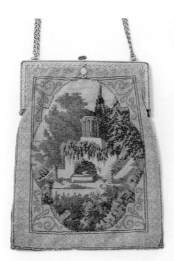

Knitted, fine multi-color seed beads, funereal theme, mausoleum with Greek columns, autumn and evergreen scene, vermeil brass frame, 9-inch length. c. mid-to-late 1800s. *Courtesy Veronica Trainer.* $800-1000

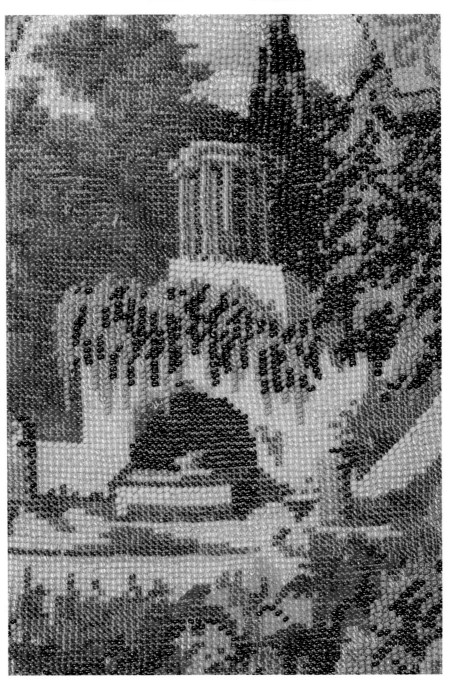

Detail.

Knitted, fine multi-color seed beads, memorial theme, mausoleum with Greek columns, path in foreground, lake, mountain, sky in background, brass enameled jeweled frame, 12-1/4 inch length. c. late 1800s. *Courtesy Veronica Trainer.* $1000-1200.

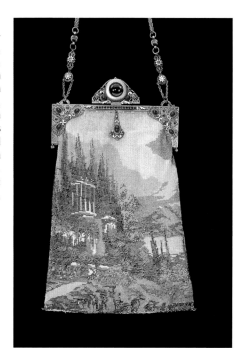

Detail.

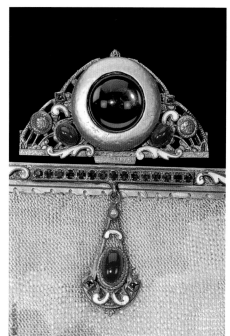

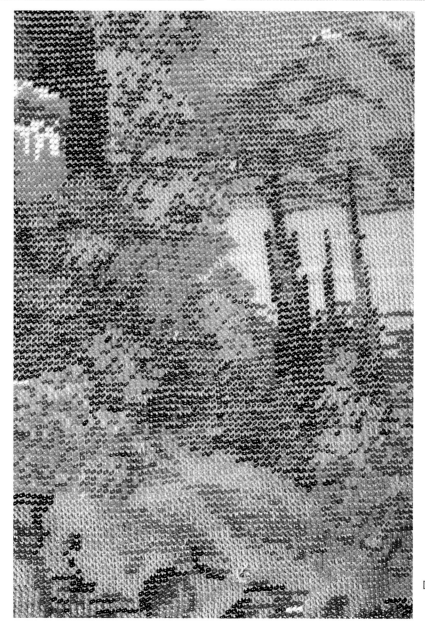

Detail.

Chapter 14
Designs on Bags

"The key to India is in London."
from a speech to the House of Lords,
March 5, 1881, by Benjamin Disraeli,
Earl of Beaconsfield

What inspired the Oriental patterns on beaded bags of the mid to late nineteenth century?

In the late nineteenth century, fashion, interior design, and the decorative arts were influenced by Oriental themes, rich brilliant colors, and elaborate patterns and designs. Oriental rugs, for example, replaced large carpets. Many of the beaded bags in this chapter resemble the designs that were depicted on Oriental rugs. Others incorporate Oriental patterns with floral designs and bits of Italian mosaic.

Another influence on the beadwork designs for purses may have come from the designs and colors on the cashmere shawls made in India, which was at that time a colony of Great Britain.

Knitted and crocheted, fine seed beads, carpet pattern, drawstring, entwined looped fringe, 8-inch length. c. late 1800 to early 1900s. *Courtesy Bunni Union.* $450-500.

Detail.

These soft wool shawls were produced in the Kashmir region where they were, and still are, hand woven from the wool of Tibetan mountain goats. Indian shawls were introduced in England early in the nineteenth century (from about 1800-1820s) and soon became a coveted fashion accessory that remained popular until the end of the century. Indian shawls were costly and difficult to obtain. Copies began to be made in Britian from sheep's wool woven in the areas of Norwich, Edinburgh, and Paisley. The British created designs for the shawls that were inspired by the swirls and floral shapes on the Indian shawls. The shawls had a plain background with borders of large floral "cone" designs in rich colors. "Paisley" became the name of the shawl and of the designs.

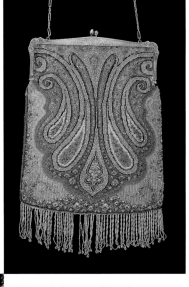

Knitted, fine seed beads, carpet pattern, sterling sliver frame, twisted fringe, 11-1/4 inch length. c. late 1800s. *Courtesy Veronica Trainer.* $800-1000.

Detail.

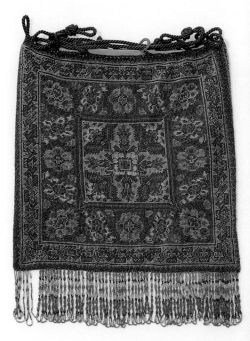

Knitted and crocheted, fine seed beads, carpet
pattern, drawstring silk cord, entwined looped
fringe, 11-inch length. c. late 1800s. *Courtesy
Veronica Trainer.* $300-500.

Detail.

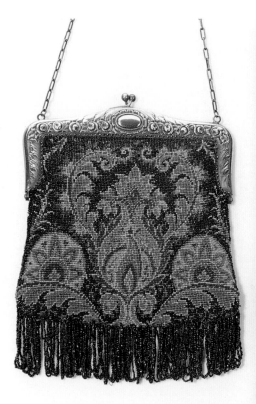

Knitted, seed beads, carpet pattern, sterling silver
frame, cut-jet looped fringe, 11-1/4 inch length.
c. late 1800s to early 1900s. *Courtesy Veronica
Trainer.* $800-1000.

Detail.

Embroidered on canvas, seed and jet beads, carpet pattern, brass frame, entwined looped fringe, 9-inch length. c. late 1800 to early 1900s. *Courtesy Bunni Union*. $450-600.

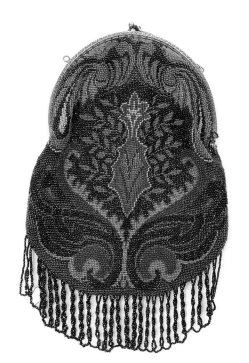

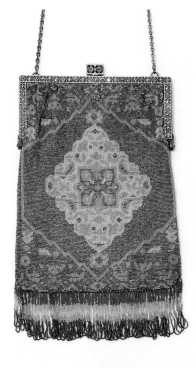

Knitted, fine seed beads, carpet pattern, enameled and jeweled frame, entwined looped fringe, 8-3/4 inch length. c. late 1800s to early 1900s. *Courtesy Veronica Trainer*. $600-800.

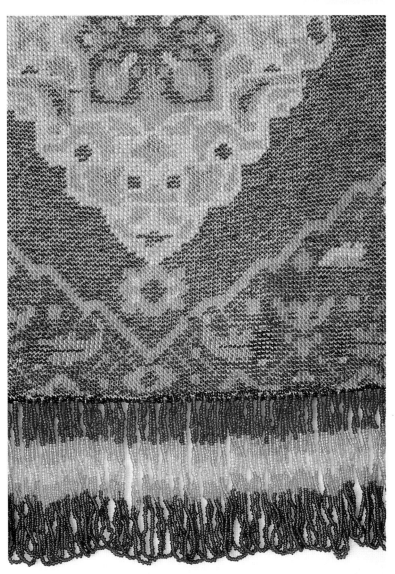

Detail.

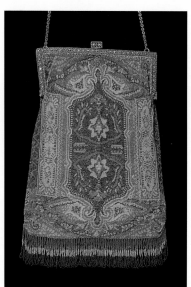

Knitted, fine seed beads, carpet pattern, enameled frame, entwined fringe, 11-1/2 inch length. c. late 1800 to early 1900s. *Courtesy Veronica Trainer.* $800-1000.

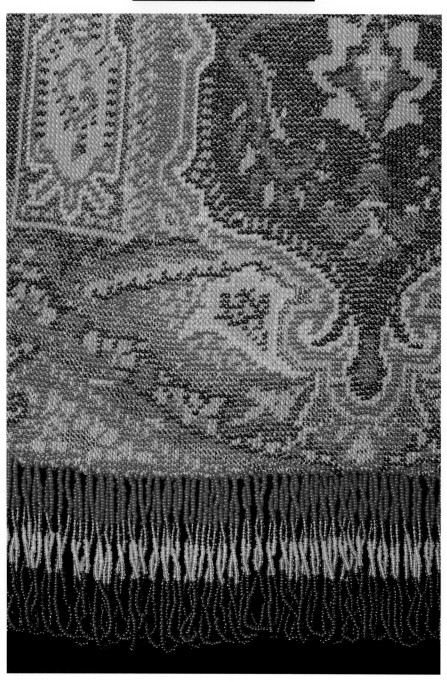

Detail.

Knitted, fine seed beads, carpet pattern, brass enameled jeweled frame, carnelian cabochon stones, looped fringe, 10-1/2 inch length. c. late 1800s to early 1900s. *Author.* $650-850.

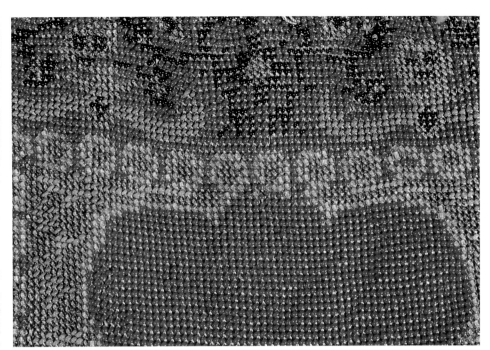

Detail.

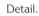

Detail.

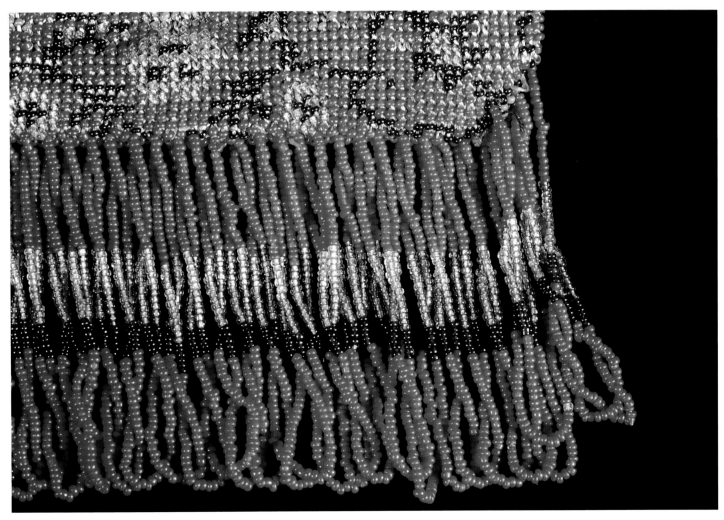

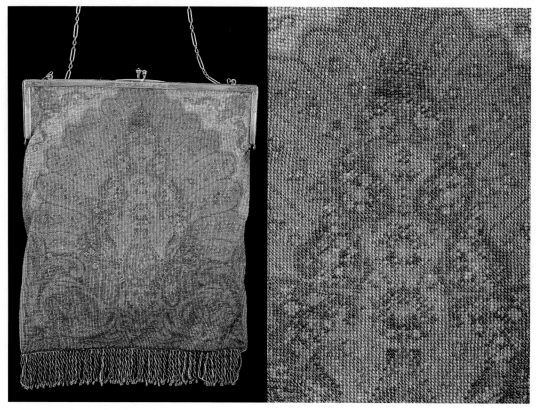

Knitted, sterling silver frame, fine seed beads, carpet pattern, twisted entwined fringe, 12-inch length. c. early 1900s. *Courtesy Anna Greenfield.* $850-1000.

Detail.

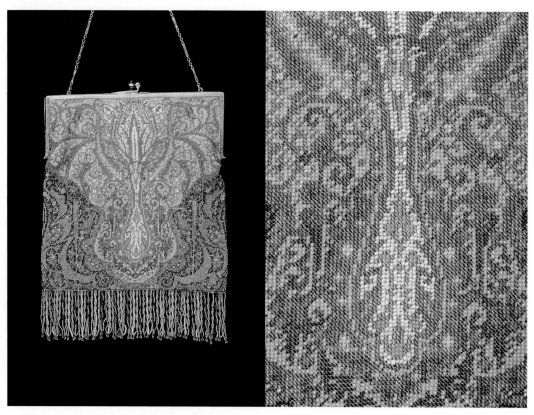

Knitted, sterling silver frame, carpet pattern, entwined fringe, 8-inch length. c. late 1800s to early 1900s. *Courtesy Veronica Trainer.* $800-1000.

Detail.

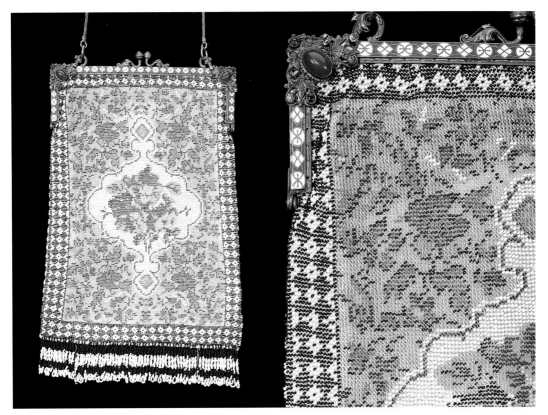

Knitted, fine seed beads, carpet pattern, brass enameled and jeweled frame, fringe, 12-inch length. c. late 1800s to early 1900s. *Courtesy Veronica Trainer.* $1000-1200.

Detail.

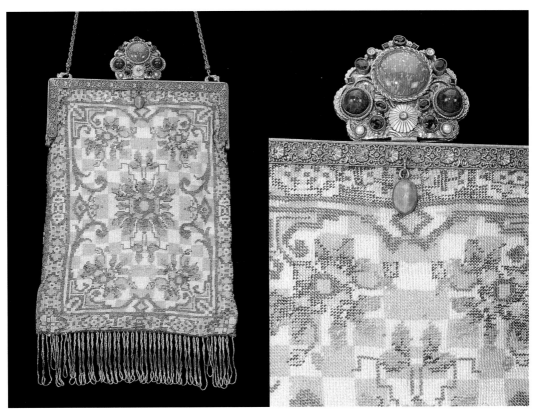

Knitted, fine seed beads, carpet pattern, brass frame with jeweled clasp, entwined fringe, 12-inch length. c. late 1800s to early 1900s. *Courtesy Veronica Trainer.* $1000-1200.

Detail.

Embroidered, cut-steel and black seed
beads, marcasite studded frame. Art
Deco, Chinese Yin-yang symbol motif,
tassel fringe, 9-inch length. c. 1930.
Author. $400-500.

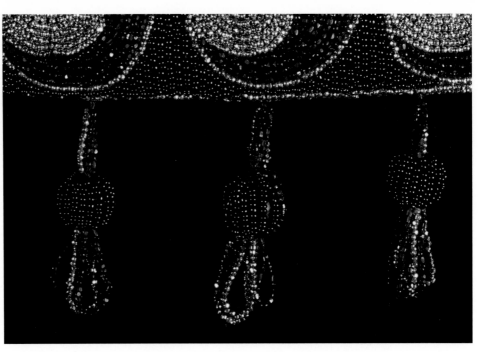

Detail.

Detail.

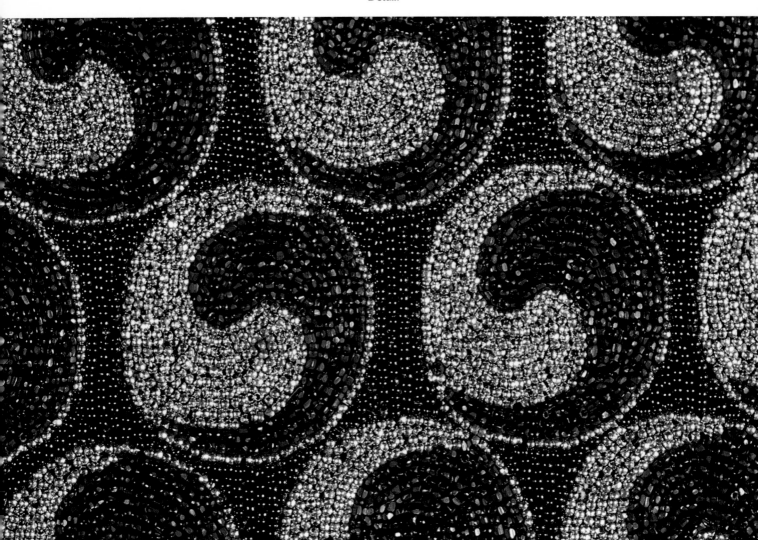

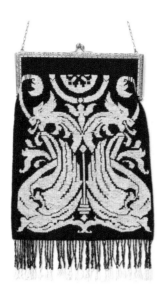

Knitted, black and white fine seed beads, mirrored griffins, brass frame with lily-of-the-valley pattern, entwined fringe, 12-inch length. c. early 1900s. *Courtesy Veronica Trainer.* $450-500.

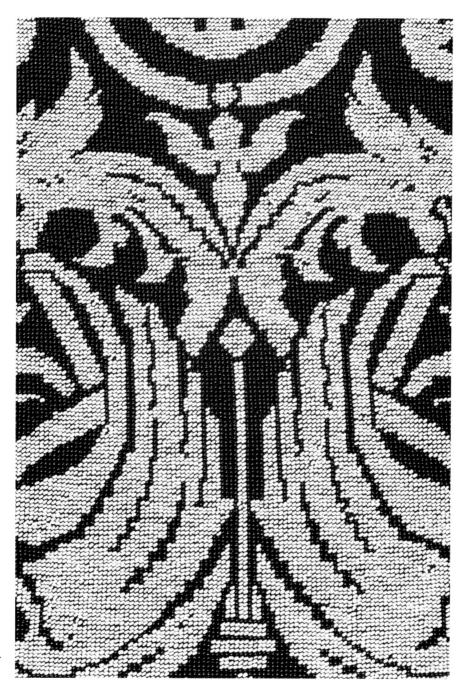

Detail.

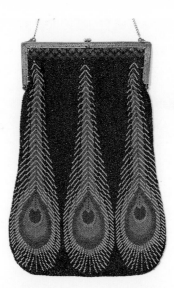

Knitted, black cut and multi-color beads, peacock feather design, brass frame, 11-3/4 inch length. c. late 1800s to early 1900s. *Courtesy Veronica Trainer.* $500-550.

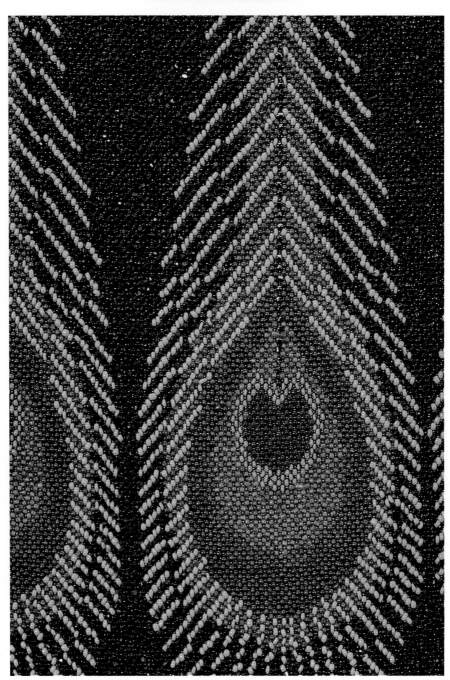

Detail.

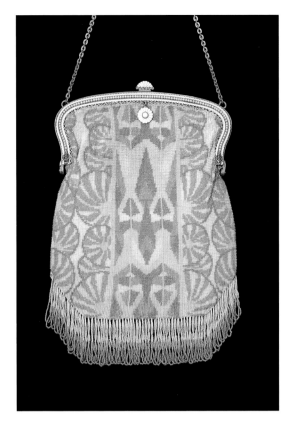

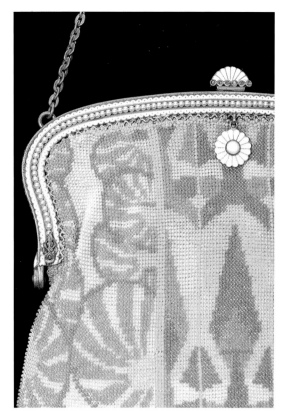

Knitted, cream and yellow fine beads, pinwheel design, mirrored geometric pattern, enameled brass frame lined in pearls, entwined fringe, 9-inch length. c. early 1900s. *Courtesy Veronica Trainer.* $500-550.

Detail.

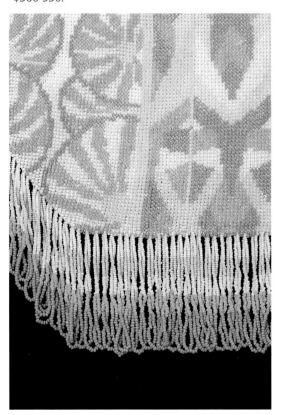

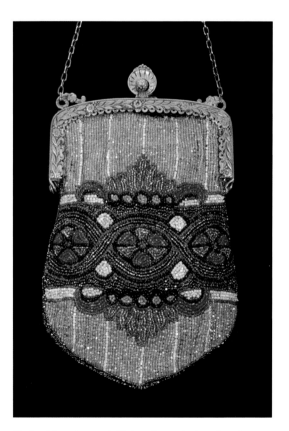

Detail.

Embroidered on net, Bohemian cut glass beads, brass frame, 6-1/2 inch length. c. early 1900s. *Courtesy Bunni Union.* $100-150.

Knitted, multi-color fine beads, geometric pattern, German silver frame with floral basket and two swans, 8-1/2 inch length. c. early 1900s. *Courtesy Bunni Union.* $450-500.

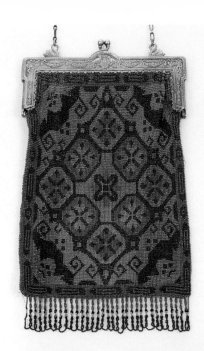

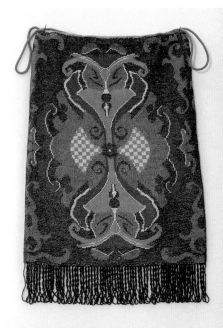

Knitted, drawstring, multi-color fine beads, mirrored geometric pattern, entwined fringe, 11-inch length. c. early 1900s. *Courtesy Veronica Trainer.* $500-550.

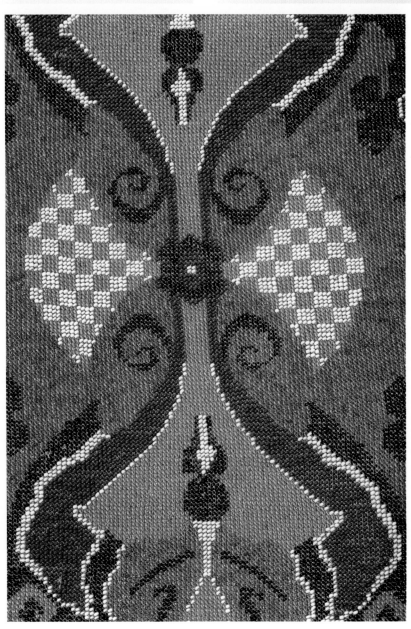

Detail.

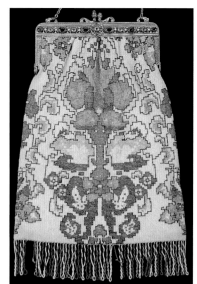

Knitted, multi-color fine beads, mirrored geometric pattern, jeweled frame, 12-inch length. c. early 1900s. *Author.* $650-800.

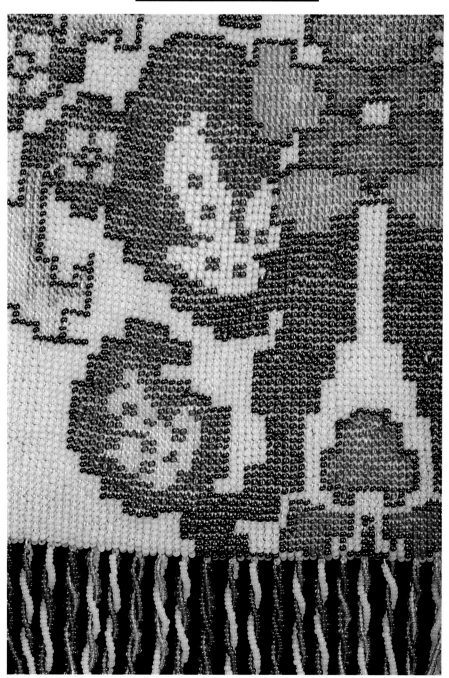

Detail.

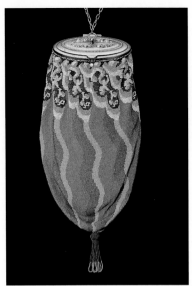

Knitted, multi-color fine beads, Art Deco, vertical waves, elliptical brass closure, 12-inch length. c. early 1900s. *Courtesy Veronica Trainer.* $500-550.

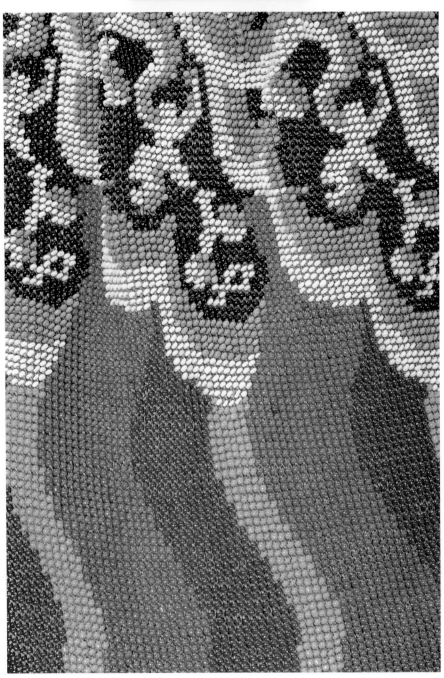

Detail.

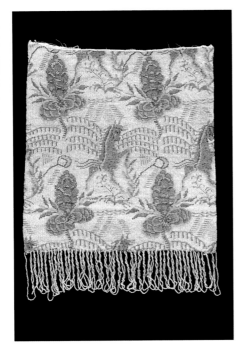

Knitted, multi-color fine beads, Raoul Dufy Art Deco motif, unframed, entwined fringe, 8-3/4 inch length. c. 1925. *Author.* $1000-1200.

Detail.

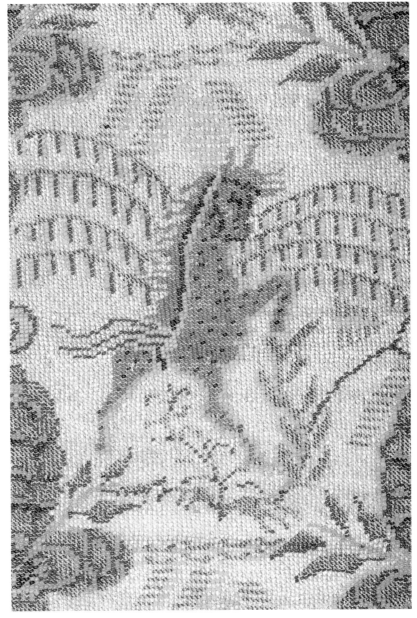

Detail.

167

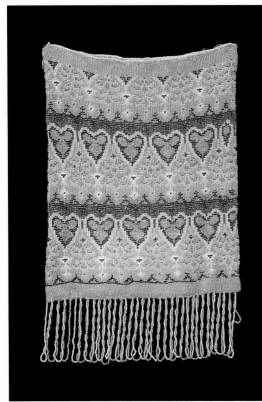

Knitted, multi-color fine beads, repeat pattern, unframed, entwined fringe, 9-inch length. c. late 1800s to early 1900s. *Courtesy Veronica Trainer.* $550-500.

Detail.

Embroidered on net, drawstring, multi-color beads, zig-zag pattern, celluloid rings, fringe tassel, 7-inch length. c. 1920s. *Courtesy Ursuline College Historic Costume Study Collection.* $90-125.

Detail.

Knitted, multi-color fine beads, Chinese dragon motif, brass frame, entwined fringe, 12-inch length. c. late 1800s to early 1900s. *Author.* $1000-1200.

Detail.

Chapter 15
Bohemian Beaded Bags

"The greatest challenge to Venice, however, came from Bohemia…"

from *Beads of the World*
by P. Francis, Jr.

What history surrounds the beaded bags made from Czechoslovakian beads?

Jablonec, Bohemia was the site of the first glass factory (1787) in what is now called Czechoslovakia. The Bohemians had learned some of the Venetian's secrets about making glass canes and established a glass industry of their own. By the middle of the nineteenth century, the Bohemians had become highly successful in producing and selling glass beads and had become the chief competitors to the Venetians in the bead industry.

In 1918, following World War I, Bohemia, Moravia, and Slovakia merged to form the republic of Czechoslovakia. During the 1920s, the United States imported great quantities of beaded bags in order to meet the demand for the popular fashion. These bags sold at "bargain" prices when compared to beaded bags made with Venetian beads.

The Czechoslovakian seed beads of that time are considerably larger than the super fine Venetian beads. Instead of being knitted, the Czech bags were usually made by tambour stitching beads onto silk netting in abstract, large paisley and oriental patterns. While it is not certain that all of the bags illustrated in this chapter were imported from Czechoslovakia, there is much similarity in bead types and in the construction of the bags.

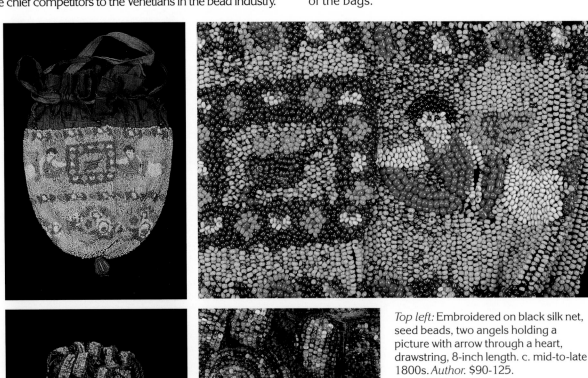

Top left: Embroidered on black silk net, seed beads, two angels holding a picture with arrow through a heart, drawstring, 8-inch length. c. mid-to-late 1800s. *Author.* $90-125.

Top right: Detail.

Bottom left: Tambour embroidered on net, seed beads and black jet, drawstring, 9-inch length. c. early 1900s. $150-200.

Bottom right: Detail.

When East Germany and Eastern Europe came under communist rule in the middle of the twentieth century, many of the glass factories closed; workers moved to factories designated by the government as being essential. After the fall of communism, in the 1980s, bead merchants had a chance to tell about the re-opening of these glass factories. Quantities of vintage beads were discovered decades later on work tables still waiting processing, in boxes in storage rooms, and loaded on railroad cars ready for transport. These wonderful old beads are now being sold to shops and beadworkers throughout the world.

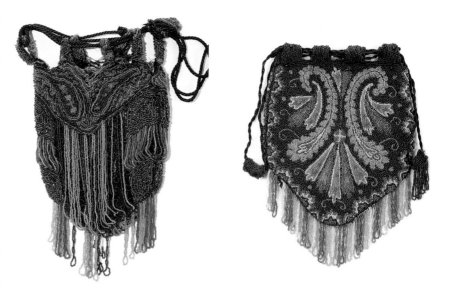

Top left: Tambour embroidered on net, multi-colored seed beads, drawstring, looped fringe, 12-inch length. c. early 1900s. *Courtesy Sandy Osborn.* $80-100.

Top right: Tambour embroidered on net, multi-colored seed beads, drawstring, looped fringe, 10-inch length. c. early 1900s. *Courtesy Bunni Union.* $200-250.

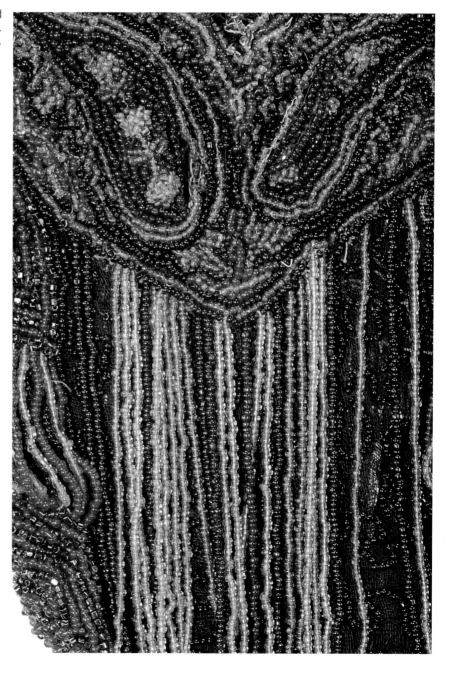

Detail.

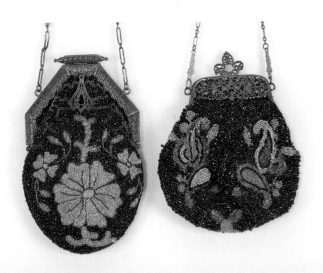

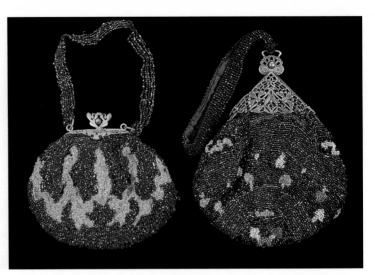

Left: tambour embroidered on lawn, cut iridescent and crystal beads, silver tone filagree frame, 7-inch length. Right: tambour embroidered on lawn, cut iridescent beads, German silver filagree frame, 6-1/2 inch length. c. early 1900s. Courtesy Paulette Batt. $175-225 each.

Left: tambour embroidered on lawn, cut bugles, brass frame, 5-inch length. Right: tambour embroidered on lawn, cut bugles and cut jet beads, German silver filigree frame, 7-inch length. c. early 1900s. Courtesy Anna Greenfield. $175-225 each.

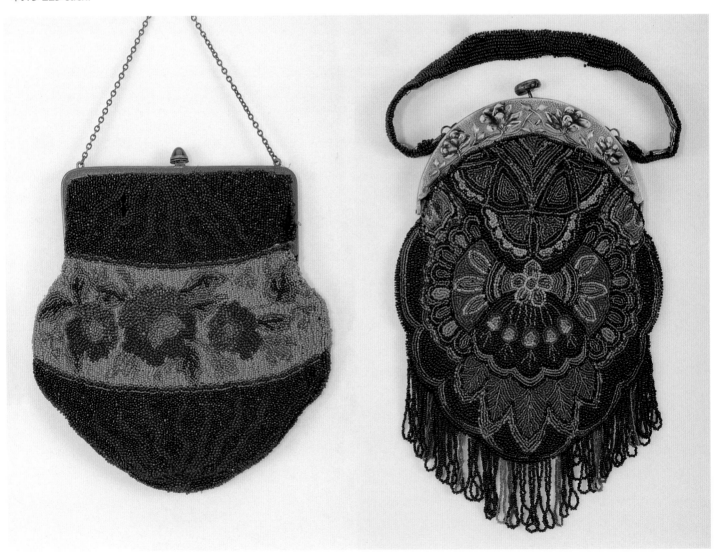

Tambour embroidered on lawn, seed beads. brass frame, carnelian cabochon clasp, 8-inch length. c. early 1900s. Courtesy Paulette Batt. $175-225.

Tambour embroidered on lawn, multi-color seed beads, painted celluloid frame, looped fringe, 11-1/2 inch length. c. early 1900s. Courtesy Paulette Batt. $250-300.

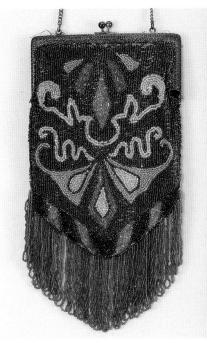

Embroidered on canvas, hematite and
multi-color seed beads, silver-tone frame,
looped fringe, 11-inch length. c. early
1900s. *Courtesy Paulette Batt.* $200-225.

Detail.

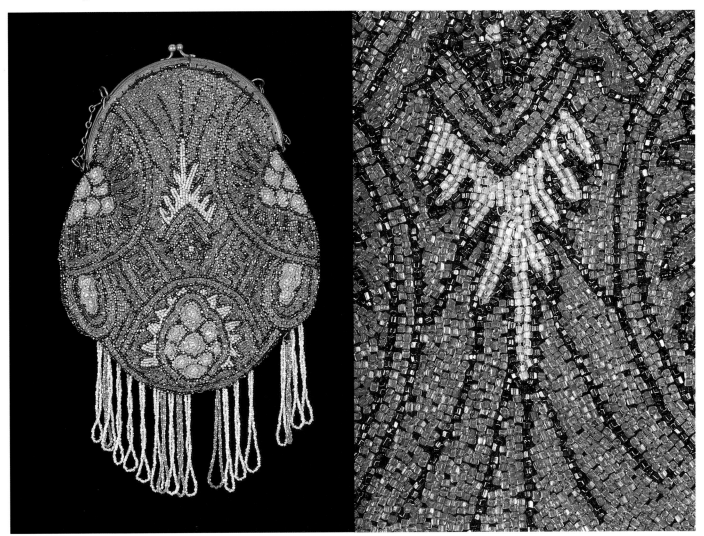

Tambour embroidered on net, color-infused crystal beads, brass
frame, looped fringe, 10-inch length. c. early 1900s. *Courtesy
Sandy Abookire.* $200-250.

Detail.

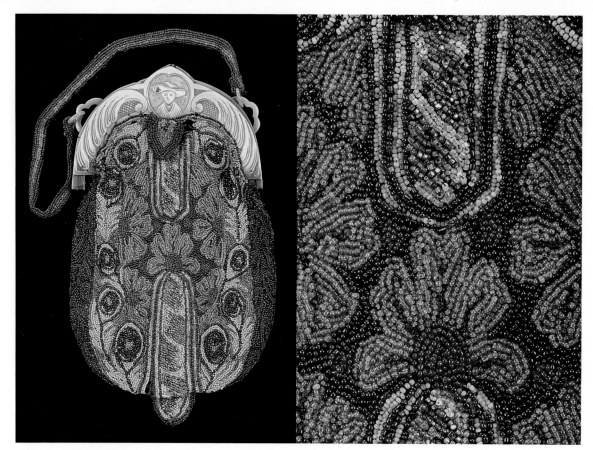

Tambour embroidered on lawn, seed beads, celluloid frame showing a man in a hat, 12-inch length. c. early 1900s. *Courtesy Janet King Mednik.* $350-450.

Detail.

Tambour embroidered on lawn, black cut and color-infused crystal beads, celluloid frame, looped fringe, label "Made in France," 11-inch length. c. early 1900s. *Courtesy Bunni Union.* $250-300.

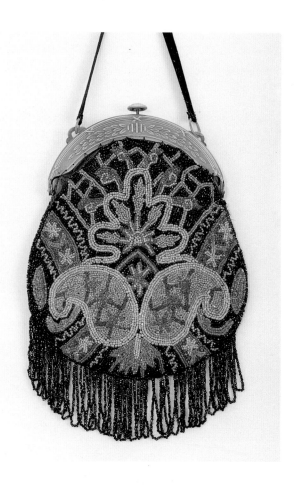

Opposite page: Detail.

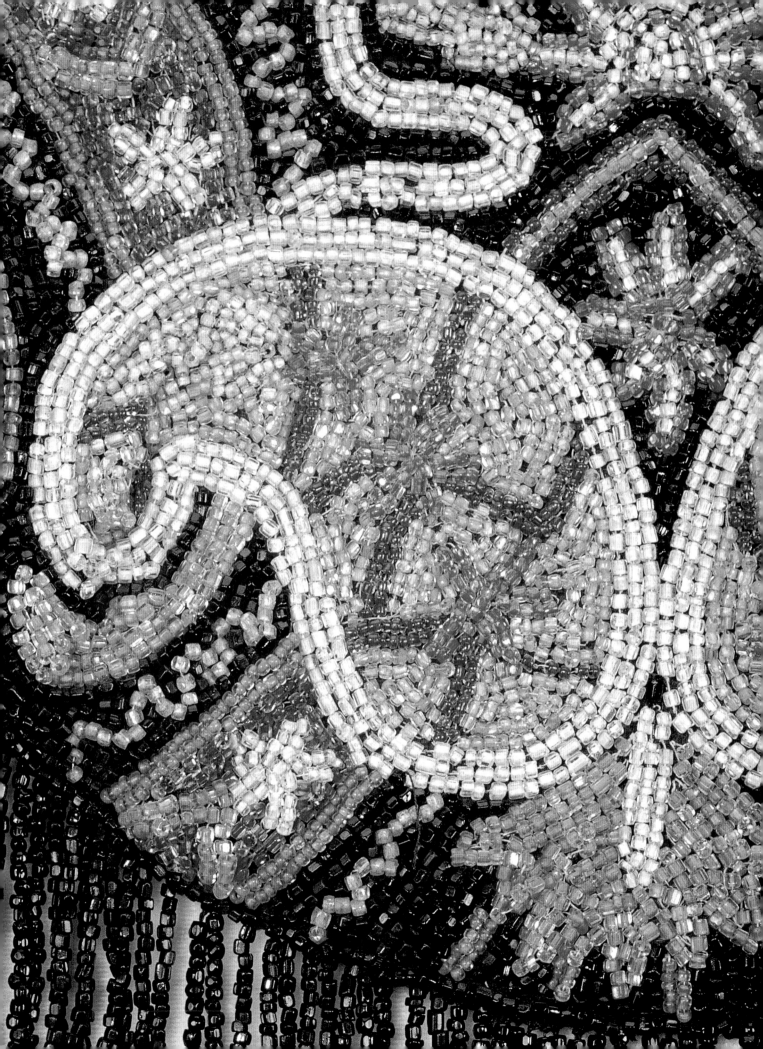

Chapter 16
Cut-Steel Beaded Bags

*"Two nations can, for all intent and purposes,
be considered the chief manufacturers of
cut-steel beads: France and the United States."*
from *More Beautiful Purses,* by E. Haertig

When were steel beads first used to make purses?

By the end of the eighteenth century, the Industrial Revolution had introduced new materials and manufacturing techniques. At the same time, the French Revolution, and the following Napoleonic Wars brought about a period of austerity in Europe. By the middle of the nineteenth century, cut-steel beads and cast-iron jewelry had replaced precious stones and metals used in fashions. France and the United States became the chief manufacturers of cut-steel beads. In this and previous chapters, there are several examples of early bags embroidered with cut-steel beads.

How is a purse made of French cut-steel beads identified?

The French beads are, in general, more finely crafted. French cut-steel beads were colored through a process known as electro-plating. The result is bags crafted from a wide array of very beautifully colored beads. The bags are usually loom woven, and the patterns of the purses are especially beautiful and intricate, with decorative fringes that are long and woven into the netting.

Also French beads are smaller in comparison to American steel beads, for example and were produced in a variety of shapes, including square-cut, faceted, rounded, and tubular. Additionally, some purses made from French cut-steel beads are marked "Made in Austria;" many of these happen to be the most beautiful!

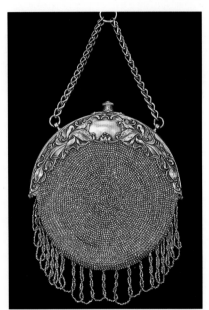

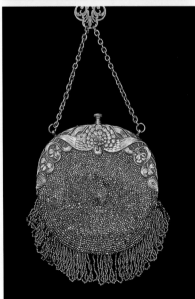

At the end of the nineteenth and into the early twentieth century, however, there was a large production of French bags that used primarily four colors of cut-steel beads—gold, silver, bronze, and aluminum. Numerous examples of these bags can still be found, and collectors refer to these as quite "common."

Over time, French cut-steel beads will oxidize and fade, however they will not rust. To make matters worse, because these bags are loom woven with thread, the weight of the beads eventually causes damage: horizontal splits occur that are almost impossible to repair without re-weaving the entire purse. The fact that many of these bags are too heavy to carry and are damaged may have contributed to an end in their popularity.

How do purses made from American cut-steel beads differ?

American cut-steel beads are generally larger than the French beads. Typically the bags made from these beads are not as finely crafted—usually embroidered in simple designs. Purses made in fabrics such as velvet or silk may show embellishments with silver cut-steel beads outlining designs of embroidered glass beads. The popular leather chatelaine-style handbag, for example, common during the mid-to-late nineteenth century, shows a continuous circle of cut-steel beads in an overall design attached with couched stitches to the front of the purse.

American cut-steel beads appear "chunky" and dull, especially when compared with the luster of the French cut-steel beads. Additionally, unlike the colorful cut-steel beads made by the French, American cut-steel beads are not colored, and when exposed to moisture, they *will* rust.

Top: Crocheted chatelaine, American beads, German silver frame with vines, marked "Patent Pending," reverse in leather, entwined fringe, 7-inch length. c. late 1800s to early 1900s. *Courtesy Ursuline College Historic Costume Study Collection.* $200-250.

Bottom: Crocheted chatelaine, American beads, German silver frame with peacock, clover, strawberries, marked "Patent Pending," reverse in leather, entwined fringe, 7-inch length. c. late 1800s to early 1900s. *Courtesy Ursuline College Historic Costume Study Collection.* $200-250.

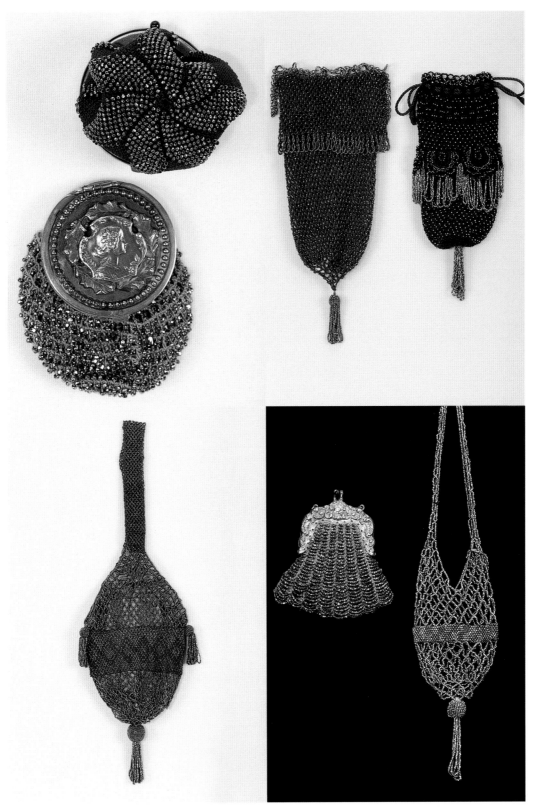

Top left: Top: bottom view of crocheted coin bag, pinwheel design, American beads, German silver lid not shown. *Bottom:* crocheted coin bag, American beads, German silver lid with profile, 3-inch length. c. late 1800s to early 1900s. *Courtesy Bunni Union.* $50-100 each.

Top right: Left: crocheted lattice pattern in moss green, chain drawstring, American beads, entwined fringe, tassel, 11-inch length. *Right:* crocheted lace pattern in brown, silk drawstring, American beads, looped fringe, tassel, 10-inch length. c. late 1800s to early 1900s. *Courtesy Paulette Batt.* $90-125 each.

Bottom left: Woven pouch, French beads, lattice pattern, lined in silk, woven wrist handle, three tassels with beaded balls, 15-inch length. c. early 1900s. *Courtesy Paulette Batt.* $100-125.

Bottom right: Left: knitted child's bag, French beads, swag pattern, brass frame, 4-inch length. *Right:* woven lattice pattern, French beads, woven wrist handle, tassel unlined, 11-inch length. c. late 1800s to early 1900s. *Courtesy Bunni Union.* $75-125 each.

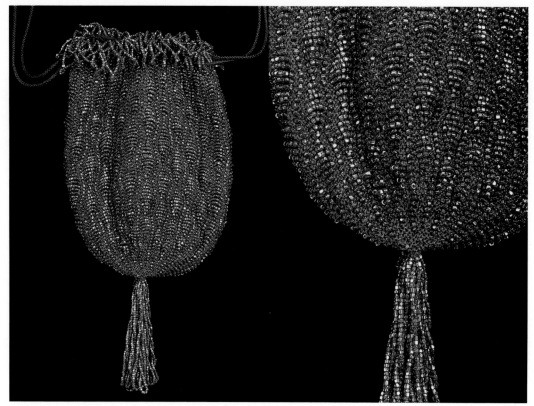

Crocheted, drawstring, French beads, woven lattice pattern trim, tassel, 10-inch length. c. early 1900s. *Courtesy Anna Greenfield.* $100-125.

Detail.

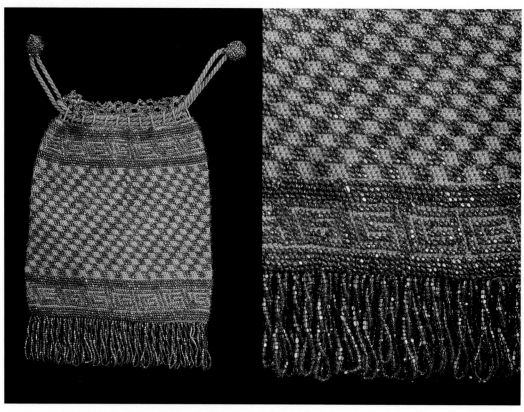

Crocheted, drawstring, French beads, geometric pattern, looped fringe, 8-inch length. c. early 1900s. *Courtesy Anna Greenfield.* $100-125.

Detail.

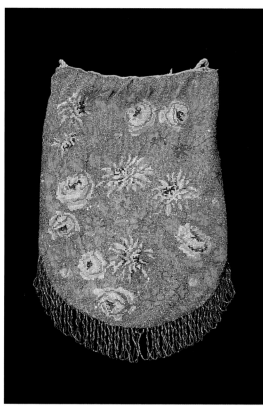
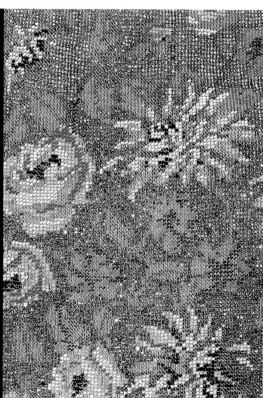

Knitted, drawstring, French beads, floral
pattern in pastel glass beads, fringe, 9-3/4 inch
length. c. late 1800s. *Courtesy Veronica
Trainer.* $400-500.

Detail.

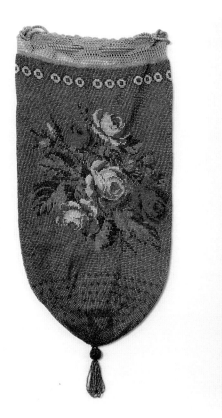
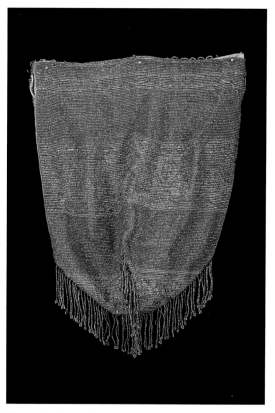

Knitted, crocheted header, drawstring, French
beads, floral pattern in glass beads, tassel, 15-inch
length. c. late 1800s to early 1900s. *Courtesy
Veronica Trainer.* $375-400.

Knitted, unframed, French beads, stylized floral
pattern, fringe, 7-inch length. c. early 1900s.
Courtesy Paulette Batt. $175-225.

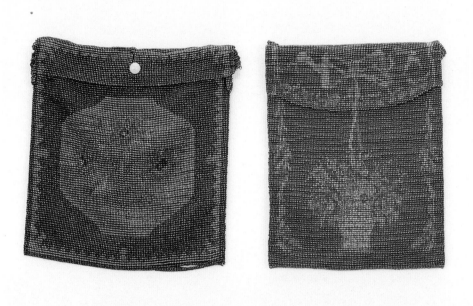

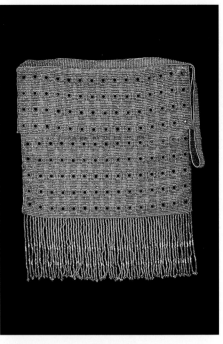

Left: woven, French beads, envelope, red poppy design, 4-1/2 inch length. *Right:* woven, French beads, envelope, bouquet basket design, 4-1/2 inch length. c. early 1900s. *Courtesy Bunni Union.* $100-125 each.

Woven, pouch with woven handle, French beads, studded with black jet, gold and silver fringe, 14-inch length. c. early 1900s. *Courtesy Paulette Batt.* $250-300.

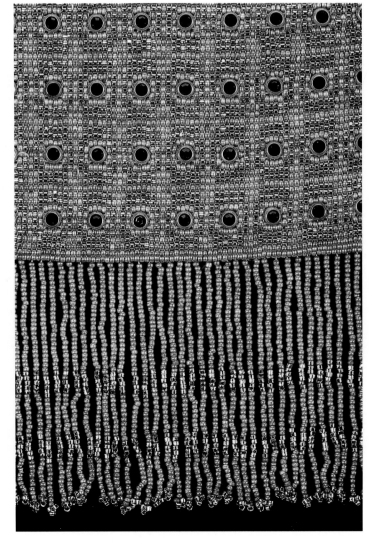

Detail.

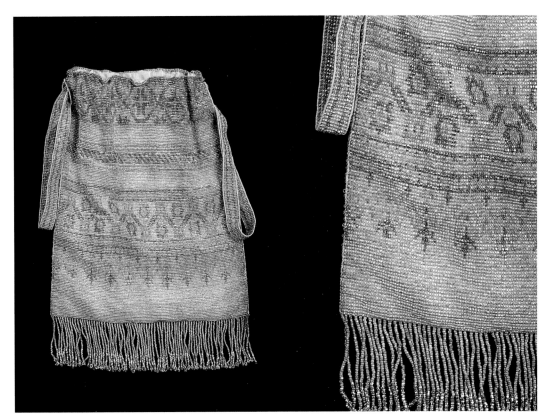

Woven, pouch with woven handles, French beads, geometric and stylized floral design, fringe, 11-inch length. c. early 1900s. *Courtesy Anna Greenfield.* $100-150.

Detail.

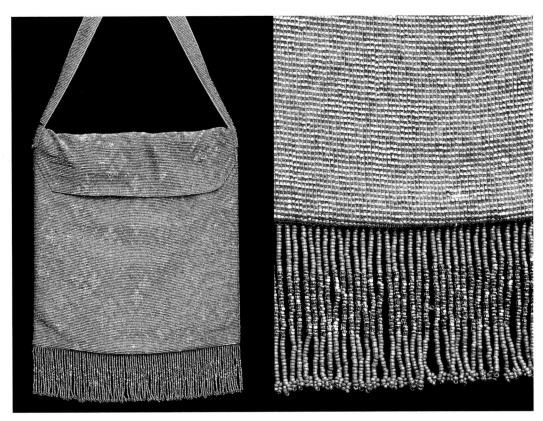

Woven, envelope with woven handle, French beads, geometric diamond design, fringe, 8-1/2 inch length. c. early 1900s. *Author.* $100-150.

Detail.

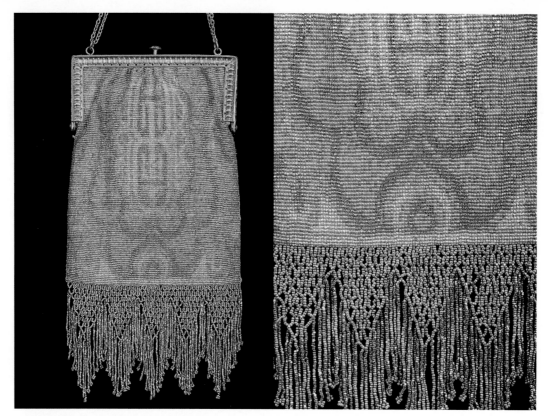

Woven, brass frame, French beads, geometric design, lattice fringe, 12-inch length. c. early 1900s. *Courtesy Anna Greenfield.* $250-300.

Detail.

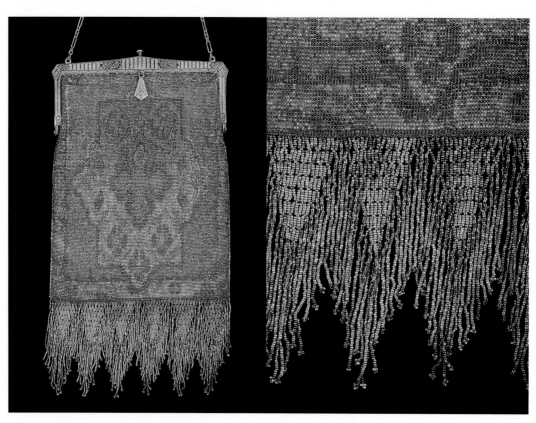

Woven, brass frame, French beads, lavender steel beads, lattice fringe, 12-inch length. c. early 1900s. *Courtesy Ruth Glick Kyman.* $250-300.

Detail.

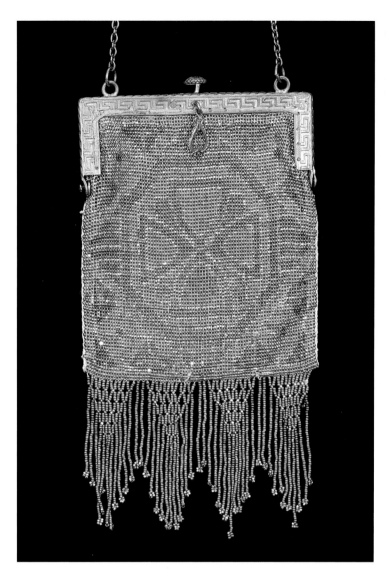

Woven, brass frame, French beads, geometric pattern, lattice fringe, 9-inch length. c. early 1900s. *Courtesy Anna Greenfield.* $175-225.

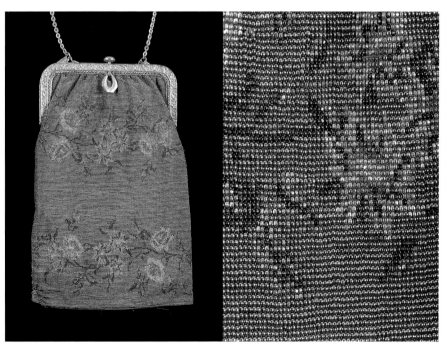

Woven, brass frame, French beads, floral pattern, 10-inch length. c. early 1900s. *Courtesy Anna Greenfield.* $250-300.

Detail.

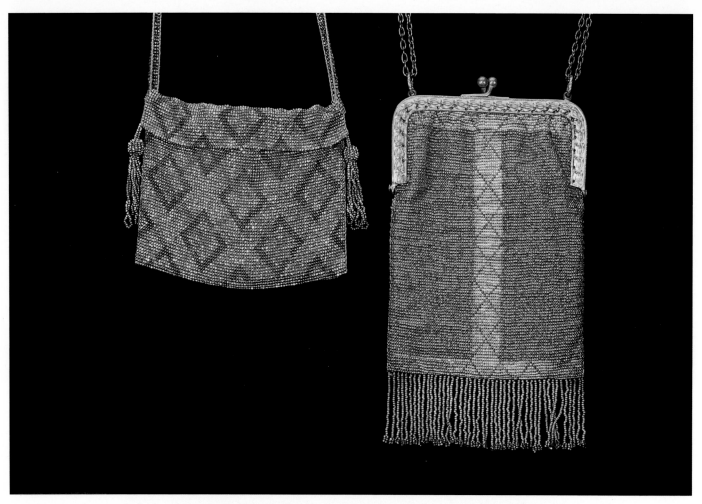

Left: woven, envelope, French beads, geometric argyle pattern, woven handle, side tassels, 9-inch length. c. early 1900s. *Right:* woven, brass handle, French beads, stylized floral lattice pattern, fringe, 8-1/2 inch length. c. 1920s. *Courtesy Bunni Union.* $90-125 each.

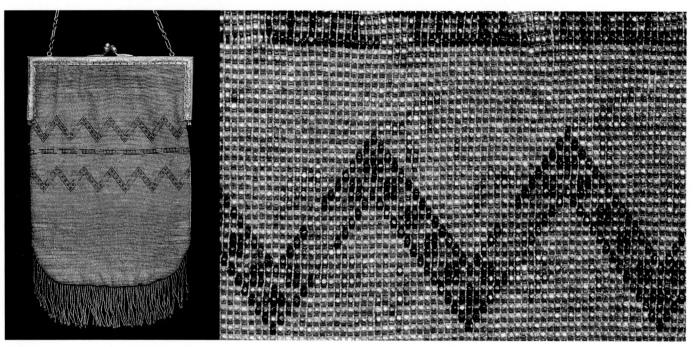

Woven, silver-tone frame, French beads, chevron pattern, fringe, 11-inch length. c. 1920s. *Author.* $175-225.

Detail.

Woven, glass mosaic hand-set Italian frame, French beads, heart pattern, fringe, 12-inch length. c. 1920s. *Author.* $350-400.

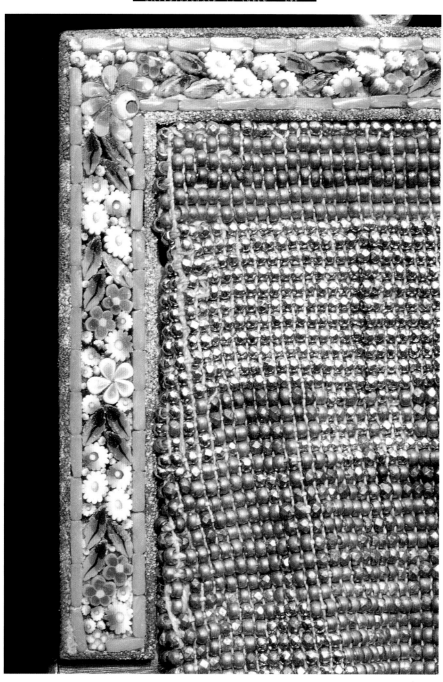

Detail.

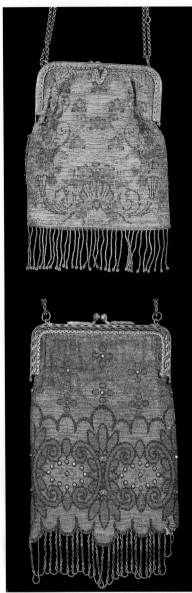

Top left: Woven, brass frame, French beads, fringe. c. late 1800s to early 1900s. *Courtesy Janet King Mednik.* $200-250.

Top right: Detail.

Bottom left: Woven, brass frame, French beads, diamanté studs, scallop design, entwined fringe, 12-inch length. c. early 1900s. *Teresa Winfield.* $150-200.

Bottom right: Detail.

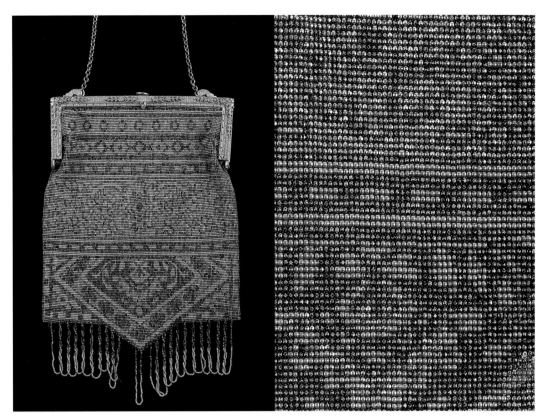

Woven, brass frame, French beads, geometric pattern, entwined fringe, 10-inch length. c. late 1800s to early 1900s. *Courtesy Anna Greenfield.* $200-250.

Detail.

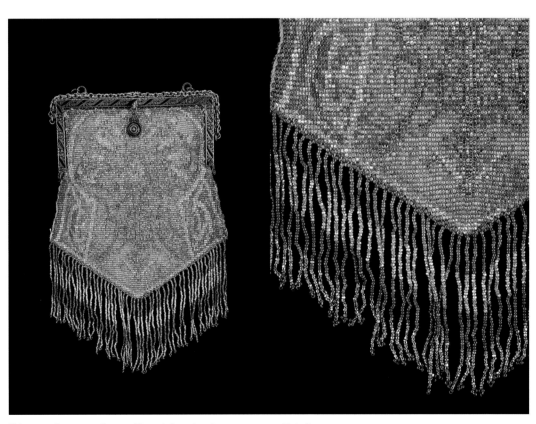

Woven, silver-tone frame, French beads, chevron design, fringe, 9-1/2 inch length. c. early 1900s. *Owner Viola C. VanOss 1893-1961. Courtesy Velma Behringer Roche and Elayne Roche Kramer.* $200-250.

Detail.

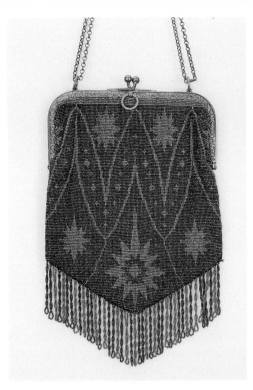

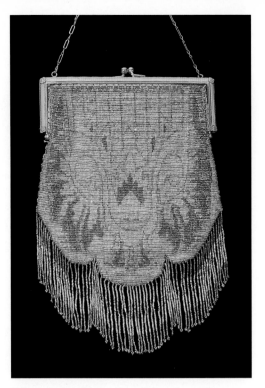

Woven, brass frame, French beads, chevron design with star burst pattern, entwined fringe, 9-inch length. c. 1920s. *Courtesy Bunni Union.* $200-250.

Woven, brass frame, French beads, scallop design, oriental pattern, fringe, 11-1/2 inch length. c. early 1900s. *Courtesy Veronica Trainer.* $300-450.

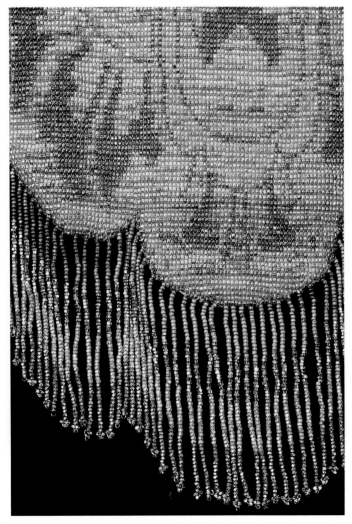

Detail.

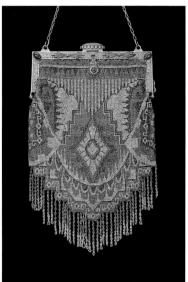

Woven, jeweled brass frame, French beads, geometric pattern, twisted fringe, 12-inch length. c. early 1900s. *Courtesy Veronica Trainer.* $750-875.

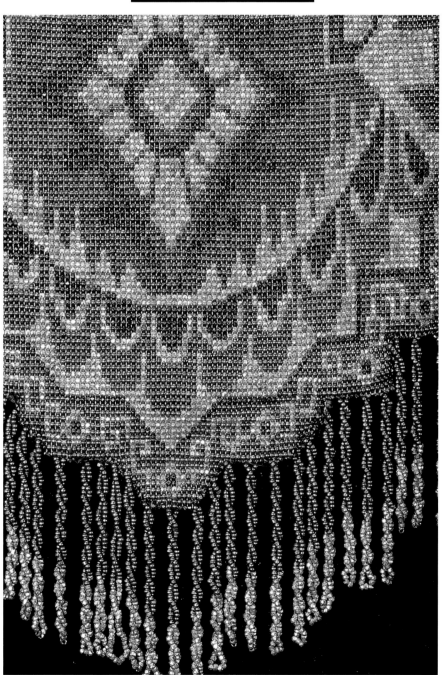

Detail.

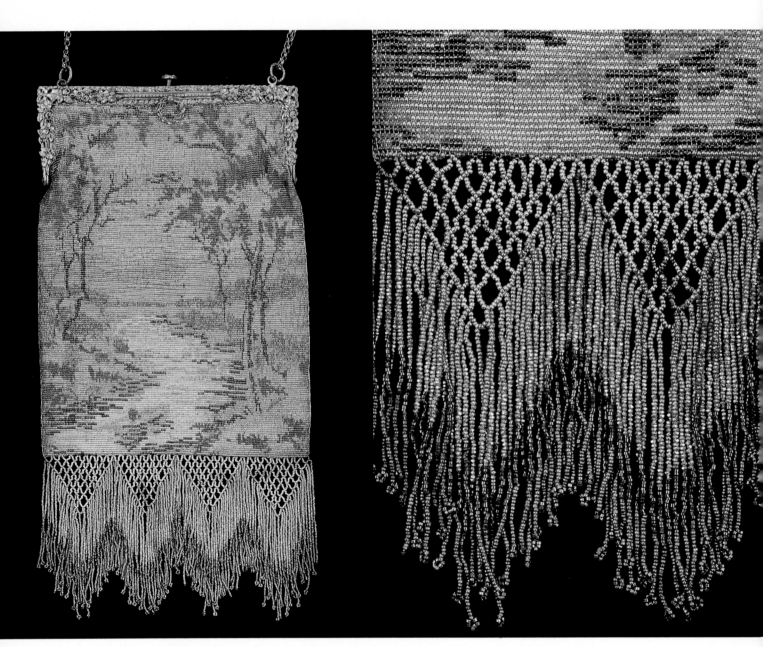

Woven, brass frame, French beads, stream and trees, lattice fringe, Detail.
12-inch length. c. early 1900s. *Author.* $550-650.

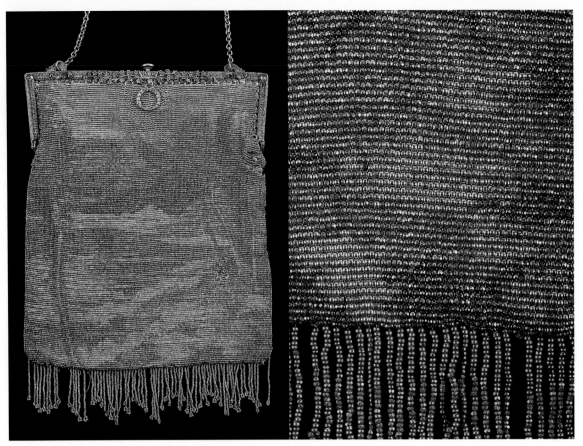

Woven, German silver jeweled and enameled frame, French beads, mountains with stream and pink flowers in the foreground, fringe, 10-inch length. c. early 1900s. *Courtesy Anna Greenfield.* $200-250.

Detail.

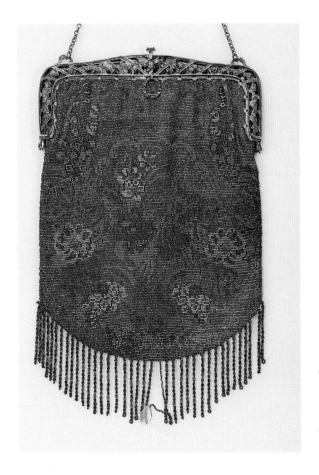

Woven, silver-tone frame, French beads, label "Made in France," floral pattern, twisted fringe, 11-inch length. c. early 1900s. *Courtesy Bunni Union.* $200-250.

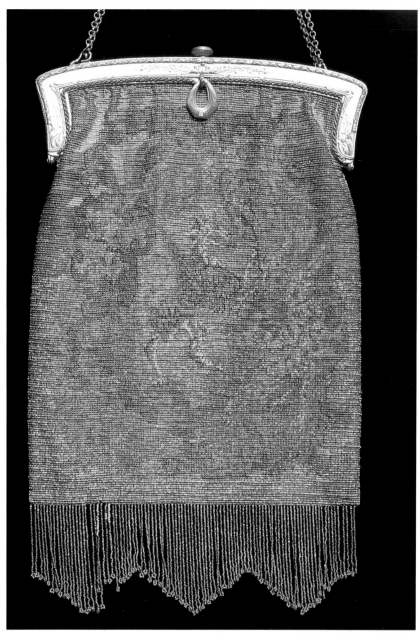

Woven, brass frame, French beads, griffin pattern, fringe, 10-1/2 inch length. c. early 1900s. *Author.* $300-350.

Detail. Detail.

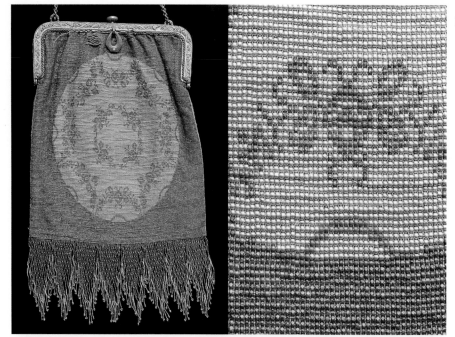

Woven, brass frame, French beads, floral medallion pattern, lattice fringe, 12-inch length. c. early 1900s. *Author.* $300-350.

Detail.

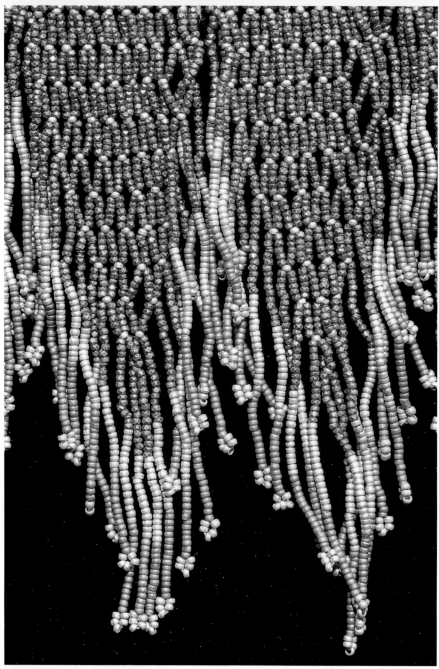

Detail.

Woven, jeweled brass frame, French beads, lattice fringe, 14-inch length. c. early 1900s. *Courtesy Anne Katherine Brown of Friends Antiques.* $600-800.

Detail.

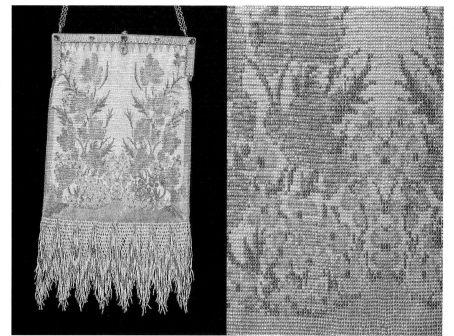

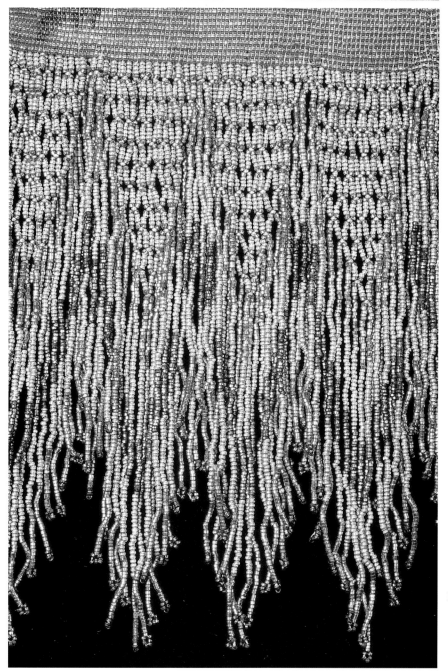

Detail.

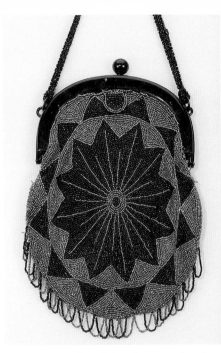

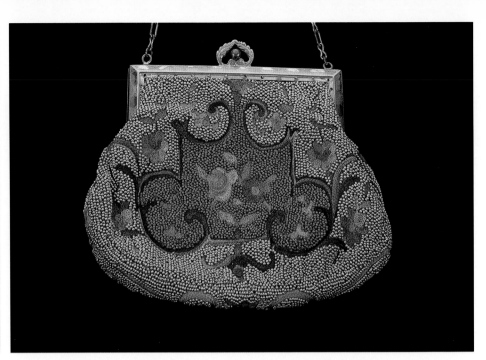

Embroidered, French beads, cut jet beads, Bakelite frame, bead embroidered handle, starburst pattern, looped fringe, 11-inch length. c. 1900s. *Courtesy Bunni Union.* $150-200.

Embroidered, French beads, tambour stitched silk, brass frame, label "Made in France," 5-inch length. c. 1930s. *Courtesy Alayne Reitman.* $150-200.

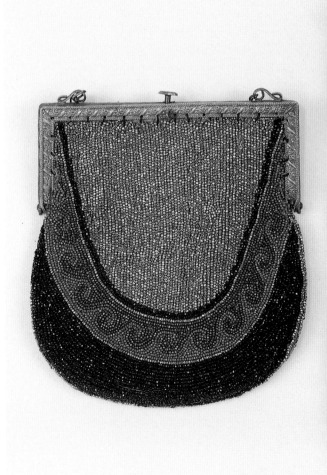

Embroidered, American and French beads, French cut "jet" beads, brass frame, swirl pattern, 9-inch length. c. early 1900s. *Courtesy Sandy Abookire.* $150-200.

Detail.

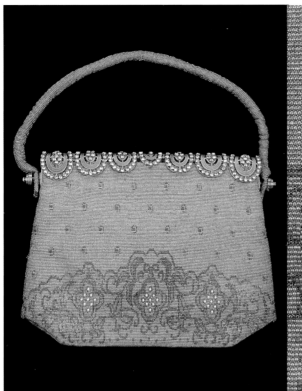

Embroidered, French beads, pearls and rhinestones, bead embroidered handle, brass jeweled closure, 10-1/2 inch length. c. 1930s. *Courtesy Anna Greenfield.* $100-150.

Detail.

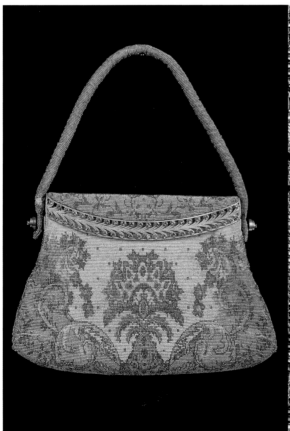

Embroidered, French beads, bead embroidered handle, brass jeweled closure, 10-1/2 inch length. c. 1930s. *Author.* $100-150.

Detail.

Chapter 17
Contemporary Bags

"Throughout this century, the handbag has faithfully mirrored women's occupations and aspirations. On the one hand, bags are entirely practical and on the other, they are the stuff of fantasy…"
from *A Century of Bags: Icons of Style in the Twentieth Century*
by C. Wilcox

Will the beaded bags of the late twentieth century become the antiques and collectibles of the next century?

Without a doubt, some of the beaded bags from the late twentieth century will find their way into costume museums and private collections. Most bags of this category will be those created by name designers, or by bead and needlework artists.

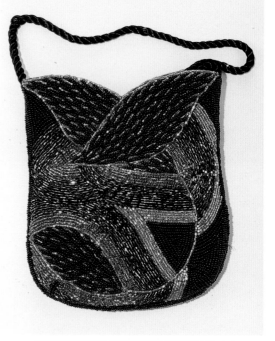

From the 1970s, and into the new millennium, numerous quantities of evening bags have been exported from Japan, Indonesia, India, and China. Many of these bags, beaded mostly by hand or hand manipulated on a beadwork sewing machine, are sold at "affordable" prices, and they are quite plentiful. Despite the simple designs and patterns of these contemporary beaded bags, they remain attractive and popular by today's standards of fashion. Similar in pattern and composed generally—with workmanship and designs considered to be not the "finest" in quality—it is unlikely for these bags to be

Top right: Embroidered, tulip inspired shape, silk cord strap, label "Made in Italy." c. 1980s. *Courtesy Gloria Azzolina Lorenzo.* $50-100.

Top left: Detail.

Bottom left: Embroidered, butterfly inspired, silk cord strap. c. 1980s. *Courtesy Emma Lincoln.* $50-100.

Bottom right: Embroidered, star pattern. c. 1980s. $50-100

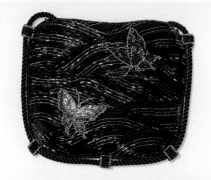

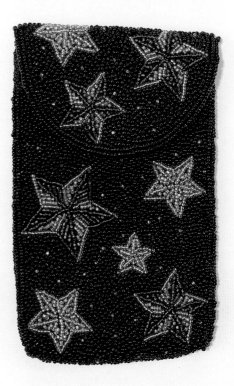

valued highly as collectibles; unless they have unusual designs.

Many internationally famous designers commission beadwork to be fashioned in Japan, Indonesia, India, and China. As a result, the quality of work, under the guidance of these top-name designers (e.g., Judith Leiber, Larisa Barrera, Christiana, Fendi, Prada, Moschino, Etro, Galliano, Badgley Mischka) is considered exemplary; these bags are considered beautiful works of art and will be highly collectible in the future. Currently, beaded bags by designers such as these retail in exclusive women's fashion stores with prices ranging from hundreds to thousands of dollars. Of these designers, Fendi, loyal to Italian workmanship commissions beadwork to be done in the villages of Italy, perhaps by the descendants of the beadworkers who made the bags of the nineteenth century.

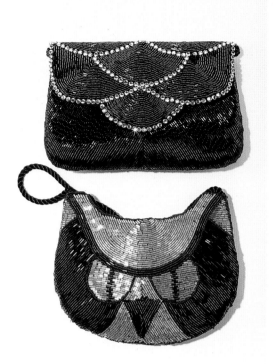

Top: embroidered, bugle beads, petal pattern. c. 1980s. *Bottom:* embroidered, bugle beads, owl pattern. c. 1980s. $50-100 each.

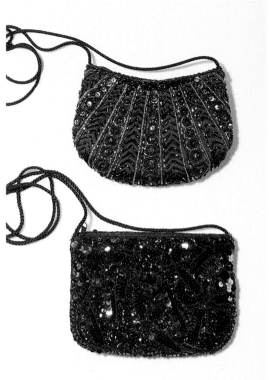

Top: embroidered, vertical pattern, silk cord. c. 1980s. *Bottom:* embroidered, sequins, silk cord. c. 1980s. $20-35 each.

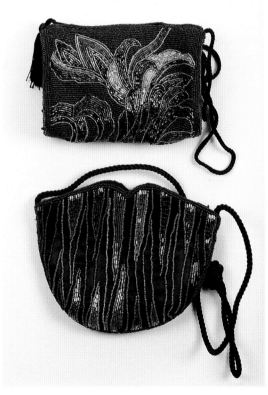

Top: embroidered, floral pattern, silk cord. c. 1980s. *Bottom:* embroidered, flame pattern, silk cord. c. 1980s. $35-50 each.

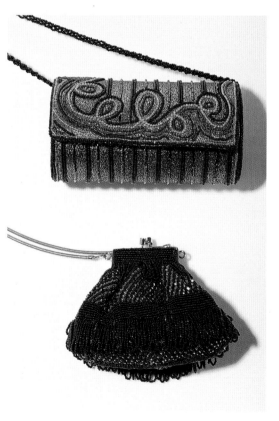

Top: embroidered, gold lame, bead woven cord. c. 1980s. *Bottom:* embroidered, brass frame, looped fringe. c. 1980s. $40-60.

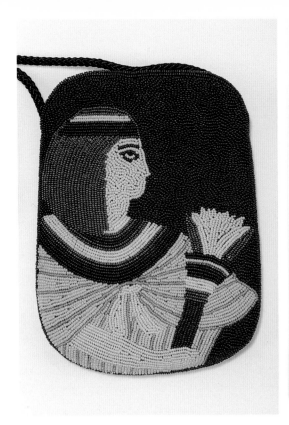

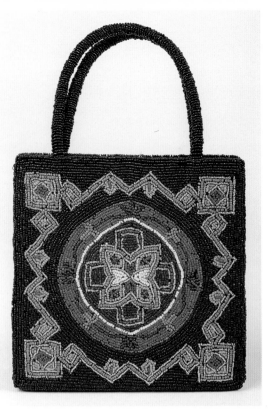

Embroidered on silk, Egyptian profile, silk cord. c. 1980s. *Courtesy Emma Lincoln.* $40-60.

Embroidered, multi-color seed beads, "Carpet Bag Tote" by Christiana, made in India. c. 1999. *Courtesy Knuth Shoes.* Retail: $120.

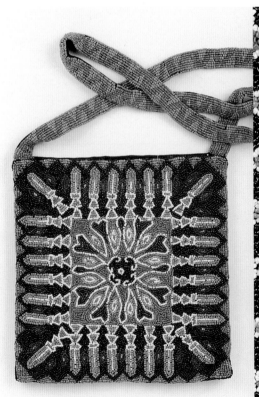

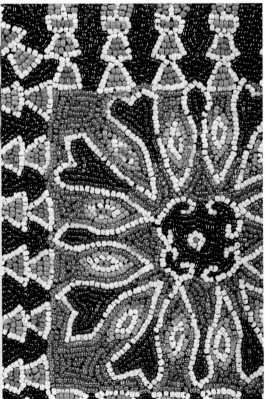

Embroidered, multi-color seed beads, "Messenger Bag" by Christiana, made in India. c. 1999. *Courtesy Knuth Shoes.* Retail: $110.

Detail.

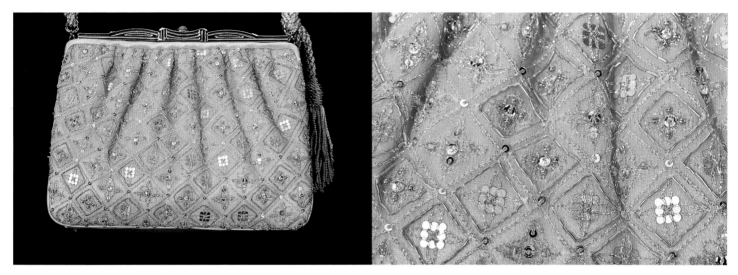

Embroidered on silk, diamond pattern, silk cord, entitled "Scroll," Judith Leiber designer. c. 1999. *Courtesy Alson Jewelers.* Retail: $2000.

Detail.

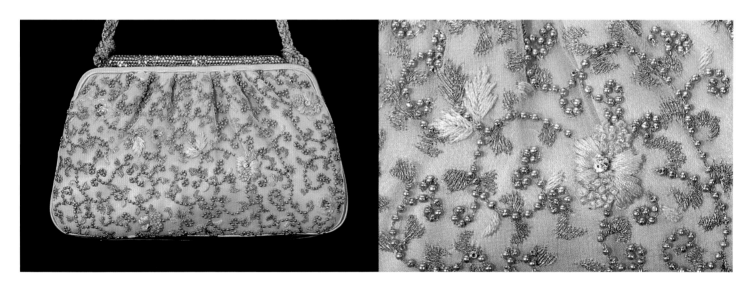

Embroidered on silk, silver beads, silk cord, entitled "Corn Flower," Judith Leiber designer. c. 1999. *Courtesy Alson Jewelers.* Retail: $1600.

Detail.

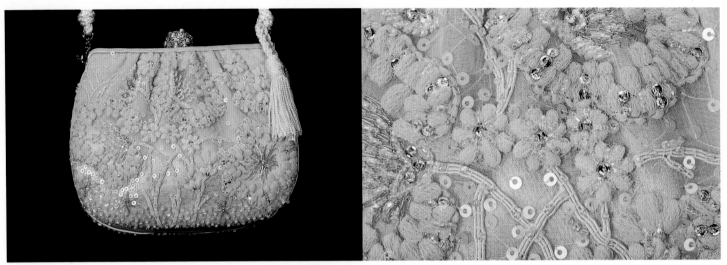

Embroidered on silk, silk cord, crystal beads, entitled "Star Burst," Judith Leiber designer. c. 1999. *Courtesy Alson Jewelers*. Retail: $2400.

Detail.

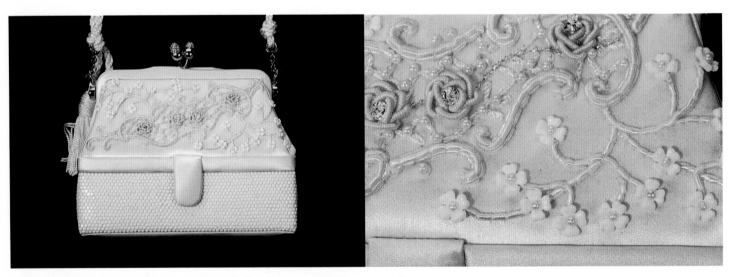

Embroidered on satin, silk cord, pearls and glass flowers, entitled "Rosebud," Judith Leiber designer. c. 1999. *Courtesy Alson Jewelers*. Retail: $2100.

Detail.

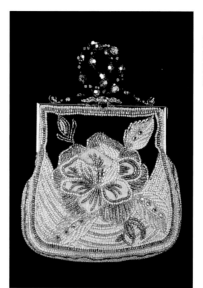

Embroidered on velvet, pearls, antique silver infused bugle beads, faceted silver and crystal beads on handle, rhinestone closure, by Larisa Barrera. c. 1999. *Author.* Retail: $950.

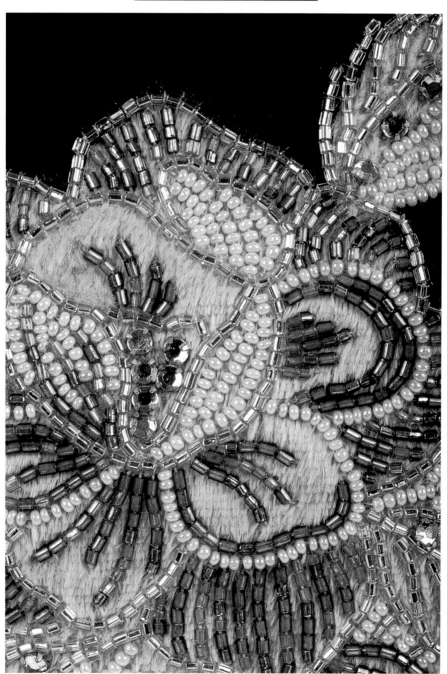

Detail.

Chapter 18
Collecting & Care

"When being considered for purchase the condition of the beaded purse is even more important than the condition of other types of bags."
from *More Beautiful Purses*
by E. Haertig

What considerations should be made when searching for a beaded bag to begin or add to a collection?

Eye appeal and personal taste will always be a major factor. Nonetheless, condition is an important issue, and should be taken into careful consideration in the actual purchase. Beadwork and beaded bags dating from the nineteenth and early twentieth centuries are fragile. Their threads are weakened by age, light, stress from use, from hanging the bag on display, and/or from general wear of the beads against the thread. Repair is difficult, at the very least, costly if an expert is found who will tackle the problem, and, unfortunately, all too often, an impossible task. Experienced collectors, however, will not shy away from a bag that has missing or damaged fringe, if they know how to do the beadwork. Having a resource to supply antique beads for the repair is also a necessary component.

Carefully compare the price asked for the item with the item's present condition. A bag in "good" or "perfect condition"—that is, without holes, rust, heavy soil, missing beads or fringe—will increase in value through the years. Making exceptions for bags that feature examples of unusual patterns, or for items that are rare, is important, especially if the price of the item reflects its condition. Experience with collecting, buying, selling, and simply searching for beaded bags is the best indicator of when an item is worthy of the risk.

How is the value of a beaded bag established?

Condition, design, rarity, and desirability all affect the resale cost of a beaded bag. A good rule of thumb for desirability is to 'collect what you love or desire.' If an item is simply *irresistible,* this will definitely affect the price a collector is willing to pay for the article. In addition—and possibly the most important factor—the price a dealer or collector originally paid for the article will affect its resale price.

The range of values in this book reflects the purchase prices of beaded bags offered (by experienced collectors and dealers) at the large antique shows and auctions held in the United States and London, England, between 1997 to 1999. These ranges are suggestions that are subject to variations and change, and *neither the authors nor the publisher can be responsible for any outcomes from consulting this guide.*

The quest for antique beaded bags, a collecting craze that began in the late 1960s, still continues today. At the start of the twenty-first century, it is becoming more and more difficult to find these highly collectible treasures—especially those that remain in excellent condition or intricately knitted from fine Venetian beads. Today many of these rarities are kept in museums or private collections, or owned by collector/dealers. When these collections become available on the market, their prices are sure to be high.

Are the sizes and/or type of beads factors in determining value?

Bags made from fine or very fine Venetian seed beads, knitted in intricate patterns, usually will command a higher value than bags made from larger seed beads. Bags in good or perfect condition, woven in multi-colored, cut-steel beads will retain a much higher value than those of the same condition that are woven in French, cut-steel beads in the more common colors of silver and gold.

Where are vintage beaded bags sold? Are there still bargains to be "had?"

Beaded bags can be purchased from antique and vintage dealers, collectors, auction houses, estate sales, on-line, and every now and then, at a thrift shop. Search and discovery is part of the excitement of collecting. Finding a bargain is still possible, although not as common as it was fifteen years ago. One find worth mentioning occurred at an auction held in Saint Louis, Missouri, November 1998. A lucky bidder paid $160 for two bags: one was described as having a Venetian scene. There is no way to know the condition of this bag, but at the price paid, it was, no doubt, a bargain!

Should beaded bags be worn?

Beaded bags must be handled with the greatest of care if they are to be preserved. If used, they should be regarded as ornaments or jewelry, and "carried" rather than "worn." Measures should be taken to insure that nothing is stored in them that will cause stress to the threads. Weight from cosmetics or a cell phone (!) will damage the threads connecting the beadwork to the frame and deteriorate the overall strength of the bag. Even gentle use can expose the looped fringe to possible snags or breaks.

Originally carrying a beaded bag was intended to display the expert workmanship and the beautiful needlework afforded by the maker. If not properly cared for, it is unlikely that these treasures will survive as statements of beauty and fine artistry.

How should beaded bags be stored and cared for?

The most harmful elements to affect antique beaded bags are the same factors that are potentially damaging for all treasures from the past: **light, dirt,** and **moisture.**

Beaded bags should be stored flat, wrapped with acid-free tissue paper. Investing in acid-free boxes is also advised. (Acid-free, or "acid-proof," tissue paper and boxes are available by special order from suppliers such as Talas (New York) and from container stores located in the malls of most large cities.) Keep these boxes in dark, clean, cool, dry areas. Most attics and basements are not suitable places.

Also items should not be stored in plastic bags. Enclosing in plastic will retain the moisture and risk damage from mildew. American cut-steel beads will rust in that condition.

If a beaded bag is dusty or covered with some loose dirt, it can be cleaned lightly with a vacuum on low power, with a paper or cotton filter applied to the nozzle. Distilled water can be used, lightly and with care, to remove the film often seen on vintage jet beads (otherwise known as "jet disease"), and the light soil from vintage glass beads that are not dyed. (Careful though, infused, or dyed, beads will lose their color if water is applied.) Consulting the department of textile conservation of a museum may help if further cleaning is needed.

What are some of the ways beaded bags can be displayed?

It is difficult to enjoy a collection, if wrapped in tissue, stored away and out of sight. Beaded bags are most assuredly small works of art. Even those with simple patterns or in one color reflect light and provide wonderful color interest. A collection is appealing for the "stories" these works of art capture and the histories they tell. In addition to the bags themselves, their "stories" should also be appreciated and shared by admirers. Interior designers show creative displays of beaded bags, hanging from a decorative rack or hook on the wall, in bedrooms, vanity areas, and entrance halls. Decorators exhibit them set out in living rooms on end tables, chests, or other furniture, and in display cases.

Again, important factors to consider are light, dust, and stress. Glass beads infused with color, colored (French) cut-steel beads, and crocheted and knitted threads will all fade and weaken with excessive, and sometimes even minimum, exposure to light. Light, natural and artificial, is truly the most damaging element when it comes to fabrics and dyes. Beaded bags should be placed on display in an area that is out of direct sunlight. If possible, collections should be rotated, so the same bags are not continually on display.

Dirt, dust, and grime cause damage and deterioration, also. Items should not be displayed in areas where they are exposed to grease or chemical deposits—such as in kitchens, near cooking areas, or in bathrooms. (These areas also present high levels of humidity and moisture.)

Early American Indian bags show signs of damage from when they were closed in areas with open fires; there is a stiffness in the leather and deposits of grime on the surface of the beads. Bags hung for extended periods in powder rooms show a build up from soap scum and white dust from the paper products used.

The weight of the beads alone is a factor that places stress on the bags, weakening their condition—especially damaging the beaded threads that attach directly to the frame. Over time, these threads will fray and break, a particular concern when the larger beaded bags constructed from glass or cut-steel beads are hung from their handles for display.

Consult an art gallery or a framing shop when creating displays for fragile items or those that are historic antiques. Specialists in conservation and display will be able to evaluate the best method for mounting these items. New materials and display methods can allow for a setting that is transparent, providing the bags and beadwork with support without intruding or impinging upon a bag's beauty.

We wish you the enjoyment that the experience of owning, displaying, and admiring your own collection of beaded bags will bring. May their beauty be preserved for the future.

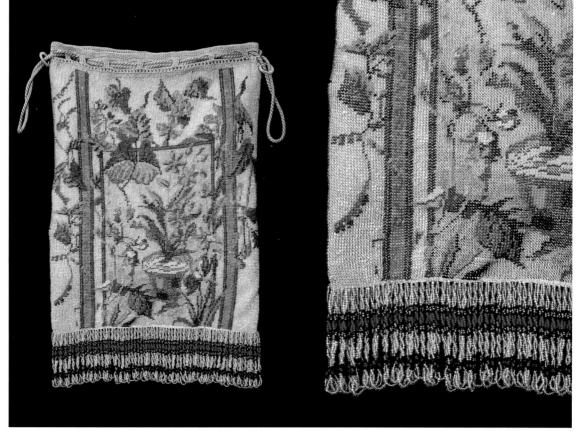

Left: Knitted, crocheted header, drawstring, fine multicolor seed beads, Japanese floral motif, twisted entwined fringe, 12-inch length. c. late 1800s. *Courtesy Veronica Trainer.* $750-900.

Right: Detail.

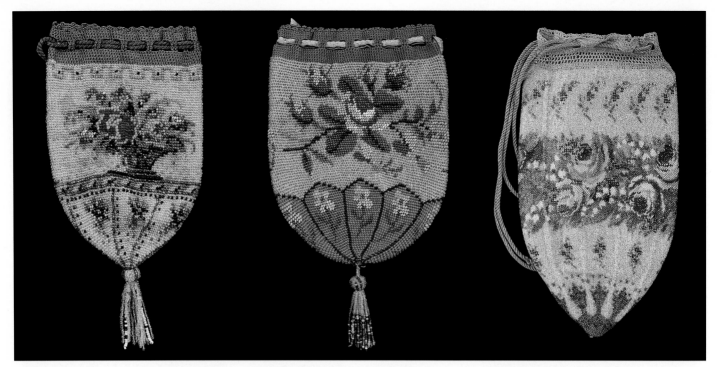

Knitted, blue silk crocheted header, drawstring, multi-color glass seed beads, floral basket motif, beaded tassel, 8-1/2 inch length. c. early 1900s. *Courtesy Frances Farrer Evans.* $250-375.

Knitted, green silk crocheted header, drawstring, original French ribbon, multi-color glass seed beads, floral motif, beaded tassel, 8-1/2 inch length. c. early 1900s. *Courtesy Charlotte L. Cudlip.* $250-375.

Embroidered on open weave silk, multi-color fine seed beads, roses, forget-me-nots, and lily-of-the-valley, tan silk crocheted header, drawstring, missing tassel, (showing seam) 10-1/2 inch length. c. late 1800s to early 1900s. *Courtesy Madeleine Parker.* $250-300.

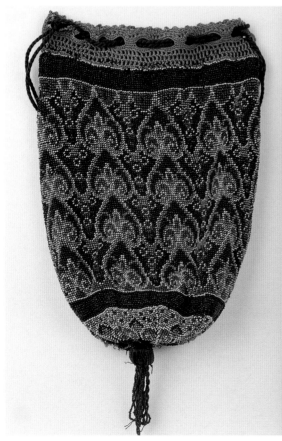

Knitted, tan silk crocheted header, multi-color fine seed beads, repeated pattern, drawstring, beaded tassel, 8-1/2 inch length. c. late 1800s to early 1900s. $250-375.

Detail.

Front view: knitted multi-color fine seed beads, floral and 'eternal fire' funereal motif, weeping willow tree, iron frame, 7-inch length. c. early 1800s. *Courtesy Madeleine Parker.* $450-500.

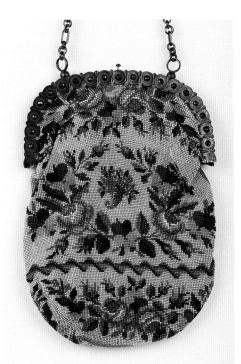

Back view: cornucopia.

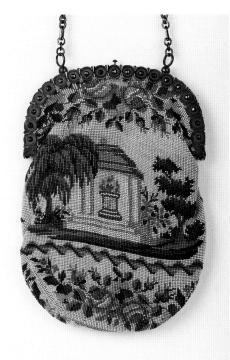

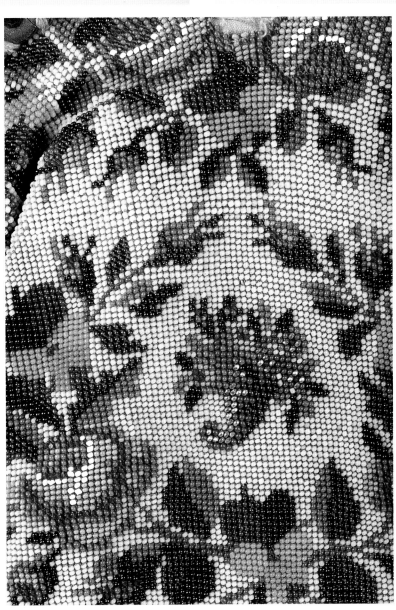

Detail. Approximately 490 beads per square inch.

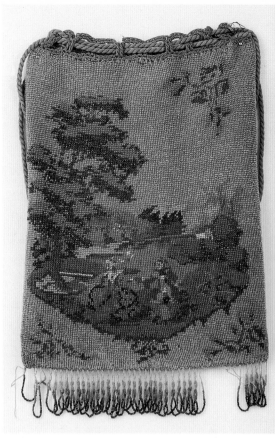

Top left: Knitted, tan silk crocheted header, multi-color very fine seed beads, courting motif, man on his knee with bouquet of yellow flowers, his hand stretched out to a lady, both figures on the bank of a lake, dressed in eighteenth-century costume, drawstring, 7-1/2 inch length. c. early-to-mid 1800s. *Courtesy Madeleine Parker.* $350-500.

Top right: Detail. Approximately 450 beads per square inch.

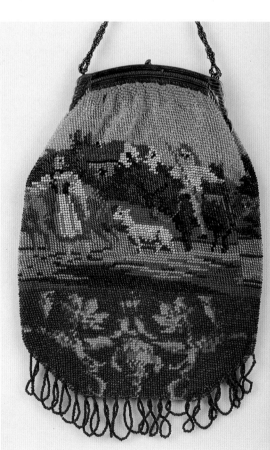

Bottom left: Knitted, multi-color seed beads, figural motif, woman leading a cow, man on a donkey, following a lamb, structures and trees in the background, nickel frame, looped fringe, 7-inch length. c. early 1800s. *Courtesy Madeleine Parker.* $450-600.

Bottom right: Detail. Approximately 350 beads per square inch.

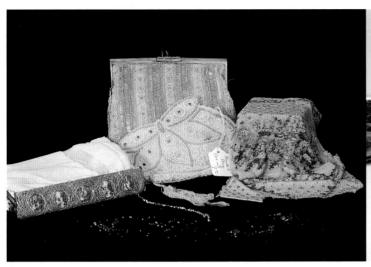

A grouping of vintage beads, beadwork, and beaded bags used to repair other bags. Bags in poor condition can be purchased at bargain prices. *Author.* The center bag is marked with a sales tag: $1.00.

Vintage black French "jet" (glass) beads found in thrift shops. The spool of twisted-purse-silk thread, strung with beads, is an unfinished project from the 1920s. *Author.*

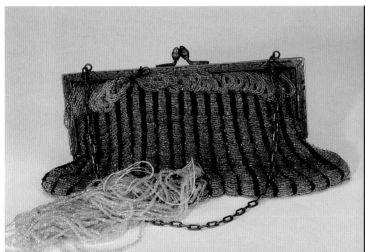

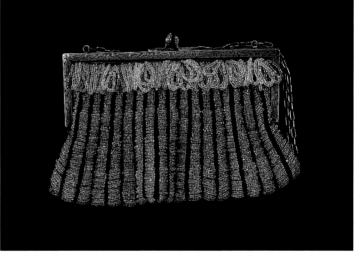

A vintage bag from the 1920s with a broken fringe. The strings of antique crystal beads is used to repair the fringe. *Courtesy Judith K. Brown.*

Completed repair. The vintage cotton thread of the fringe was the weak; as the repair was in process, the vintage cotton thread continued to break in new areas. Even a repair that appears simple, such as this fringe, can take hours of patience. *Courtesy Judith K. Brown.*

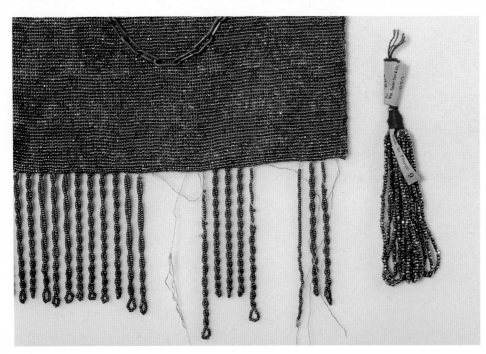
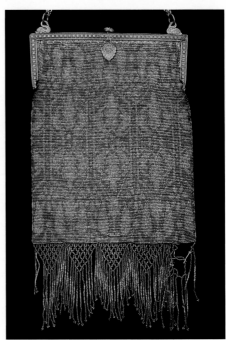

Missing fringe on a French cut-steel beaded bag; beads from the same era. Beads are marked "Made in France, Wm. Taylor Son & Co." c. 1920s. *Author.*

Damaged fringe on a French cut-steel beaded bag; needle woven fringe in a lattice pattern is difficult to repair. 12-inch length. c. 1920s. *Courtesy Estate of Gertrude Freedland.*

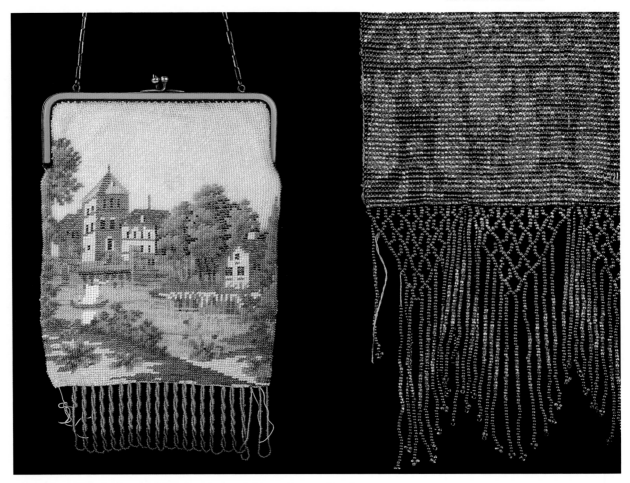

Knitted, multi-color fine seed beads, pond, red tile roof in the background, toy sailboat with white sail in the foreground, turquoise enameled frame, blue cabochon clasp, twisted entwined fringe, label "Made in Germany," 7-1/2 inch length. c. early 1900s. *Courtesy Madeleine Parker.*

Detail.

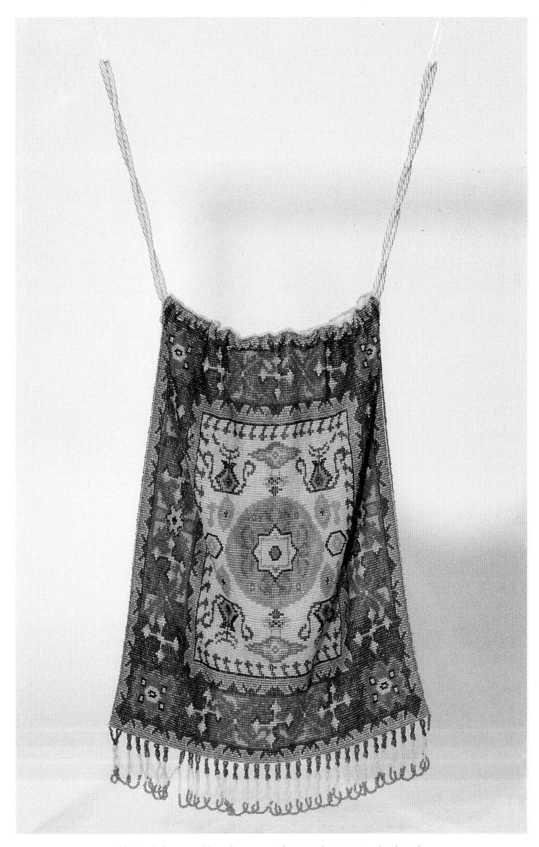

Knitted, fine seed beads, carpet design, drawstring, displayed
in a Lucite box, 13-inch length. c. late 1800s. *Author.*

Bibliography

Ashelford, Jane. *The Art of Dress, Clothes and Society 1500-1914*. London: National Trust Enterprises Limited, 1996. 320 pages. A history of costume using antique apparel from Britain's National Trust; color illustrations.

Barnes, Galer Britton. "A Matter of Fashion: Beaded Bags from the Civil War Era," *Piecework* (Vol. II, No. 3, 1994): 48-51. Historical information and color illustrations.

Barth, Georg J. *Native American Beadwork: Traditional Beading Techniques for the Modern Day Beader*. Stevens Point, Wisconsin: R. Schneider, Publishers, 1993. 219 pages. Brief history and complete instructions for American Indian beadwork; black and white illustrations of vintage beadwork.

Batt, Paulette. (Owner of Larchmere Antiques and Paulette's Vintage, Cleveland, Ohio. Expert in collecting and restoring vintage apparel; schooled in Belgium for needle work and bead embroidery.) Personal interview, February-November, 1998.

Beaded Bags & More. Jules and Kaethe Kiliot, editors. Berkeley: LACIS Publications, 1998. 112 pages. Collection of five original publications on beaded bags, with black and white illustrations, instructions, charts for knitting and crocheting purses.

Beadwork. Jules and Kaethe Kiliot, editors. Berkeley: LACIS Publications, 1984. 56 pages. Unabridged edition of *Priscilla Bead Work Book* by Belle Robinson, 1912; and selections from two other instruction books for beaded purses, 1912 and 1924; with black and white illustrations.

Berry, Sue. (Western Reserve Historical Society, Chisholm Halle Costume Wing, Cleveland, Ohio.) Personal interview, September, 1998.

Blair, Joane. *Fashion Terminology*. New Jersey: Prentice Hall, 1992. 129 pages. Dictionary of fashion terminology with illustrations.

Boucher, Francois. *20,000 Years of Fashion; The History of Costume and Personal Adornment*. New York: Harry N. Abrams, Inc., 1987. 459 pages. One of the most comprehensive costume histories using illustrations from museum holdings in black and white and color plate.

Bradfield, Nancy. *Costume in Detail: 1730-1930*. New York: Costume & Fashion Press, 1997. 391 pages. Original sketches of costume and accessories from British museums with descriptions and history.

Brafford, C. J., and Laine Thom. *Dancing Colors: Paths of Native American Women*. San Francisco: Chronicle Books, 1992. 120 pages. Traditions of Native American culture; color illustrations of artifacts from American museums.

Broyles, Mary. (President of Ornamental Resources, Inc., Idaho Springs, Colorado; an order company for beads and related supplies.) Telephone interviews, July-August, 1998.

Caring for Your Collections. Arthur W. Schultz, General Editor. New York: Harry N. Abrams, Inc., 1992. 216 pages. Chapters and essays by experts regarding the care of collectibles; black and white and color illustrations.

Charming Collection of Modern Beaded Bags. A. New York: Dritz-Traum Co., (HIAWATHA) 1924. 31 pages. Black and white illustrations and instructions.

Chervenka, Mark. "Antique & Collectors Reproduction News, Beaded Purses: Distinguishing the Old from the New," *Antique Trader* (April 8, 1998): 79. A comparison of design and technical differences between vintage beaded purses and reproductions.

Christie, Archibald H. *Pattern Design: An Introduction to the Study of Formal Ornament*. New York: Dover Publications, Inc., 1969. An illustrated history of designs used for ornamentation; reprinted from Oxford, England: Clarendon Press, 1910; with black and white illustrations.

Cigliano, Jan. *Showplace of America: Cleveland's Euclid Avenue, 1850-1910*. Kent, Ohio, and London: The Kent State University Press, 1991. 398 pages. Description of the life and times of historically important families who lived in Cleveland, Ohio; black and white illustrations.

Clabburn, Pamela. *Beadwork*. Aylesbury, Bucks, England: Shire Publications, 1980. 32 pages. Historical information with black and white illustrations.

Coles, Janet, and Robert Budwig. *Beads: An Exploration of Bead Traditions Around the World*. New York: Simon & Schuster Editions, 1997. 160 pages. Historical information and color illustrations.

Cumming, Valerie. *The Visual History of Costume Accessories*. New York: Drama Publishers, 1998. 178 pages. An illustrated history of accessories including purses with black and white and color plates.

Cummins, Genevieve E., and Nerylla D. Taunton. *Chatelaines: Utility to Glorious Extravagance*. Woodbridge, Suffolk, England: Antique Collectors' Club, 1994. 311 pages. The most complete historical research available on the history of the chatelaine; black and white and color illustrations.

De Jong-Kramer, E. *Classic Beaded Purse Patterns*. Berkeley: LACIS Publications, 1996. 56 pages. Pattern instructions and color and black and white illustrations of antique purses.

Dooner, Kate. *A Century of Handbags*. Atglen, Pennsylvania: Schiffer Publishing Ltd., 1993. 156 pages. A catalog of vintage purses from 1920s–1980s; color plates; includes historical information.

Dublin, Lois Sherr. *The History of Beads: From 30,000 B.C. to the Present*. New York: Harry N. Abrams, Incorporated, 1987. 364 pages. Comprehensive history of beads with full page color and black and white illustrations; time-line chart.

————. *The History of Beads: From 30,000 B.C. to the Present, Concise Edition*. New York: Harry N. Abrams, Incorporated, 1987. 136 pages. Abridged edition of history of beads with color photographs.

Edwards, Joan. *Bead Embroidery*. Berkeley: LACIS Publications, 1992. 192 pages. Comprehensive history with research and sketches of beadwork in English museums.

"Emporium," *Lady's Gallery* (Vol. I, Issue 2, 1993): 94. Includes pricing for steel and glass beaded purses.

Ettinger, Roseann. *Handbags*. Atglen, Pennsylvania: Schiffer Publishing Ltd., second edition, 1998. 184 pages. A catalog of vintage purses; includes a history of the purse; with color plates and a value guide.

Ewing, Elizabeth. (Revised and updated by Alice Mackrell.) *History of Twentieth Century Fashion*. Third edition. New York: Quite Specific Media Group Ltd., 1992. 300 pages. Comprehensive history with black and white illustrations.

Fashions and Costumes from Godey's Lady's Book. Stella Blum, editor. New York: Dover Publications, Inc., 1985. 91 pages. Black and white illustrations of apparel and accessories from 1830-1870.

Forrington, Sandy. *Picot Lace™, Innovative Beadwork*. Ft. Bragg, California: SFO Enterprises, 1993. 160 pages. An instruction book for producing lace like patterns with seed beads using needle and thread.

Foster, Vanda. *Bags and Purses*. London: B.T. Batsford Ltd, 1982. 98 pages. An illustrated history of the purse from 1600 to 1980's.

————. *A Visual History of Costume: The Nineteenth Century*. London: B. T. Batsford, Ltd, 1984. 144 pages. A series of black and white and color illustrations of paintings, engravings, woodcuts, and photographs with descriptions and history; includes purses.

Francis, Peter, Jr. *A Short Dictionary of Bead Terms and Types*. Peter Francis: 1979. 119 pages. Comprehensive, technical dictionary of beads and beading terms.

Fukuyama, Yusai. *Tambour Work*. Berkeley: LACIS Publications, 1997. 120 pages. Comprehensive instructions with black and white illustrations.

Gimble, Frances. *After a Fashion: How to Reproduce, Restore, and Wear Vintage Styles*. San Francisco: Lavolta Press, 1993. 337 pages. Comprehensive instructions for identifying, collecting, reproducing, and restoring vintage apparel; list of resources.

Gips, Kathleen. *Flora's Dictionary: The Victorian Language of Herbs and Flowers*. Chagrin Falls, Ohio: TM Publications, 1990. 187 pages. A concise compilation of information on the language of flowers.

————. *Language of Flowers, The: A Book of Victorian Floral Sentiments*. Chagrin Falls, Ohio: Pine Creek Press, 1990. 199 pages. A complete dictionary of the meanings of herbs, flowers, trees, and shrubs.

Goldstein, Doris. "Value Judgements: Chatelaines," *Art & Antiques* (Vol. XXI, No. 5, 1998): 80-82. A brief history of chatelaines and current values.

Gordon, Lesley. *Green Magic: Flowers, Plants & Herbs in Lore and Legend*. New York: The Viking Press, 1977. 200 pages. A comprehensive study of the symbolism of flowers, plants, and herbs in history, mythology, religion, witchcraft, communication, etc.

————. *Language of Flowers, The*. London: Grange Books, 1984. 48 pages. The explanation and history of the sentiment of some flowers.

G. Grilli—Venezia: *Premiata Fabrica di Frange, Fiori, Fantasie in Perle*. Venice, Italy: Grilli, 1924. 37 pages. A glass company brochure with black and white illustrations.

Handbook of Needlecraft, Number 2. Augusta, Maine: Needlecraft Publishing Company, 1915. 64 pages. Instructions for needlework projects for crocheting, tatting, knitting, and embroidery.

Haertig, Evelyn. *Antique Combs & Purses*. Carmel, California: Gallery Graphics Press, 1983. 304 pages. A history of the purse and comb from prehistoric times to the 1920s; color and black and white illustrations.

————. *More Beautiful Purses*. Carmel, California: Gallery Graphics Press, 1990. 575 pages. Possibly the most comprehensive history and catalog of handbags, especially beaded; color and black and white illustrations.

————. "Venice and Its History of Beads," *Lady's Gallery* (Vol. III, Issue 2, 1995): 16-20; 47-48. An edited chapter from *More Beautiful Purses* by Evelyn Haertig; color illustrations.

————. "The Purse in History," *Lady's Gallery* (Vol. I, Issue 3, 1993): 28-30. An edited chapter from *Antique Combs & Purses* by Evelyn Haertig; color illustrations.

Harding, Deborah. *Bagging the Tourist Market*. (Masters Thesis, April 1994): 109 pages. A descriptive and statistical study of nineteenth-century Iroquois beaded bags. Illustrations of beadwork examples from American museums and a private collection.

Harris, Elizabeth. *A Bead Primer*. 6th printing. Arizona: The Bead Museum, 1987. 30 pages. Pamphlet; descriptions and history of glass beads with black and white illustrations by Karen Lindquist.

Harris, Kristina. *Vintage Fashions For Women, 1920s–1940s*. Atglen, Pennsylvania: Schiffer Publishing Ltd., 1996. 192 pages. A catalog in color plates of vintage fashion; includes few beaded purses.

Hill, Thomas E. *Hill's Manual of Social and Business Forms*. Chicago: Hill Standard Book Co., 1882. 401 pages. A late 1800s comprehensive guide to "correct writing." Includes a dictionary of the language of flowers, and examples of how to apply the descriptions.

Holiner, Richard. *Antique Purses: A History, Identification and Value Guide*. Paducah, Kentucky: Collector Books, 1987. 207 pages. A brief history of purses and color catalog.

Kinsler, Gwen Blakey. "The Ingenious Miser's Purse," *Piecework* (Vol. IV, Number 6, 1996): 46-51. A brief history with bibliography and color illustrations; instructions for crocheting a miser's purse.

Kock, Jan, and Torgen Sode. *Glass, Glassbeads and Glassmakers in Northern India*. Denmark: THOT Print. 30 pages. Personal account of exploring the glass producing centers of Northern India with color illustrations.

Korach, Alice. "Bead Knitting Madness," *Threads* (Number 24, 1989): 24-29. Instructions for knitting a beaded bag in a vintage pattern.

Lane, Dottie. "Judith Leiber Handbags," *Lady's Gallery* (Vol. III, Issue 3, 1995): 40-45.

Laver, James. *Costume & Fashion, A Concise History*. Reprinted 1986. New York: Thames and Hudson, Ltd., 1969-1982. 288 pages. Comprehensive history with black and white (some color) illustrations.

Liese, Gabrielle. (Director and founder of The Bead Museum, Prescott, Arizona.) Personal interview, January 1998.

Lichten, Frances. *Decorative Art of Victoria's Era*. New York: Bonanza Books, 1950. 274 pages. A comprehensive compilation of aspects of nineteenth-century arts and customs.

Lohrmann, Charles J., and Jeri Ah Be Hill. "Beadmakers of the Southern Plains," *Piecework* (Vol. VI, Number 4, 1998): 14-21. A description of traditional beadwork and customs; color illustrations and instructions for specific stitches.

Lui, Robert K. "Glass Beads: Costantini Beads," *Ornament* (Vol. 20, No. 4, 1997): 60. A brief discussion of the Costantini glass bead factory and store in Venice, Italy.

Mailand, Harold F. *Considerations for the Care of Textiles and Costumes: A Handbook for the Non-Specialist*. Indiana: The Indianapolis Museum of Art, 1980. 23 pages. Basics of techniques and practices of conserving collections of costumes and textiles.

Metzger-Krahe, Frank. *Glasperlenarbeiten im 19 Jahrhundert*. Nienburg, Germany, 1980. 72 pages. Catalog published in conjunction with an exhibit by the same name (Glass Beadwork of the Nineteenth Century) at the Nienburg Museum; descriptions of bead embroidery and black and white illustrations; German text.

Monture, Joel. *The Complete Guide to Traditional Native American Beadwork*. New York: Macmillan Publishing Company, 1993. 113 pages. A study of tools, materials, techniques and patterns; some color illustrations.

Muller, Helen. *Jet Jewellery and Ornaments*. Buckinghamshire, United Kingdom: Shire Publications Ltd, 1980. 32 pages. A history of jet jewelry with black and white illustrations.

Newman, Denise. (Isle of Beads, Cleveland, Ohio.) Personal Interviews 1998 and 1999.

Palmer, Heather. "Recapturing the Garden: The Prevalence of Floral Motifs in Needlework in the Mid-Nineteenth Century," *Piecework* (Vol. VII, No. 3, May/June 1999): 18-20.

Peacock, John. *Costume: 1066-1990s*. London: Thames and Hudson Ltd., 1994. 135 pages. Documentation of the changes in costume since 1066; original sketches of costumes and accessories.

Phillips-Selkirk Auctioneers and Appraisers. *Collectible and Couture Auction*. November 12, 1998. 24 pages. Catalog of 776 lots, with descriptions, black and white illustrations, bid ranges, and sales prices; includes some purses.

Pictorial History of Costume, A. Dorine van den Beukel, editor. New York: Costume & Fashion Press, 1998. 224 pages. Color illustrations from the pre-Christian era to the 1900s; includes accessories.

Queen Victoria. Jane Drake, editor. Andover, Hampshire, UK: Pitkin Pictorials LTD.: 1992. 21 pages. A brief outline of the era of Queen Victoria, with color and black and white illustrations.

Rothstein, Natalie. *Four Hundred Years of Fashion*. Reprint, 1992. London: Victoria and Albert Museum, 1984. 176 pages. Description, history, and color illustrations of costume and accessory collections.

Schwartz, Lynell K. "The Home Purse Making Market," *Lady's Gallery* (Vol. III, Issue I, 1995): 48-53. An edited chapter from *Vintage Purses At Their Best* by Lynell K. Schwartz; with color illustrations.

———. *Vintage Purses At Their Best*. Atglen, Pennsylvania: Schiffer Publishing, Ltd., 1995. 160 pages. A color illustrated catalog of collectible purses from the 1800s and 1900s with historical information and a price guide.

Sears, Roebuck Catalogue, 1908: A Treasured Replica from the Archives of History. Joseph J. Schroeder, ed. Illinois: DBI Books, Inc., 1971. 1,184 pages. Re-publication of the original catalog.

Smith, Sarah Phelps. *Dante Gabriel Rossetti's Flower Imagery and the Meaning of his Painting*. Doctoral Thesis submitted to University of Pittsburgh, 1978. 207 pages.

Stanley-Millner, Pamela. *North American Indian Beadwork Patterns*. New York: Dover Publications, Inc., 1995. 64 pages. Graphs with patterns of designs from American Indian artifacts found in United States' museums.

Swarthout, Doris L. *An Age of Flowers: Nature, Sense & Sentiment in Victorian America*. Old Greenwich, Connecticut: The Chatham Press, 1975. 159 pages. A comprehensive study of the effect of nature on daily life, decorative arts, and sentiment of Victorian America.

Thomas, Mary. *Mary Thomas's Knitting Patterns*. New York: Dover Publications, Inc., 1972. 320 pages. Illustrations of knitting patterns and instructions; includes instructions for stitches used for knitting Miser's bag; re-published from the Hodder and Stoughton, Ltd., London publication, 1943.

Treasures from the Embroiderers' Guild Collection. Elizabeth Benn, editor. London: David & Charles, 1991. A study of the collections held by The Embroiderers' Guild Museum.

Van de Krol, Yolanda. "Ladies' Pockets," *Antiques* (March 1996): 438-445. A history of the pocket, which is the precursor of the purse; color illustrations from American museums.

Warren, Geoffrey. *Fashion Accessories Since 1500*. New York: Drama Book Publishers, 1987. 160 pages. A comprehensive history of fashion accessories illustrated in black and white original sketches of items from print and museum collections.

White, Mary. *How to do Bead Work*. New York: Dover Publications, Inc., 1972. 142 pages. Black and white illustrations and sketches of vintage beadwork with instructions; reprint of Doubleday, Page and Company, 1904.

Wilcox, Claire. *A Century of Bags: Icons of Style in the Twentieth Century*. Edison, New Jersey: Chartwell Books, 1997. 160 pages. A brief history with color illustrations of purses throughout the 1900s.

William Doyle Galleries. *Couture and Textiles*. November 10, 1998. 126 pages. Catalog of 635 lots, with descriptions, black and white illustrations, bid ranges, and sales prices; includes some purses.

———. *Couture and Textiles*. May 12, 1999. 100 pages. Catalog of 515 lots, with descriptions, black and white illustrations, bid ranges, and sales prices; includes some purses.

World of the American Indian, The. Jules B. Billard, editor. Washington, D.C.: National Geographic Society, 1989. 400 pages. A cultural description of Native American Indian tribes; color illustrations.

Index

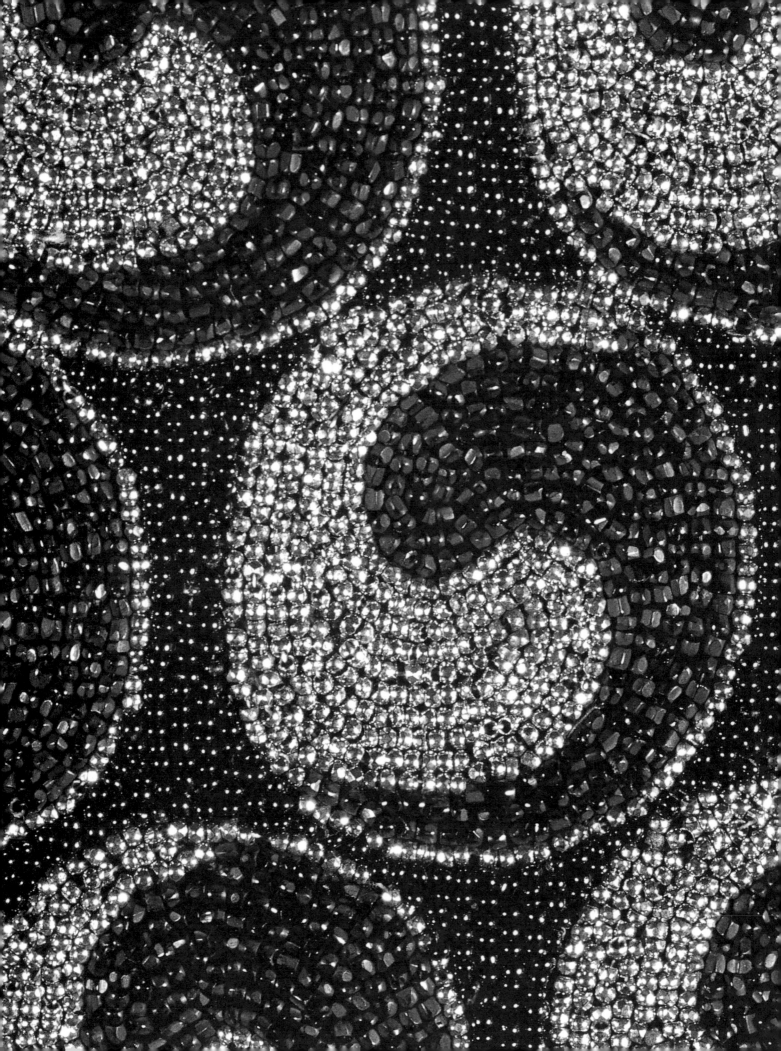